MW01201959

DICKEY CHAPELLE UNDER FIRE

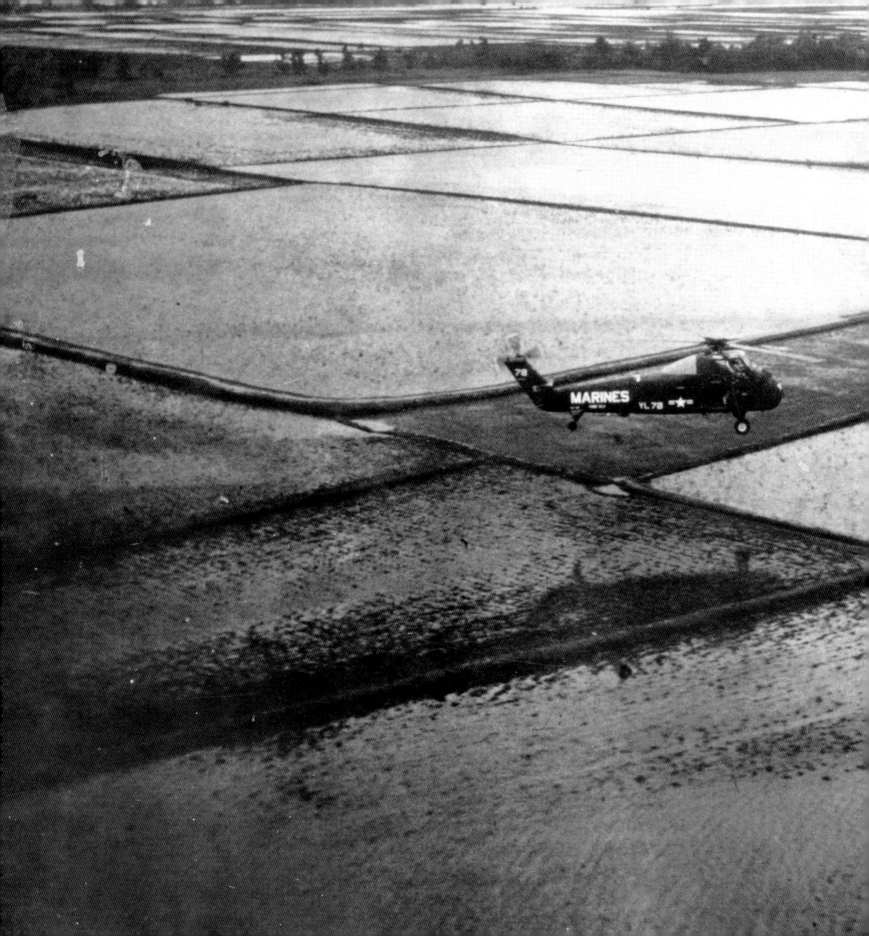

DICKEY CHAPELLE
UNDER FIRE

Photographs by the First American Female
War Correspondent Killed in Action

JOHN GAROFOLO

Foreword by Jackie Spinner,
former war correspondent for the *Washington Post*

WISCONSIN HISTORICAL SOCIETY PRESS

Published by the Wisconsin Historical Society Press
Publishers since 1855

© 2015 Text by John Garofolo

For permission to reuse material from *Dickey Chapelle Under Fire* (ISBN 978-0-87020-718-1; e-book ISBN 978-0-87020-719-8), please access www.copyright.com or contact the Copyright Clearance Center, Inc. (CCC), 222 Rosewood Drive, Danvers, MA 01923, 978-750-8400. CCC is a not-for-profit organization that provides licenses and registration for a variety of users.

wisconsinhistory.org

Photographs identified with WHi or WHS are from the Society's collections; address requests to reproduce these photos to the Visual Materials Archivist at the Wisconsin Historical Society, 816 State Street, Madison, WI 53706.

Printed in the United States of America
Designed by Ryan Scheife / Mayfly Design

Front cover photo: WHi Image ID 86868

19 18 17 16 15 1 2 3 4 5

Library of Congress Cataloging-in-Publication Data
Garofolo, John., 1957–
 Dickey Chapelle under fire : photographs by the first American female war correspondent killed in action / by John Garofolo ; foreword by Jackie Spinner, former war correspondent for the Washington Post.
 pages cm
 ISBN 978-0-87020-718-1 (hardcover : alk. paper)—ISBN 978-0-87020-719-8 (ebook)
1. Chapelle, Dickey, 1919–1965. 2. Chapelle, Dickey, 1919–1965—Pictorial works.
3. Photojournalists—United States—Biography. 4. Photojournalists—United States—Biography—Pictorial works. 5. War photography—United States—History—20th century.
6. War photography—United States—History—20th century—Pictorial works. I. Title.
 PN4874.C44G38 2015
 070.4'333092—dc23
 [B]
 2015004429

∞ The paper used in this publication meets the minimum requirements of the American National Standard for Information Sciences—Permanence of Paper for Printed Library Materials, ANSI Z39.48-1992.

For all veterans and wounded warriors,

*brave men and women
who served their country*

*and those who continue their legacy
of service and sacrifice.*

*For the families who support them,
suffer their loss,
and serve as a constant reminder
of what's worth fighting for.*

*And for Diana.
I love you to infinity and beyond.*

Acknowledgments

To my editors, Carrie Kilman and Kate Thompson, who are as passionate about and committed to this project as I am. Our goal was to make a great book, and I couldn't imagine having done this without them. To Wisconsin Historical Society Press director Kathy Borkowski and marketing director Kristin Gilpatrick and the great staff at the Wisconsin Historical Society Library-Archives, Andy Kraushaar, Harry Miller, Jonathan Nelson, and John Nondorf in particular.

To the Milwaukee Press Club Endowment and to board member Martin Hintz, who not only helped renew interest in Dickey Chapelle in recognition of the fiftieth anniversary of her death, but also generously alerted me that the Wisconsin Historical Society Press was looking into the possibility of publishing a book of Dickey's photographs.

To the Meyer family, Martha, Betsy, Rob, Dewey, and especially Marion and the late Robert Meyer, who allowed me the privilege of working on Dickey's remarkable story and granted permission to use her photos and excerpts from her autobiography for this project.

To Ron Chapelle, Dickey's stepson, who very generously offered his perspectives on Dickey's life and shared anecdotes about his father, Tony Chapelle.

To reference librarian Sue Cornacchia, for her research assistance, and to my friend and colleague Jim Moloshok for sharing his digital media expertise.

To my lawyer and friend Ted Baer, a Vietnam-era Navy JAG, for continuing to be a trusted advisor in more than just business matters.

To Yelena and Diana Garofolo, who have enriched my life in more ways than I could ever express.

TO THE MEMORY OF DICKEY CHAPELLE

WAR CORRESPONDENT KILLED IN ACTION

NEAR HERE ON 4 NOVEMBER 1965

SHE WAS ONE OF US AND WE WILL MISS HER

From a plaque dedicated November 4, 1966,

by Wallace M. Greene Jr., commandant of the US Marine Corps

Contents

It was dawn before I fell asleep, and later in the morning

I was only half-awake as I fed a fresh sheet of paper into the typewriter

and began to copy the notes from the previous day out of my book.

But I wasn't too weary to type the date line firmly

as if I'd been writing date lines all my life.

FROM THE FRONT
AT IWO JIMA MARCH 5—

Then I remembered and added two words.

UNDER FIRE—

They looked great.

—Dickey Chapelle

Foreword

by Jackie Spinner, former war correspondent for the *Washington Post*

For days I stared at a blank screen, unable to shake the image of Dickey Chapelle at the end of her life, curled in the dirt on an unremarkable battlefield in Vietnam. I should have been focusing on her life, beautifully detailed and documented through pictures in John Garofolo's poignant anniversary tribute. But I was caught at her ending.

I flashed to the names of my friends and colleagues, killed in different wars decades later. Marie Colvin. Anthony Shadid. Chris Hondros. Anja Niedringhaus. I think of my own close calls, the risks I took as a correspondent for the *Washington Post* while reporting the wars in Iraq and Afghanistan, which I did on and off from 2004 to 2011. I am haunted, not by how close I came to dying, but why I didn't die. Chapelle's death at age forty-seven—shrapnel to the neck a half century earlier after a Marine accidentally triggered a booby-trap—was a reminder of the randomness of who dies and who survives.

My friend Joao Silva, a photographer for the *New York Times*, survived after stepping on a landmine in Afghanistan in 2010 while on a patrol with the US Army. In the seconds after the mine detonated, he clicked three times, recording the moment. *Snap. Snap. Snap.* Silva lost both legs in the blast. After he was injured, I cofounded a combat photography exhibit in his honor that features the work of thirty civilian and military photographers and videographers from the frontlines of Iraq and Afghanistan. I created the exhibit with the help of a Marine combat veteran. *He's*

one of us, Lt. Col. Steve Danyluk told me, explaining why his Independence Fund, a nonprofit run by military veterans for severely injured military veterans, would care about a severely injured civilian photographer.

She was one of us, the Marines wrote on a marker where Chapelle died in Vietnam in 1965, the first female war correspondent killed in Vietnam and the first female correspondent killed in action anywhere. In *Dickey Chapelle Under Fire*, Garofolo reminds us that Chapelle knew the dangers posed by her profession, "yet she was determined to follow each story as far and as long as it would take her."

In Vietnam fifty years ago or in Iraq ten years ago, reporters could be caught by sniper bullets or pinned down by gunfire. But I wonder what Chapelle would have thought about the new dangers of war reporting: the fear of being kidnapped and beheaded. When two Al Qaeda militants tried to kidnap me outside of Abu Ghraib prison in 2004 in Iraq, this was what I most feared, captured on grainy video. It was not an unimaginable fear. It happened to our colleagues James Foley and Steven Sotloff in Syria. And yet, we still write. We still document. We still go.

I have a photograph taken of me in the back of a Marine truck in the Iraqi city of Fallujah. I've written my last name and blood type in black ink on a piece of duct tape on my bulletproof vest. Fallujah was hell, a battle I wasn't sure I would survive in 2004. And yet in the photograph, I am smiling, genuinely happy. When I see Chapelle smiling from photographs in *Dickey Chapelle Under Fire*, I understand. People

assume it is the risk or the thrill that attracts us. Perhaps for some it is. For others, it is the story and the need to report it.

Whenever I travel around the country with the Conflict Zone photography exhibit, I show the three photos Silva took after he stepped on the landmine. I also show his picture. And I show a picture of my friend, Chris Hondros, who was killed in Libya in 2011. *Do you know who this is?* I have asked this of probably five hundred people, all over the United States in the past four years, and maybe three people have recognized either of them, two of the best war photographers of my generation. I ask for two reasons. I don't want people to forget the risks my colleagues took to bring their stories home to a public that can be disconnected and ambivalent. I also ask to remind myself why we go to war, because you can be the best at what you do, and you can be hurt or killed, and in a few years—not fifty years, but a few—nobody may recognize your face. I went for a story because journalists are storytellers, and this is what we do.

In an earlier generation, Dickey Chapelle was one of the best. But if I showed her photograph to the same five hundred people, I doubt I could find even three people who would recognize her. Yet, as Garofolo shows us, we should know Dickey Chapelle. We should know her like we know Martha Gelhorn. Like Christiane Amanpour. Like Andrea Bruce.

We owe Garofolo for the twenty-four years he pursued this book to bring us Chapelle through pictures, to introduce us to her. Her name was lost among the notable print journalists and photographers who covered Vietnam, a list that includes trailblazing women but is often recounted for its men. Like Iraq and Afghanistan did for the reporters of my generation, Vietnam produced some of the best journalists of its time: Peter Arnett, David Halberstam, Seymour Hersh, Gloria Emerson, Tad Bartimus, Edie Lederer, Linda Deutsch, Kate Webb, Nick Ut, Walter Cronkite, Dan Rather. Dickey Chapelle belongs among them, and Garofolo rightfully places her there.

As Chapelle herself might have done, Garofolo handles the images without excessive sentiment. He does not try to speak for Chapelle. She already has done that in her 1962 autobiography, *What's a Woman Doing Here*? Instead, he presents a photographic narrative of one incredibly gifted journalist who captured the humanity and inhumanity of battle, the sorrows and the joys. We see the conflicts as she did, and I am struck by how similar they feel to the battles I saw, even if the weaponry has changed and the landscapes are different.

In *Dickey Chapelle Under Fire*, Garofolo includes a photo Chapelle took in 1957 of three Algerian children standing in dirty dress, staring at the cameras. I have similar photos of Iraqi children, some fifty years later. In another frame, Chapelle captures a Marine smoking a cigarette in Lebanon in 1958. Andrea Bruce and Chris Hondros captured the same moment, different Marine, different war, different decade.

When I tell my own modest stories of war, I always note how much life exists where death hovers. Conflict reporting captivates me for just this reason. People assume the risk attracts me. It is something quite opposite, however. At its core, it is simply an innate need to tell the stories of the living as much of the stories of the dead, to document a man at the barber shop, a woman cooking, a child walking to school, two people praying. Without death, these scenes—and the act of documenting them—do not take on the same meaning. I never felt as alive as I did trying not to die in Iraq.

Garofolo doesn't dwell on the fact that Chapelle was a woman. As a female correspondent, I appreciated that. Embedded with US troops in Iraq and Afghanistan, I did not want to be treated like a woman. Nor did I necessarily seek to be one of the guys. As Chapelle herself said in describing why she favored covering conflict with the Marines, "They taught me bone-deep the difference between a war correspondent and a girl reporter."

In *Dickey Chapelle Under Fire*, John Garofolo tells the story of a war correspondent. For that, and on behalf of all the women correspondents who followed Chapelle into war because we simply could not stay away, I am grateful. ∎

Introduction

This book has been twenty-four years in the making. I first learned of Dickey Chapelle's story in 1991 while reading Thomas Cutler's *Brown Water, Black Beret*. I hadn't expected to encounter the story of a female war correspondent working in the rivers and jungles of Vietnam, and I was surprised no one had made a movie about her life. So I did a little research. I discovered Dickey was a Wisconsin native; that her brother, Dr. Robert Meyer, was a professor at the University of Wisconsin–Madison; and that an archive of her photographs and written work—some forty thousand items in all—was filed away at the Wisconsin Historical Society.

I contacted Dr. Meyer and told him of my interest in his sister's story. I was hoping for his permission to use Dickey's autobiography, *What's a Woman Doing Here?*, as the basis for a screenplay. Sadly, before we came to an agreement, Bob died after suffering from leukemia; but several years later his wife, Marion, granted me the permission I needed to move forward.

A few years ago I contacted Marion again, asking for the family's blessing to develop a book of Dickey's photographs, which was sorely needed to help tell her remarkable story. Graciously, Marion said yes. Then, in December 2013, I learned the Milwaukee Press Club was planning to induct Dickey into their Hall of Fame, and that the WHS Press was interested in publishing a book of Dickey's work. This book is the result of our collaboration.

• • •

Dickey Chapelle reported on wars around the world, including the World War II battles of Iwo Jima and Okinawa, and witnessed the reconstruction of post–World War II Europe. She worked in Hungary, India, Jordan, Iran, Iraq, Cuba, Algeria, Lebanon, Korea, Laos, and Vietnam. She was imprisoned in Hungary, accompanied Fidel Castro into the jungles of Cuba, and was smuggled into Algeria by rebels who asked her to tell their side of the story in the war with France. She made numerous parachute jumps into Korea, Vietnam, and the Dominican Republic.

Dickey risked her life to tell the stories of brave men and women facing desperation, war, poverty, and death. Her work appeared in *Cosmopolitan, Life, Reader's Digest, The National Observer,* and *National Geographic*. She was one of only a handful of women reporting on wars abroad and at home, and she often competed for bylines with two better-known female correspondents, Margaret Bourke-White and Marguerite Higgins.

In 1965 Dickey became the first American female war correspondent killed in action. Yet despite Dickey's remarkable career, this likely is the first time many readers will have heard of her.

Her stepson, Ron Chapelle, perhaps characterized Dickey's photographic work best when he acknowledged that it was not technique-driven—she often chose not to waste time

using a light meter, for example. Rather, her talent lay in her uncanny eye for capturing powerful moments. Dickey saw many things *we* should see—images of war that are at turns dramatic, disturbing, and inspiring. Her best work resonates with an undeniable, first person, I-was-there authenticity.

On the eve of the fiftieth anniversary of Dickey Chapelle's death, a comprehensive collection of her work can be seen for the first time, documenting her twenty-year career reporting on war and its aftermath, revealing the human component of conflict. Dickey knew the dangers posed by her profession, yet she was determined to follow each story as far and as long as it would take her. Just moments before her death in Vietnam, Dickey reportedly whispered, "I knew this was bound to happen." ■

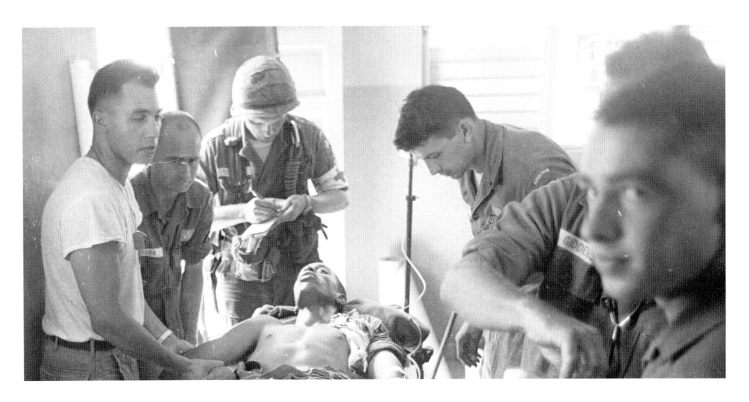

A wounded US soldier being treated by medics in the Dominican Republic

WHi Image ID 114885

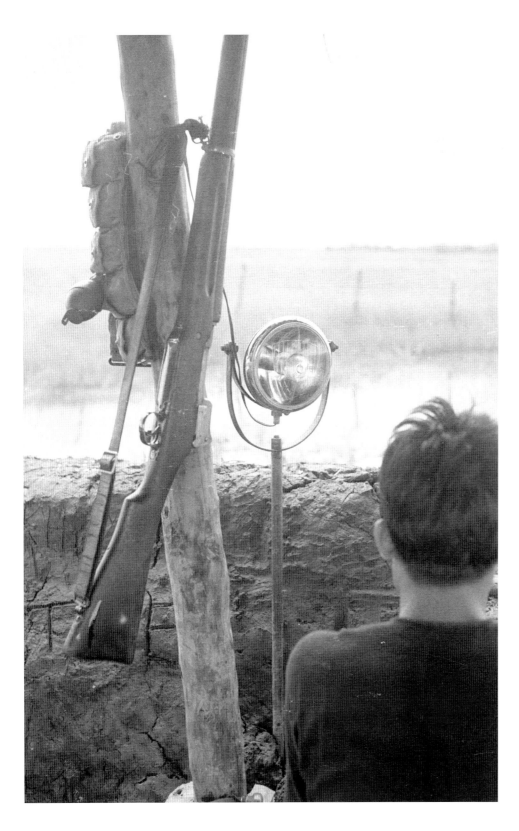

A soldier stationed near the Vietnamese village
of Binh Hung, ca. 1961

WHi Image ID 115390

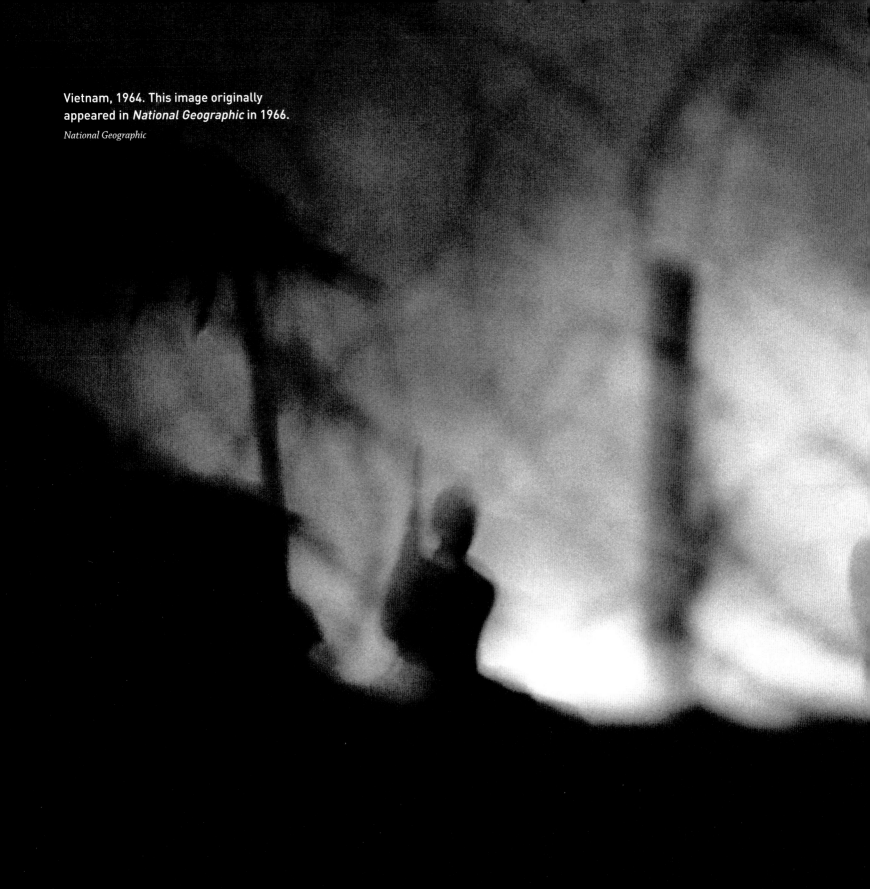

Vietnam, 1964. This image originally appeared in *National Geographic* in 1966.

National Geographic

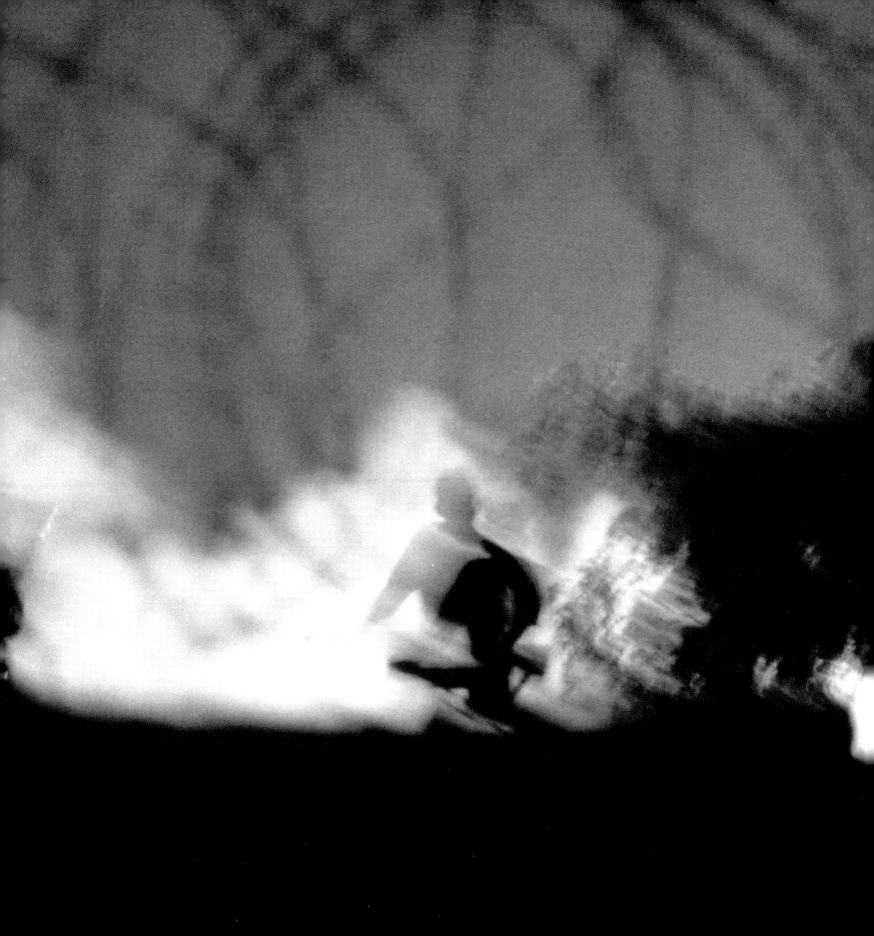

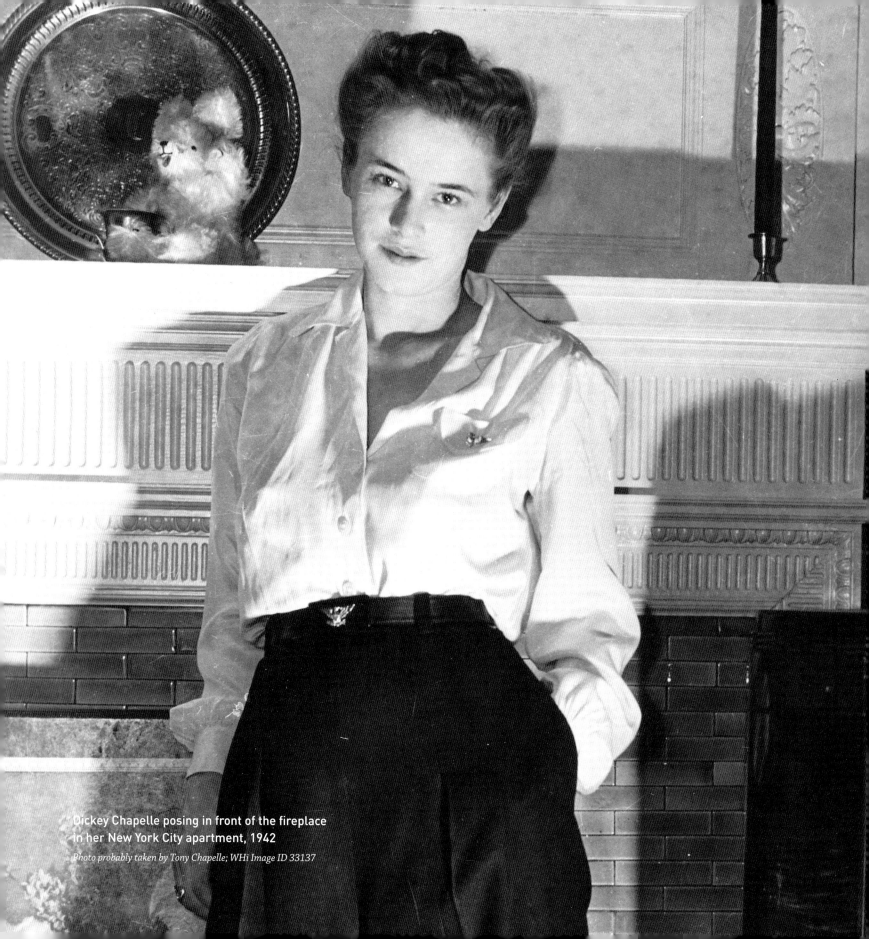

Dickey Chapelle posing in front of the fireplace
in her New York City apartment, 1942

Photo probably taken by Tony Chapelle; WHi Image ID 33137

Georgie Lou Meyer

I grew up in the heartland of the United States. I believed that I could do anything I really wanted to do and I still believe it. Nowhere else in the world can a woman of seventeen or an old lady in her forties as I am, say "I can do anything I want to do."

But I am going to condition it. You can do anything you want to do if you want to do it so badly you'll give up everything else to do it.

—**Dickey Chapelle, cited by Roberta Ostroff in _Fire in the Wind_**

Before Dickey Chapelle was a war correspondent, she was a bright, precocious, and nearsighted girl named Georgette Louise Meyer.

Georgie Lou, as her family called her, was born on March 14, 1919, in Shorewood, Wisconsin, a suburb north of Milwaukee. She grew up with her younger brother, Robert, in a household filled with adults. Georgie Lou's parents, Edna and Paul Meyer, were pacifists in a family tradition that dated back to the first Meyer relative to come to the United States, after his protests against German draft laws led to his exile in 1848. In her autobiography, *What's a Woman Doing Here?*, she described the permissive nature of their household, which allowed young Georgie Lou to do almost anything she wanted.

As a girl, Georgie Lou became fascinated with aviator and polar explorer Rear Admiral Richard E. Byrd. At age fifteen she watched a documentary at Milwaukee's Oriental Theater about Byrd's first South Pole expedition. Georgie Lou was hooked. "I came home in a daze," she later wrote, "and announced I was going to be an aerial explorer."

Her mother was dead set against Georgie Lou flying an airplane and suggested she become a writer instead. But Georgie Lou was steadfast. "I knew how I'd revolt against this outright dictation from Mother," she wrote. "I'd ignore it."

Georgie Lou did take up writing, but she maintained her enthusiasm for aviation. Soon she adopted her favorite explorer's nickname, calling herself Dickey Meyer.

At age sixteen Dickey won a full scholarship to study aeronautical engineering at the Massachusetts Institute of Technology—rare for a young woman in the 1930s. To help cover her living expenses, Dickey relied on the German she had learned from her grandmother and found employment as a live-in nanny and German teacher to the children of an army officer. This was not exactly the adventurous life Dickey had imagined for herself, until she wrote an article about the Coast Guard and sold it to the *Boston Traveler*. The proceeds, coupled with some money sent from her family, allowed Dickey to quit her job and move into her own apartment near Beacon Hill.

Dickey stalked local airports looking for stories. When a nearby town flooded, she convinced a pilot to give her a lift on his single-engine plane so she could report on an emergency food drop. It was the first time Dickey had been on an airplane. "I couldn't see how any reporter could ask for a better vantage point," she would later write.

Dickey was spending more time hanging out at the Coast Guard base and the Boston Navy Yard and less time attending classes, and she flunked out of college after only two years. She was crestfallen.

Back home in Shorewood that summer, Dickey watched stunt fliers perform in the air shows at the nearby Curtiss Wright airport. To her, their movements looked like "pure ballet in the sunlight." Soon Dickey was typing the barnstormers' correspondence in exchange for flight lessons. Her nearsightedness didn't make her much of a pilot, but her typewriter sat next to the hangar, where she "could eavesdrop on shop talk about airplanes as long as I could stay awake."

At the end of the summer Dickey's parents sent her to live with her grandparents in Coral Gables, Florida, where she found work with a local air show, writing press releases. The job took her to Havana, where she witnessed a Cuban pilot die in a plane crash during a popular air show. Dickey raced to a pay phone and landed the story in the *New York Times*.

When an editor with Transcontinental and Western Air learned how the *Times* got its story, he hired Dickey on the spot. Ten days later she reported to the publicity bureau at TWA's office in New York City. Dickey was eighteen years old.

Soon after her arrival, Dickey began taking weekly photography classes from Tony Chapelle, a photographer who worked in TWA's publicity department. Tony taught his students to think like photographers. "The picture is your reason for being," he told them. "It doesn't matter what you've seen with your eyes. If you can't prove it with a picture, it didn't happen."

Despite their twenty-year age difference, Dickey and Tony began dating. They married in October 1940 at her parents' home.

By the time Dickey and Tony settled in New York City, Dickey considered herself a photographer. She quit her job at TWA and, with Tony's help, spent six months compiling a portfolio. In 1941 Dickey sold her first photo essay, to *Look* magazine.

Shortly thereafter, on December 7, 1941, the newly married couple's world changed. Dickey was about to have her first experience as a bona fide war correspondent as the United States entered World War II. ■

Clockwise from top left

Young Georgette, ready to go swimming

Georgette in front of her childhood home

Georgette with her brother, Bob, at the family home in Shorewood

All photos from the Meyer family personal collection

Clockwise from top left

Georgette and her cousin Olive wearing authentic Japanese costumes

Georgette and brother Bob at the Milwaukee County Airport, 1932. Later Dickey would write this was "taken the first time I ever touched an airplane."

Young Georgette dressed as a scarecrow

Georgette on her way to school; by this point, she was likely going by the name "Dickey."

Photos from the Meyer family personal collection

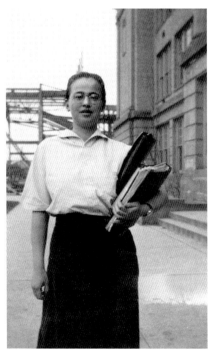

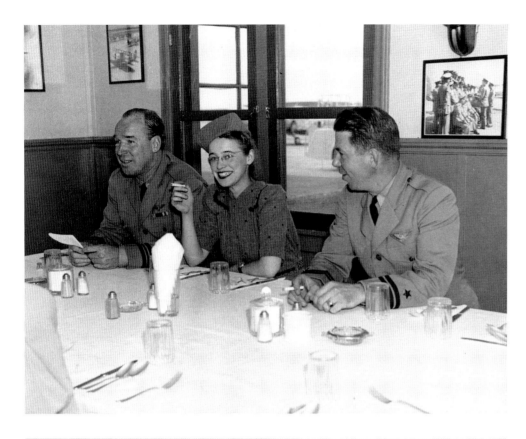

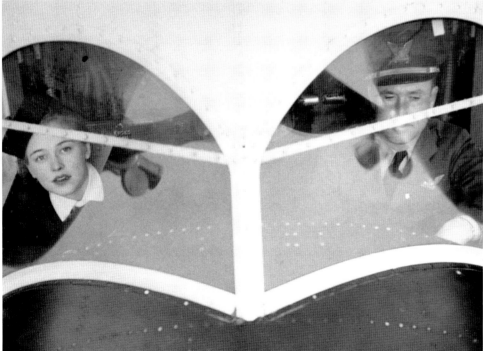

Above: Instead of going to classes at MIT, Dickey regularly spent time at a Boston Naval Air Station. Here, she holds an unlit cigarette at a dinner table with two naval aviators.

Left: Dickey sits in the co-pilot seat of a Boston-based Coast Guard seaplane.

Photos from the Meyer family personal collection

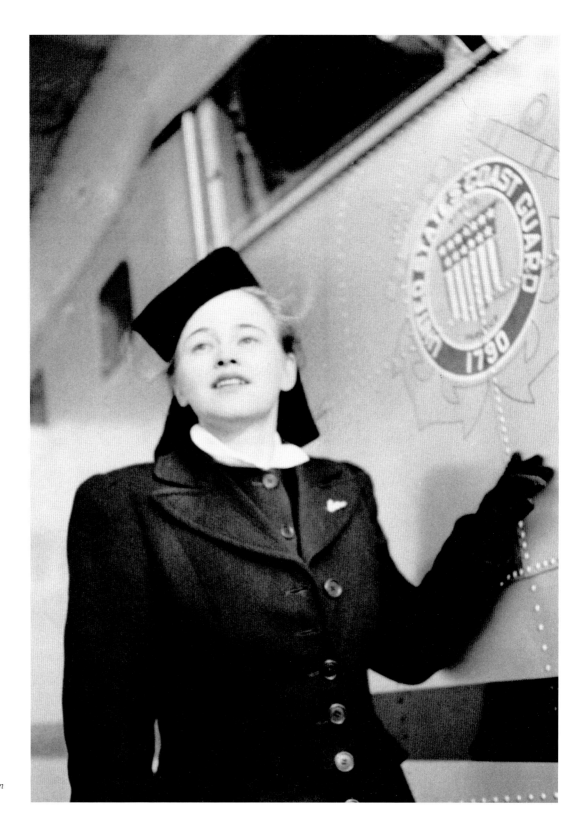

Standing outside the aircraft, just below the Coast Guard emblem

Photo from the Meyer family personal collection

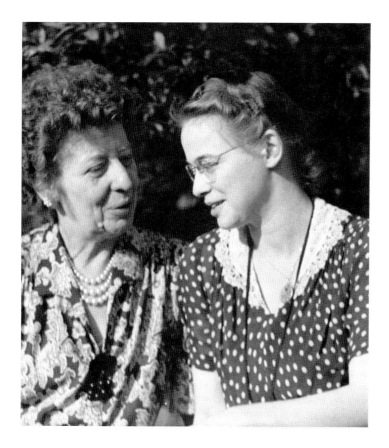

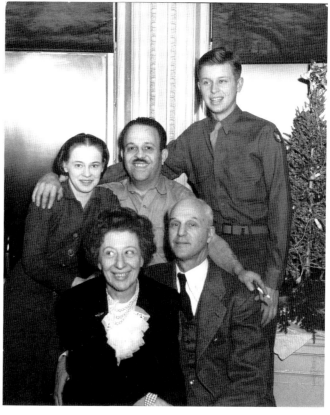

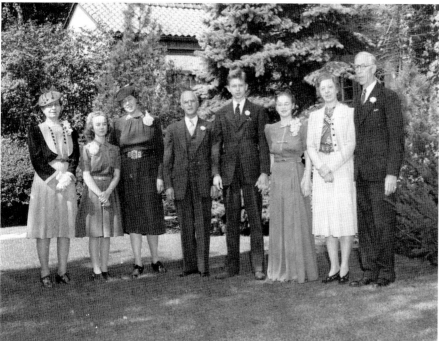

Clockwise from top left

Georgette with her mother Edna, whom she called "Marmee" into her adult life

Photo from the Meyer family personal collection

Top row: Christmas, 1943. Dickey, Tony, and Robert Meyer; bottom row: Dickey's parents, Paul and Edna Engelhardt Meyer.

Photo from the Meyer family personal collection; WHi Image ID 115212

Dickey posing with the Meyer family at her wedding

Photo probably taken by Tony Chapelle; photo from the Meyer family personal collection

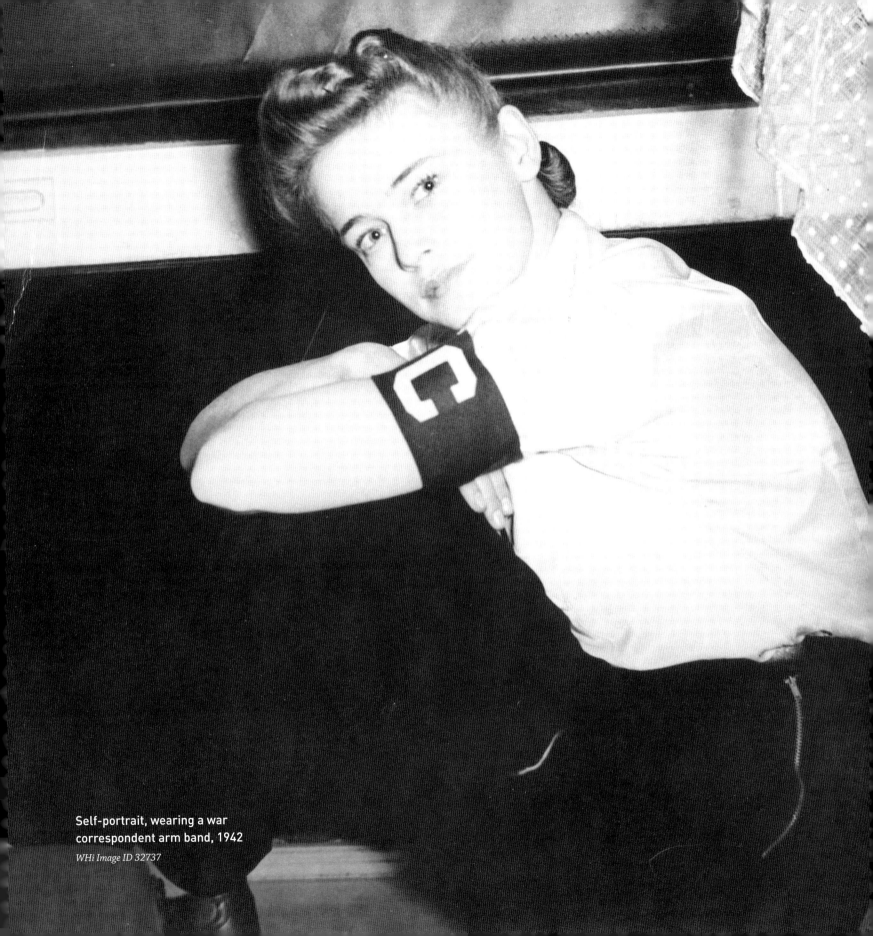

Self-portrait, wearing a war
correspondent arm band, 1942

WHi Image ID 32737

World War II

I just looked thoughtful and asked, "How many accredited woman writers has the Navy sent out from San Francisco?"

"A couple, I guess."

"And how many accredited woman photographers?"

"Never heard of one."

That settled it. Now anything I did, including breathing, west of where I sat was a scoop of some kind. "I'm a photographer, then."

"Very well. And just where was it you wanted to go?"

Now I was really surprised. I thought *he'd* tell *me* where I was permitted to go. Did he honestly mean I had a choice? Very well, I'd make one. I'd tell the truth.

"As far forward as you'll let me."

—**Dickey Chapelle, *What's a Woman Doing Here?***

When the United States entered the war, Tony, a veteran of World War I, reenlisted in the Navy with orders to go to Panama as a chief photographer's mate. Navy regulations prohibited wives from accompanying their husbands on deployment, so Dickey applied for a military press credential of her own. In 1942, she followed Tony to Panama, armed with an assignment from *Look* magazine to cover combat training for the US Army's Fourteenth Infantry division.

Nine months after Dickey's arrival in Panama, Tony was shipped to another overseas post, and Dickey returned to New York. Between 1943 and 1944, while waiting for her next assignment, Dickey wrote eight books, including *Needed—Women in Government Service* and *Needed—Women in Aviation*. In the spring of 1944 Tony returned stateside and was stationed at the Navy Pictorial Center in Astoria, Queens. For the moment, Dickey and Tony were a couple again.

In 1945 Dickey was offered an assignment by Fawcett Publications—publisher of *Woman's Day* and *Popular Mechanics*—to cover the war in the Pacific. Tony objected to the assignment; three photographers he trained in Panama had been killed in action and another seven had been wounded. Dickey went anyway.

Her first orders were to cover Navy nurses' training at the Alameda Naval Air Station before they were sent overseas. She left for California in January 1945 as the first female photographer accredited to the navy.

Next she went to Guam, where she was assigned to the USS *Samaritan,* a hospital ship on its way to the Japanese island of Iwo Jima, the site of one of the bloodiest battles in Marine Corps history. Once the ship arrived off the coast of the island, Dickey photographed the sailors, Marines, doctors, and nurses treating the stream of casualties. She was eventually granted permission to go onto the island, where she photographed the wounded and dying in a Marine field hospital.

In April 1945 the United States invaded the Japanese home island of Okinawa. Dickey arrived at Okinawa with an assignment from the Navy to cover the use of blood donations aboard the hospital ship USS *Relief*. She was supposed to stay aboard the ship and wait for casualties. Rear Admiral H. B. Miller, the ranking public relations officer for the entire Pacific Fleet, personally ordered Dickey not to go ashore. But after two days, Dickey decided to get closer to the action.

Dickey talked her way onto a Navy landing craft known as an LCVP that was headed for the island. Once there, she found favor with Major General Lemuel C. Shepherd of the Sixth Marine Division. Shepherd was surprised to see a woman on the island who wasn't a nurse. Dickey convinced him that if she could document Marine medical units in action, the photographs could help encourage blood donations in the United States, which, by 1945, were waning.

Though Dickey was a fairly inexperienced, twenty-six-year-old combat reporter, Shepherd nevertheless agreed to let her join one of his field medical units operating near the front line. Dickey stayed with the unit for ten days, photographing wounded Marines and sailors being treated by doctors and corpsmen. When the public senior relations officer learned Dickey had ignored his command, he ordered her escorted off the island and held "under arrest in quarters" on a small navy ship.

Because Dickey had not received permission through official channels to be on Okinawa, the Navy withdrew her press accreditation, effectively ending her career as a World War II correspondent. It would be nearly ten years before she would get it back. ∎

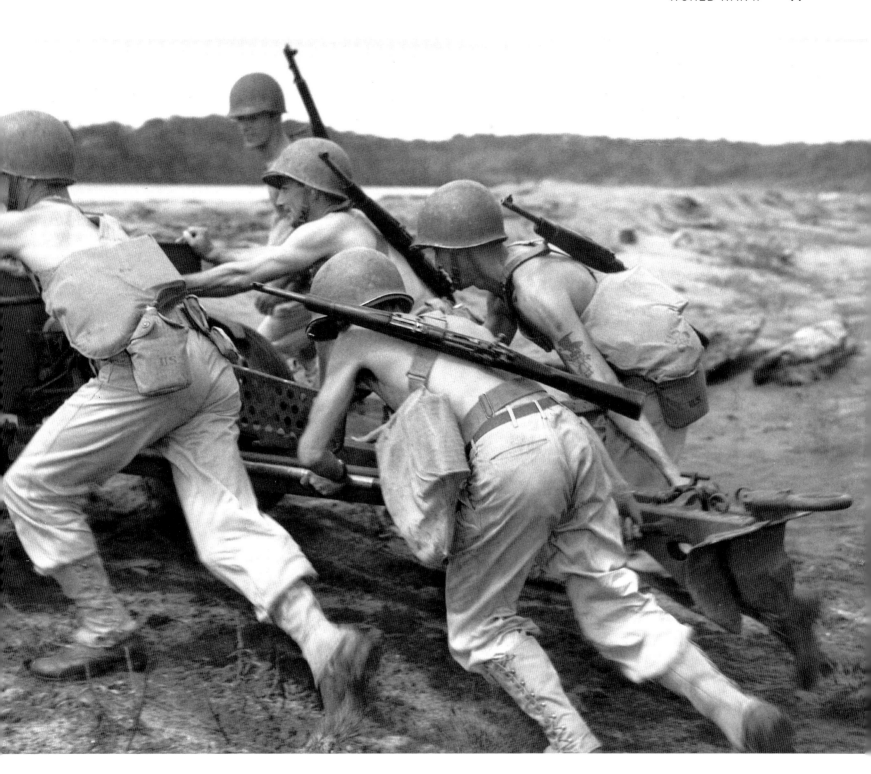

Soldiers strain to push a 75mm artillery piece into position, Panama, 1942

WHi Image ID 115205

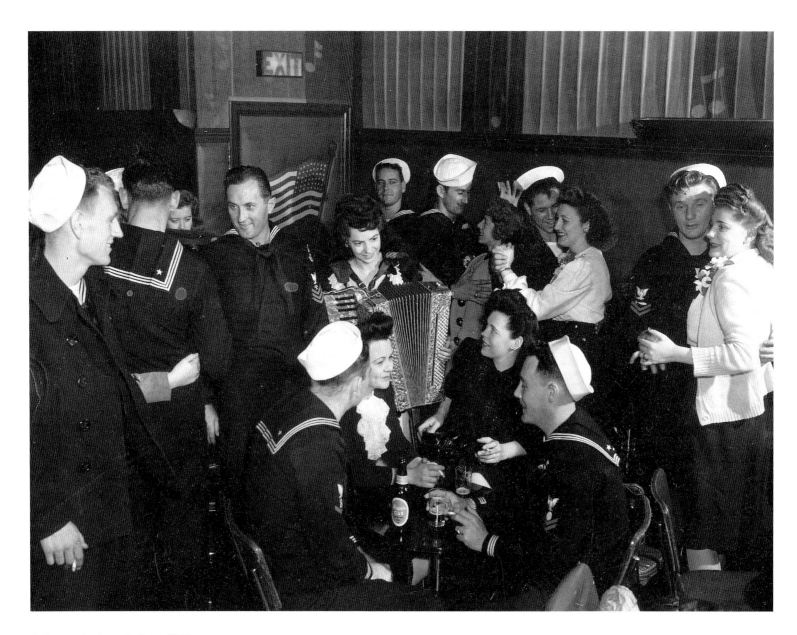

Sailors relaxing off-duty, 1942

WHi Image ID 115124

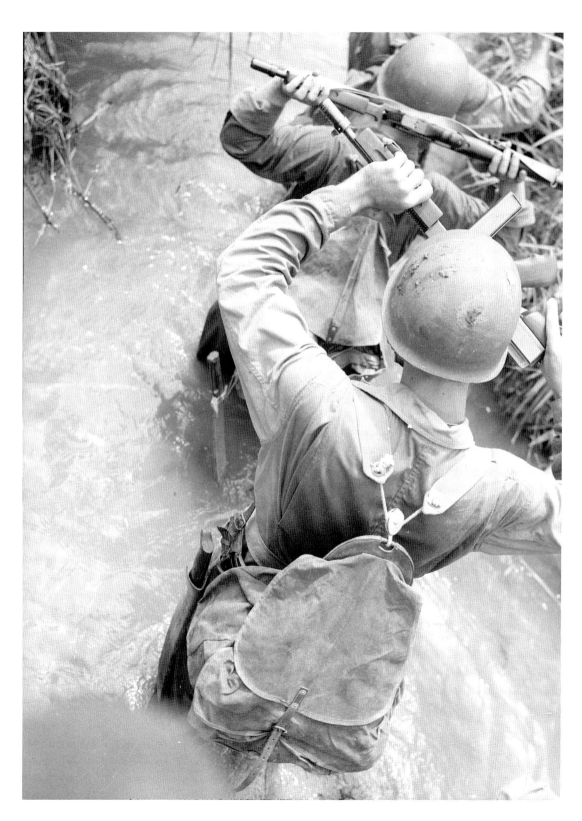

US Army Bushmasters training
in Panama, 1942

WHi Image ID 115192

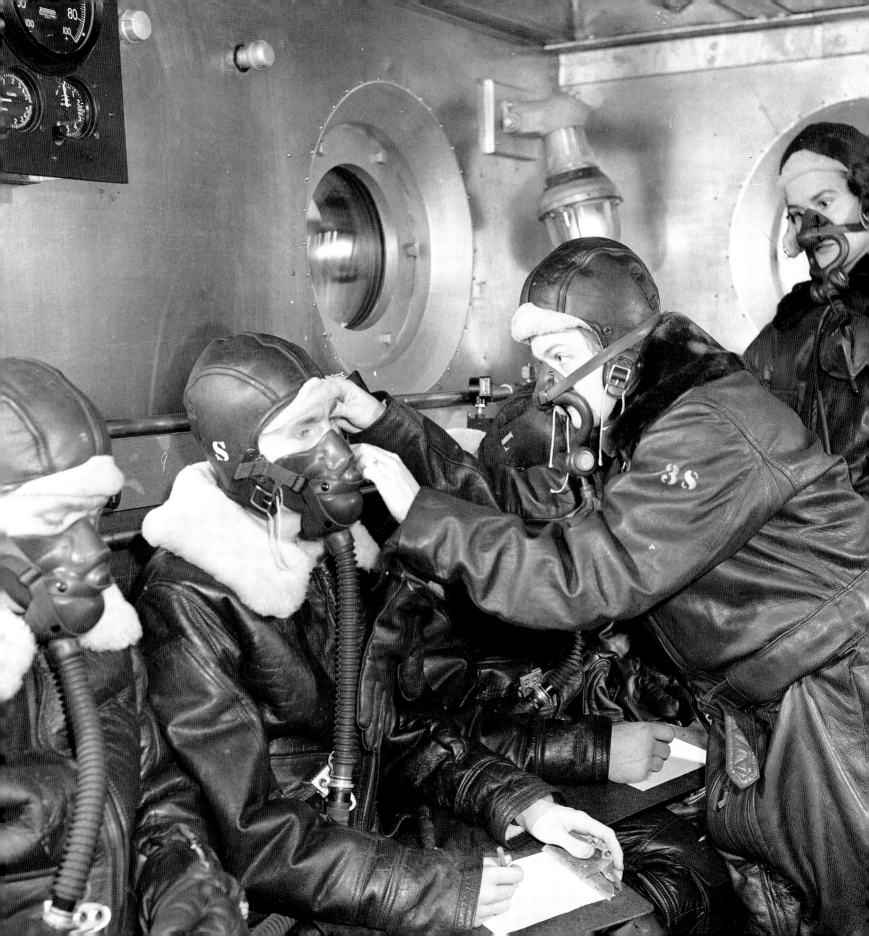

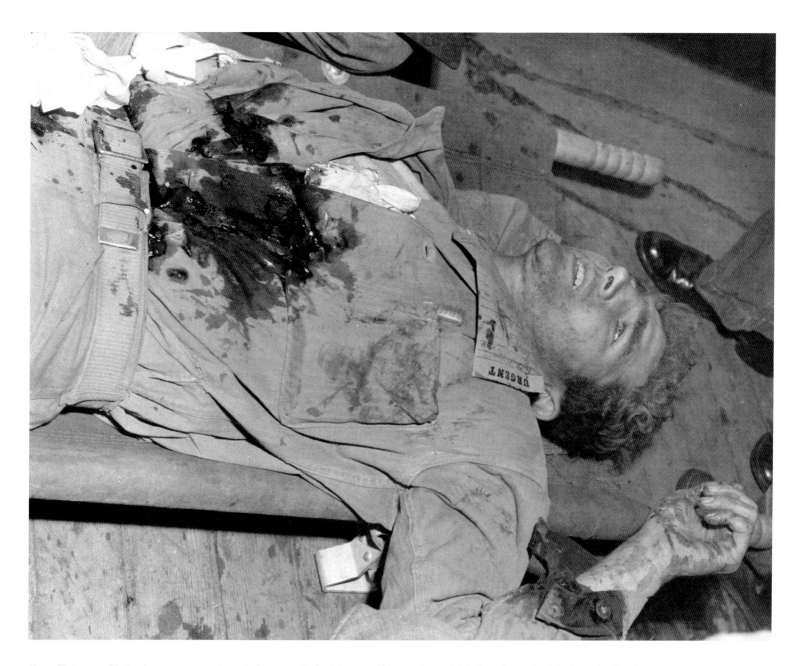

Above: This was Dickey's most reproduced photo until the Vietnam War and was initially released with the title *The Dying Marine*. The soldier in the image, Corporal William Fenton, lays badly wounded, awaiting medical treatment. In her autobiography, Dickey described Fenton as "one of the 551 critically wounded Marines brought aboard the USS *Samaritan* who wanted to live. He did. (I visited him and his family ten months later on Christmas Day at St. Albans Hospital.)" Iwo Jima, 1945

WHS Image ID 25954

Opposite: US Navy flight nurses in a high-altitude chamber at the Alameda Naval Air Station, 1945

WHi Image ID 115126

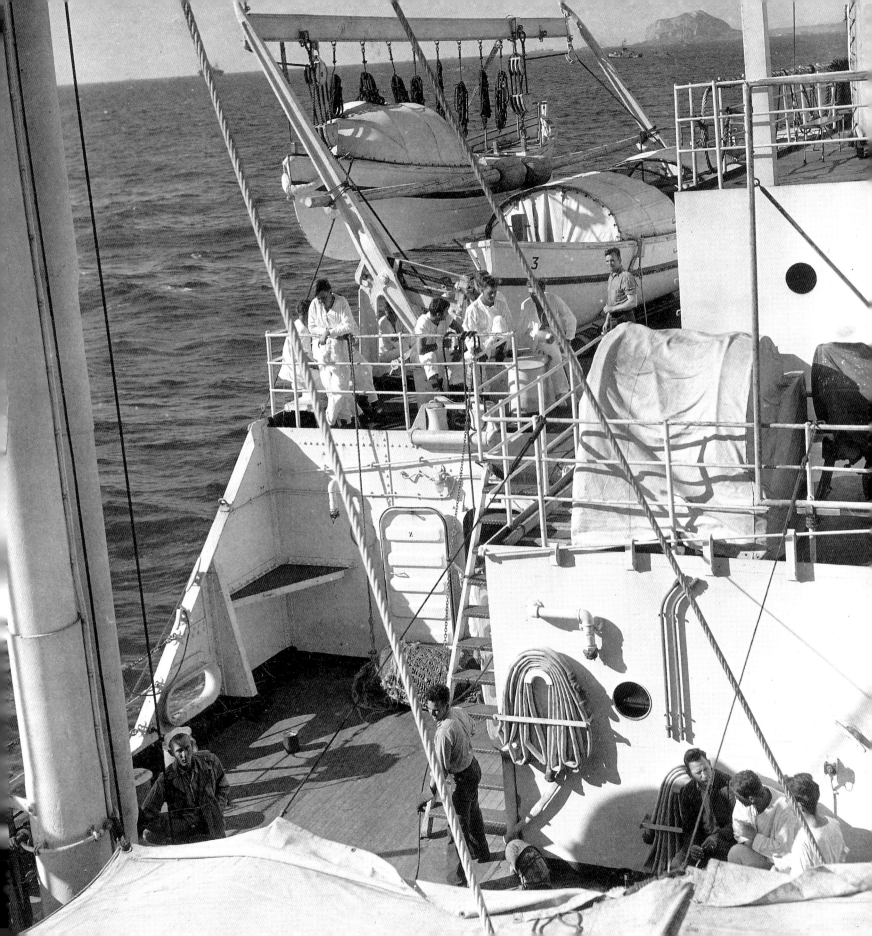

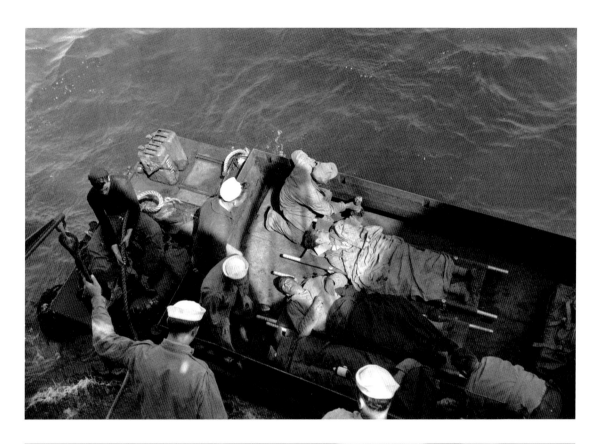

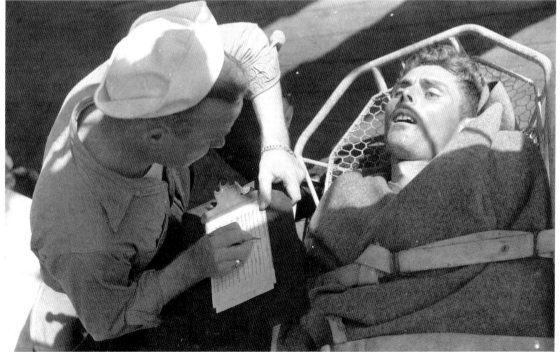

Opposite: View from the deck of the hospital ship USS *Samaritan* at sea, 1945
WHi Image ID 58817

Above: Wounded soldiers, sailors, and Marines are transferred by landing craft to the USS *Samaritan* anchored just offshore, Iwo Jima, 1945
WHi Image ID 76554

Left: Marine Roy Elgin Jones lies wounded in a rescue stretcher known as a Stokes litter, while being processed by a medic on the deck of the USS *Samaritan*, Iwo Jima, 1945
WHS Image ID 76607

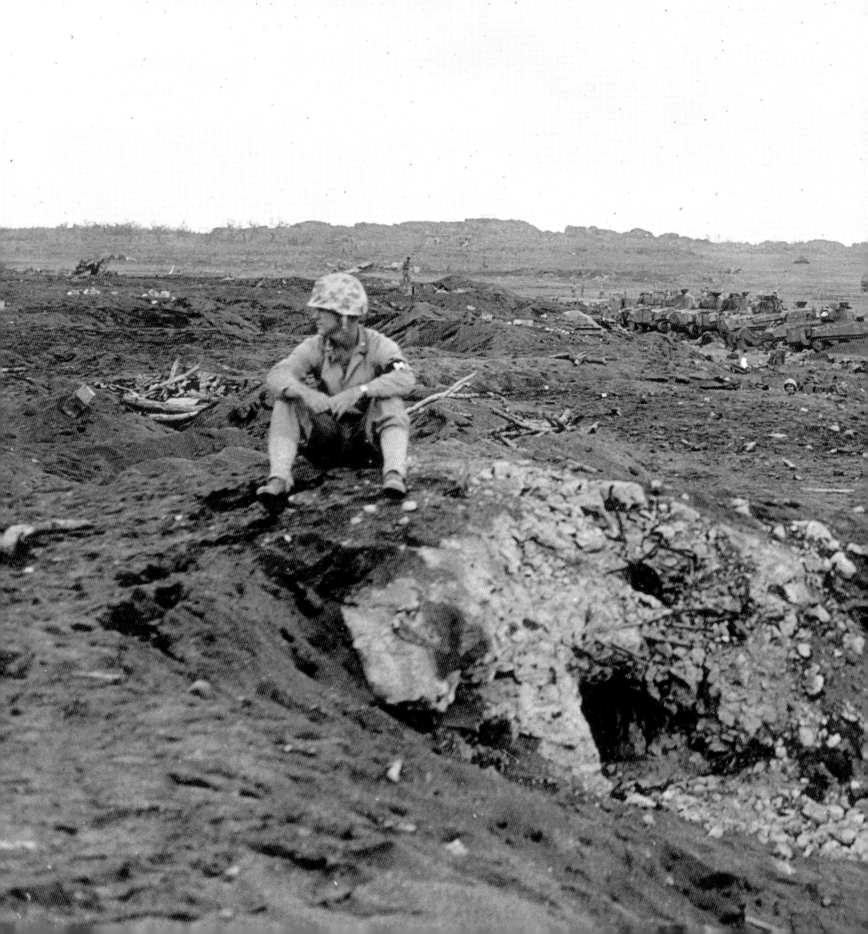

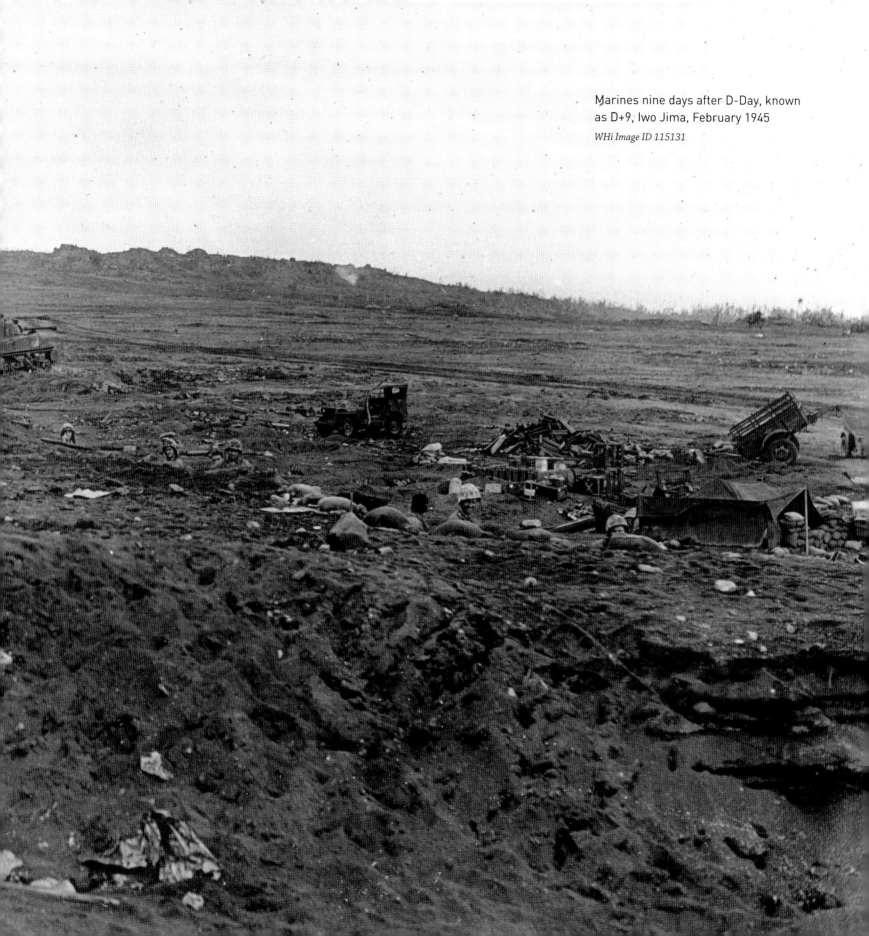

Marines nine days after D-Day, known
as D+9, Iwo Jima, February 1945

WHi Image ID 115131

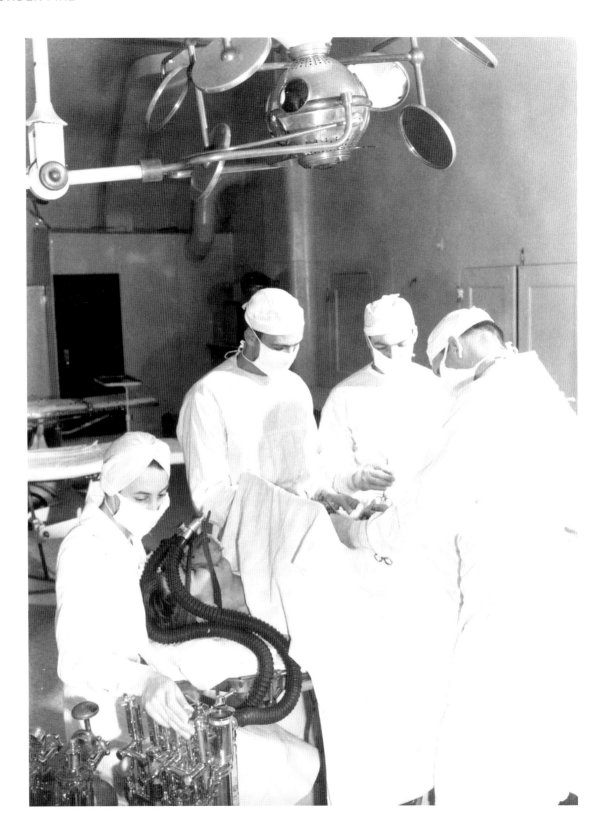

Doctors and a nurse operate
on a patient on the USS
Samaritan, 1945

WHi Image ID 115195

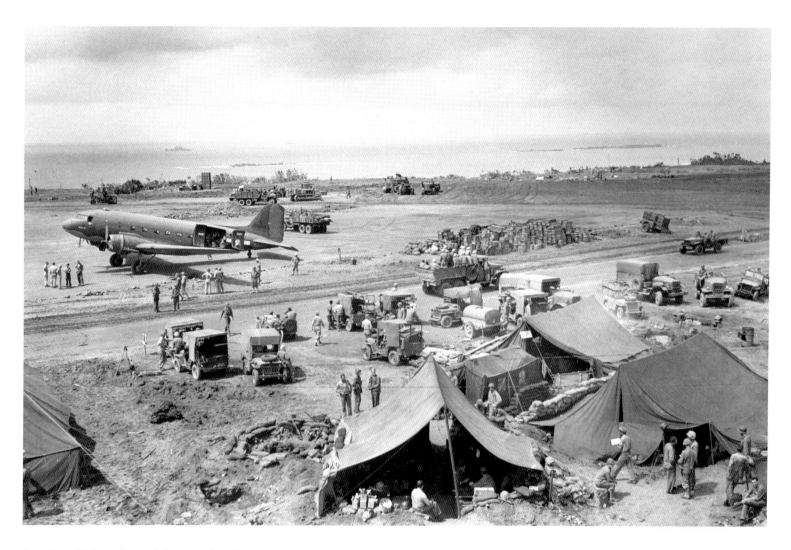

Iwo Jima Airfield #1, as it looked nine days
after the initial assault, February 1945

WHi Image ID 11369

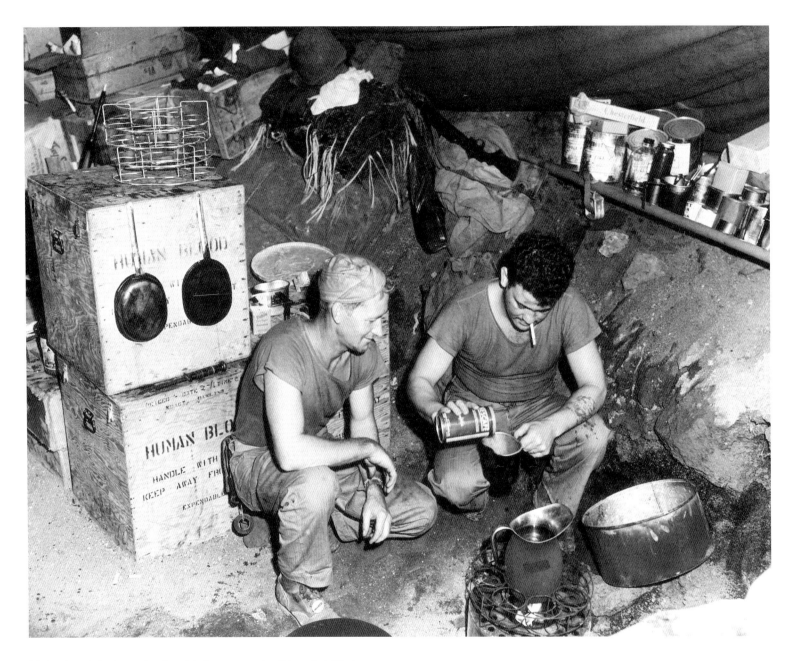

Dickey's original caption for this image reads, "Hospital Kitchen. From D [Day] plus five almost until Iwo was secure, the sole cooking facilities of the entire kitchen ([where] up to 200 men were treated each day) consisted of this single improvised burner. The grill is the innards of a blood shipping case, and the cases themselves serve as walls and storage space (Incidentally, I have enjoyed more than one canteen cup of coffee from that pitcher.)" Iwo Jima, 1945

WHi Image ID 33291

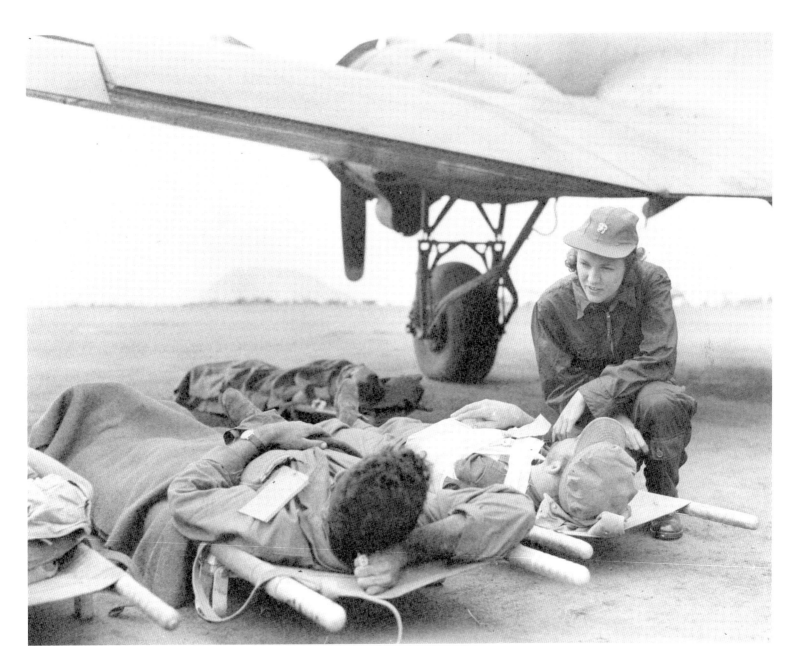

Navy flight nurse Gwen Jensen's training in Alameda, California, and work in Iwo Jima was featured in several of Dickey's photographs. Here, Jensen waits with injured patients to be loaded aboard a plane for evacuation from Iwo Jima Airfield #1, 1945

WHi Image ID 11367

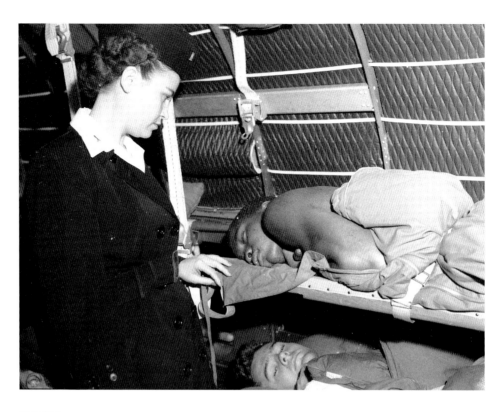

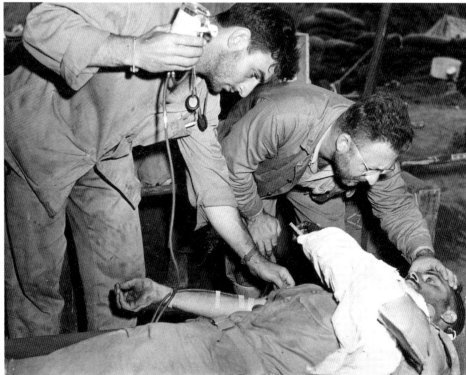

Above right: A flight nurse checks on two patients sleeping in bunks, 1945

WHi Image ID 115133

Lower right: Doctors tend to a wounded Marine, Iwo Jima, 1945

WHi Image ID 33295

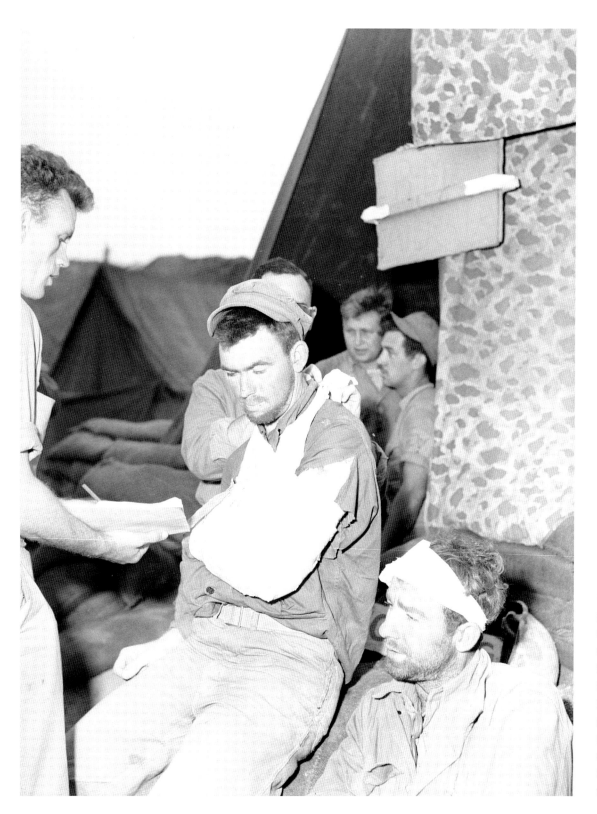

Marine casualties in a hospital tent, Iwo Jima, 1945. Chapelle's original caption, titled *Fresh Casualty*, noted that the Marine corporal with the injured arm was hit a few hours earlier and hitchhiked aboard an ammunition truck, refusing emergency treatment and waiting his turn to be seen by doctors.

WHi Image ID 115132

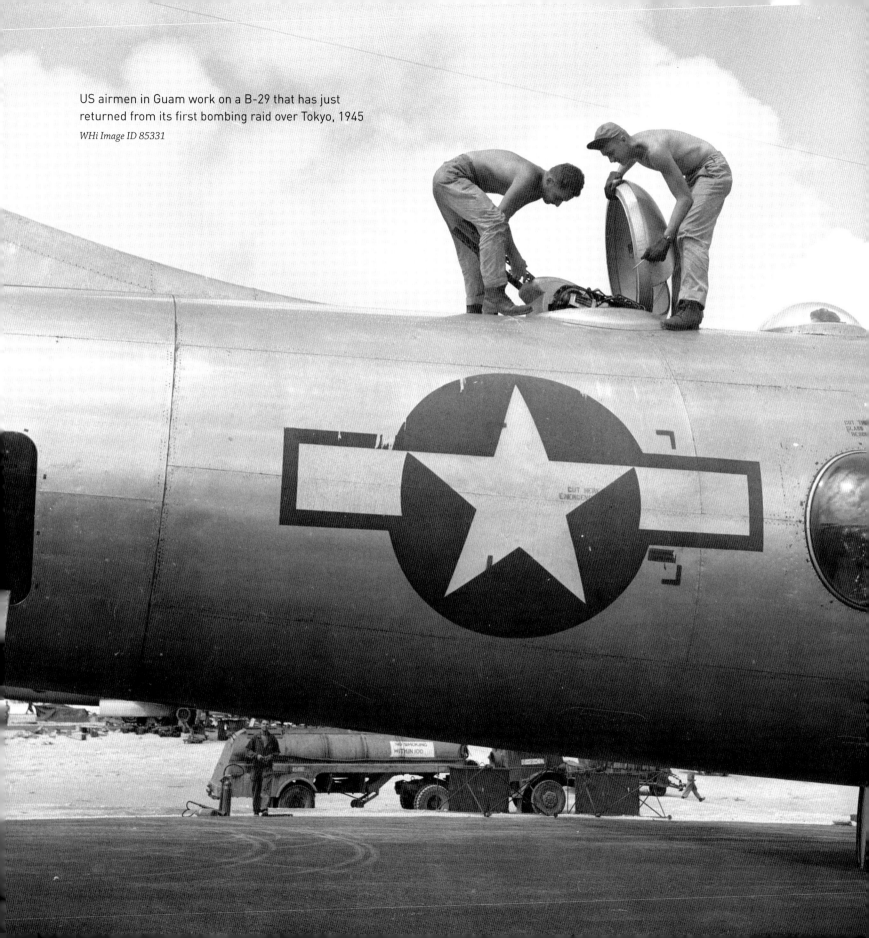

US airmen in Guam work on a B-29 that has just returned from its first bombing raid over Tokyo, 1945

WHi Image ID 85331

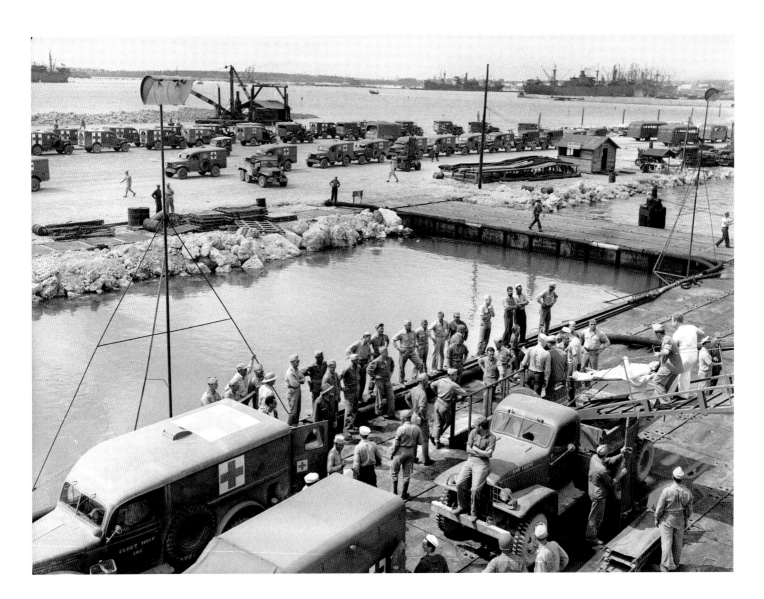

At far right, corpsmen off-load a wounded soldier from
the USS *Samaritan,* while ambulances and military
personnel stand by on the dock, Guam, 1945

WHi Image ID 115194

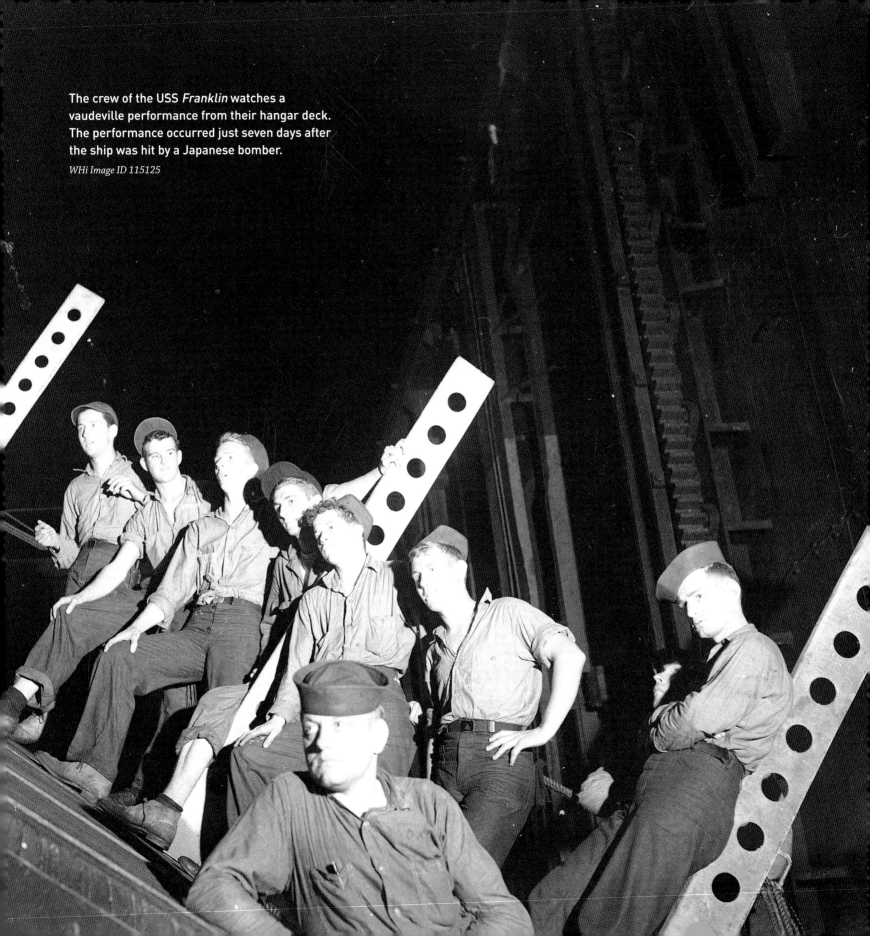

The crew of the USS *Franklin* watches a vaudeville performance from their hangar deck. The performance occurred just seven days after the ship was hit by a Japanese bomber.

WHi Image ID 115125

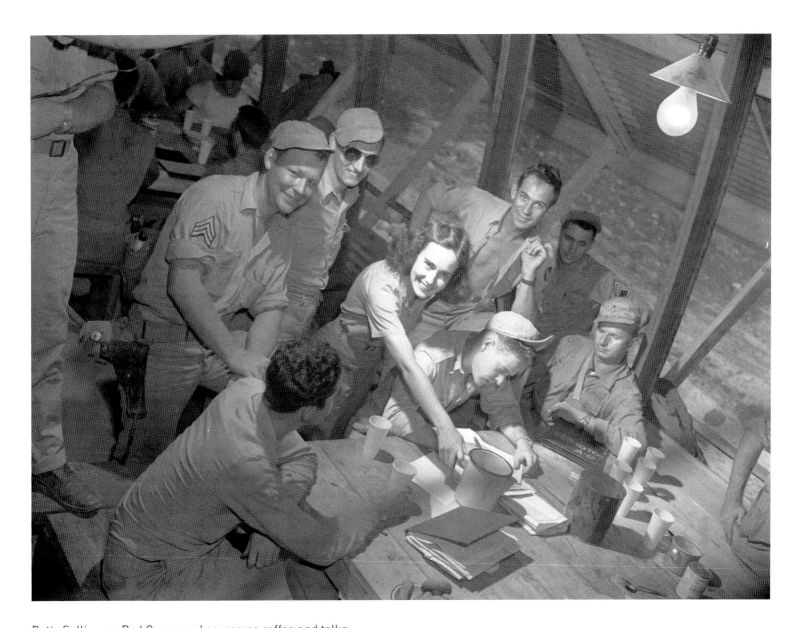

Betty Sullivan, a Red Cross worker, serves coffee and talks
with B-29 crew members at Kobler Field in Saipan, 1945

WHi Image ID 85258

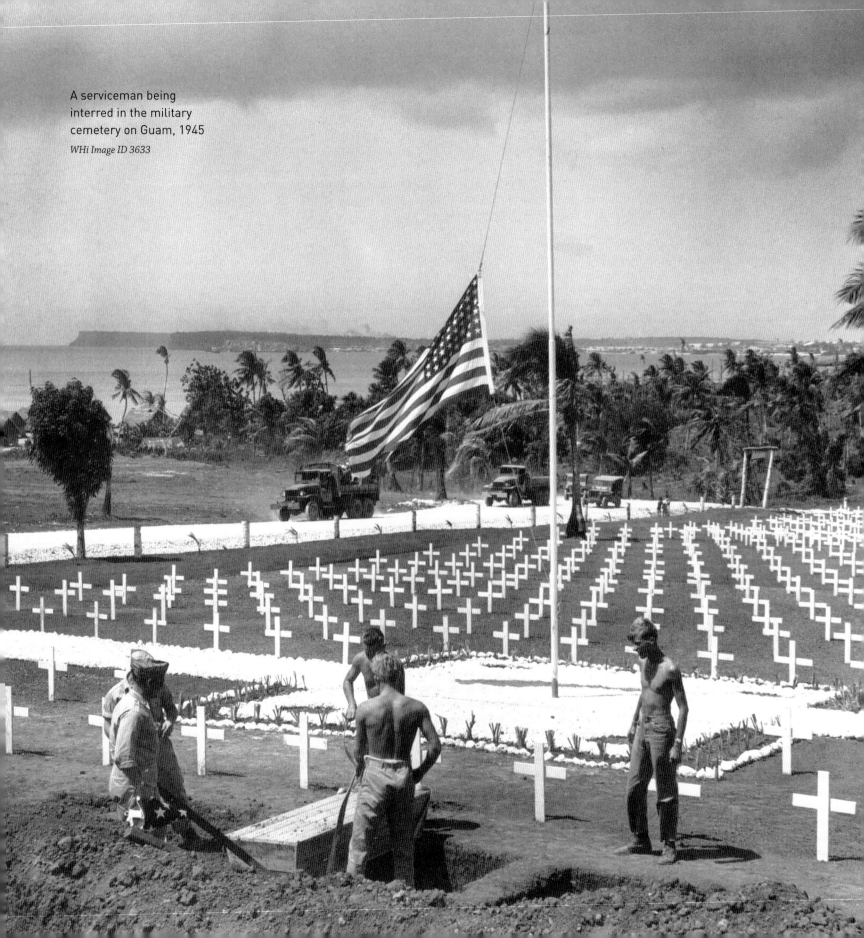

A serviceman being interred in the military cemetery on Guam, 1945

WHi Image ID 3633

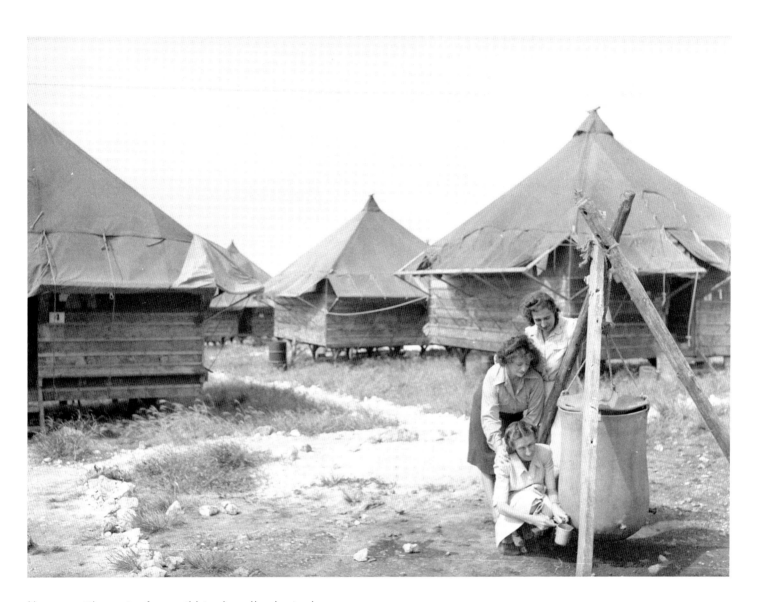

Nurses getting water from a thirty six-gallon Lyster bag
in the 148th General Hospital compound, Saipan, 1945

WHi Image ID 115199

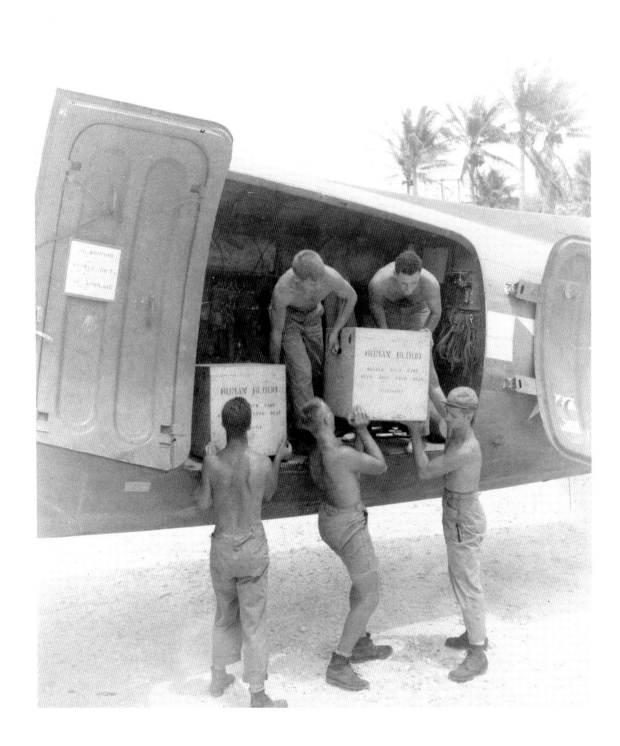

Airmen on Ulithi, an atoll in the Pacific, off-load human blood from an aircraft, March 1945

WHi Image ID 11370

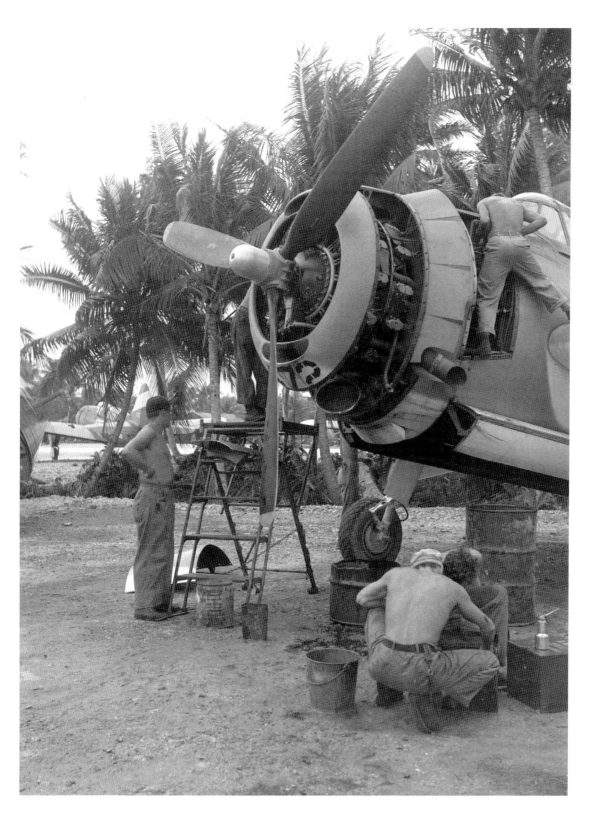

A Marine aircraft maintenance
crew at work on a Marine
Aircraft Group plane at the
Ulithi airport, 1945

WHi Image ID 85343

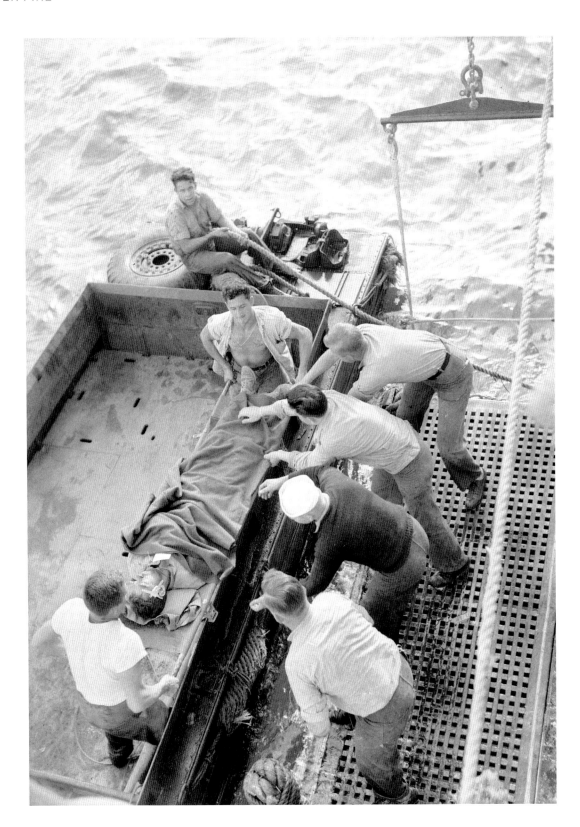

A boat crew off-loads a wounded
man onto a hospital ship, 1945

WHi Image ID 58816

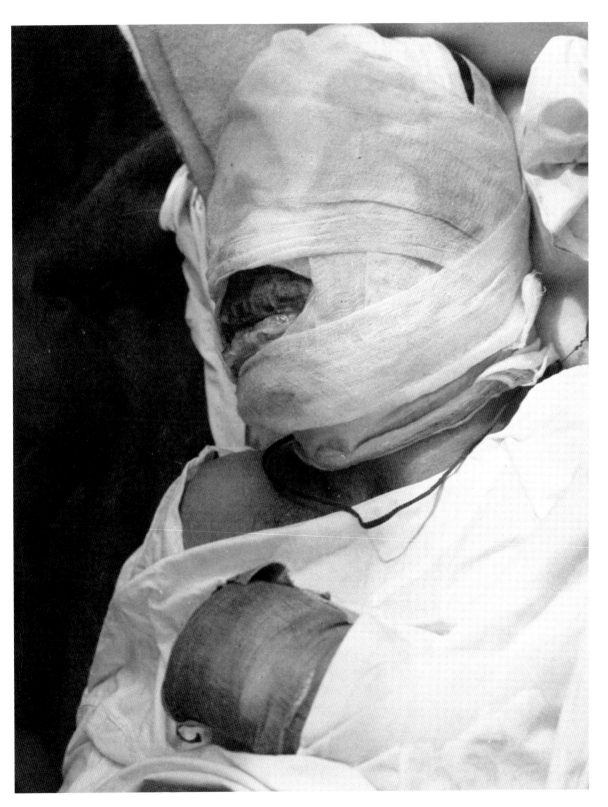

The commander of the General Sherman tank *Capetown*, 1945. When a mine explosion set their tank on fire, he was the only member of the crew to escape. He survived, with severe burns on his hands and face.

WHi Image ID 25956

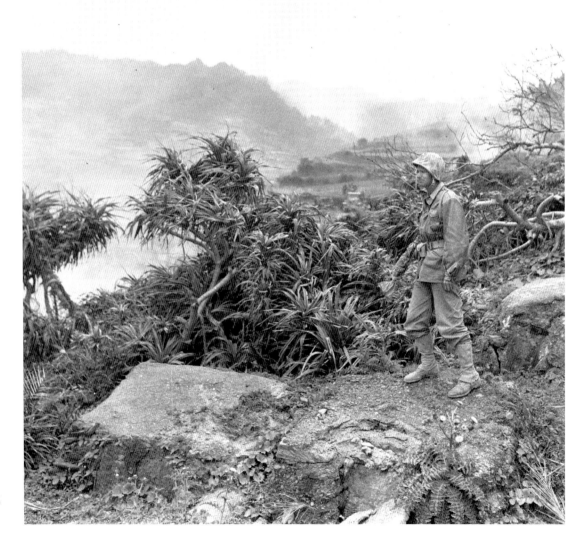

The front at Nago, Okinawa, 1945

WHi Image ID 84395

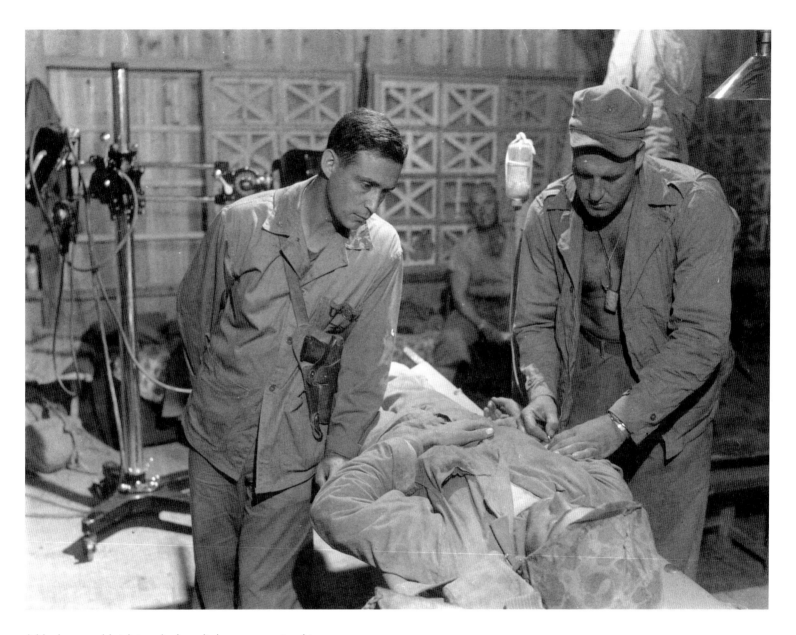

A Marine psychiatrist and a hospital corpsman tend to
a wounded Marine at a field hospital in Okinawa, 1945

WHi Image ID 115128

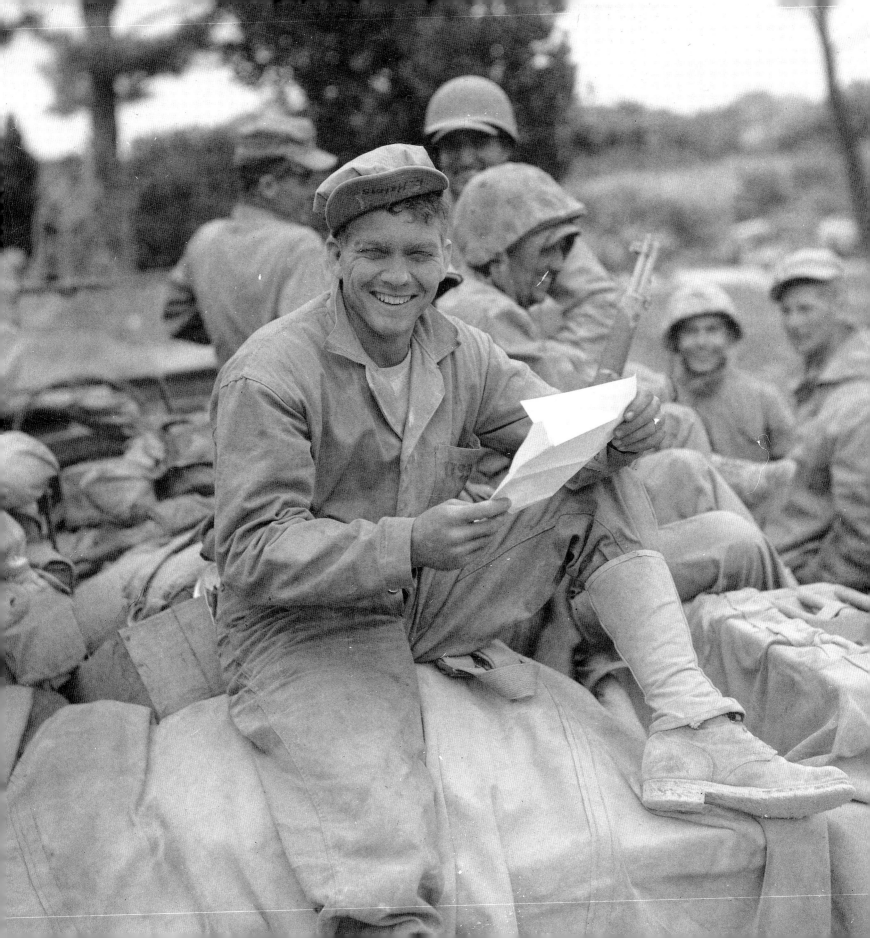

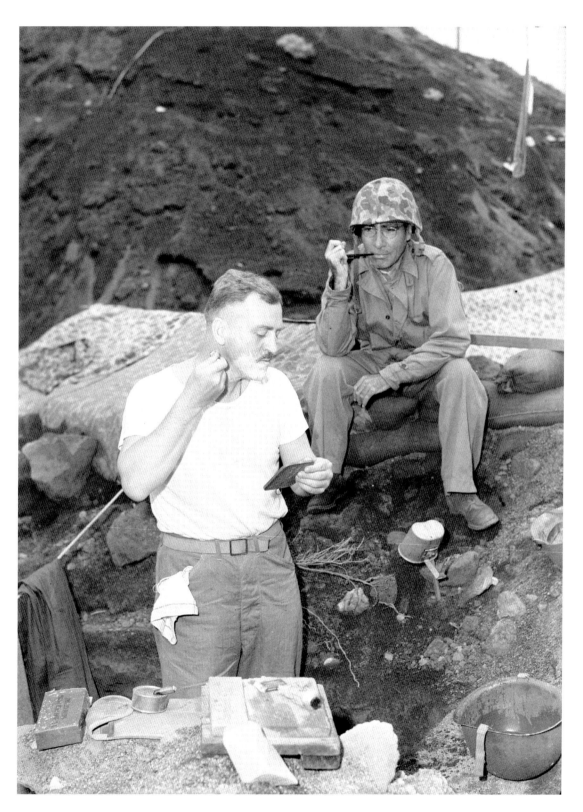

Left: Dickey's original caption for this image reads, "Commanding Officer's Quarters. All the doctors were still sleeping in foxholes when these shots were made and [they] expected no improvement in that arrangement. Here, Comdr. A. E. Reymont, C.O. of the medical battalion, is shaving for the first time in nine days while the division surgeon, Marine Capt. C. P. Archambault observes the novel operation with amusement." Iwo Jima, 1945

WHi Image ID 33293

Opposite: Mail from home was a tremendous morale booster for US forces fighting abroad. Dickey originally titled this image *Laughing Marine*, Okinawa, 1945

WHi Image ID 115129

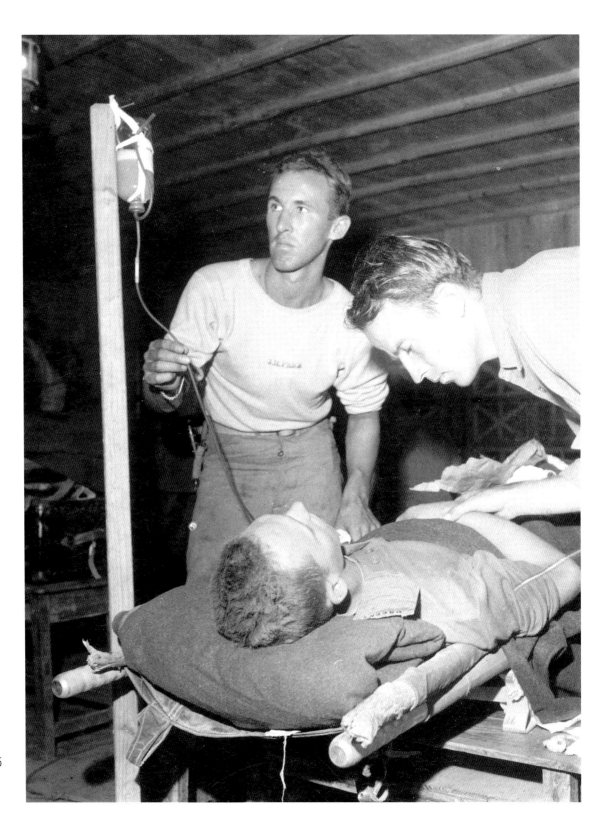

Corpsmen tend to a patient in
a field hospital, Okinawa, 1945

WHi Image ID 115201

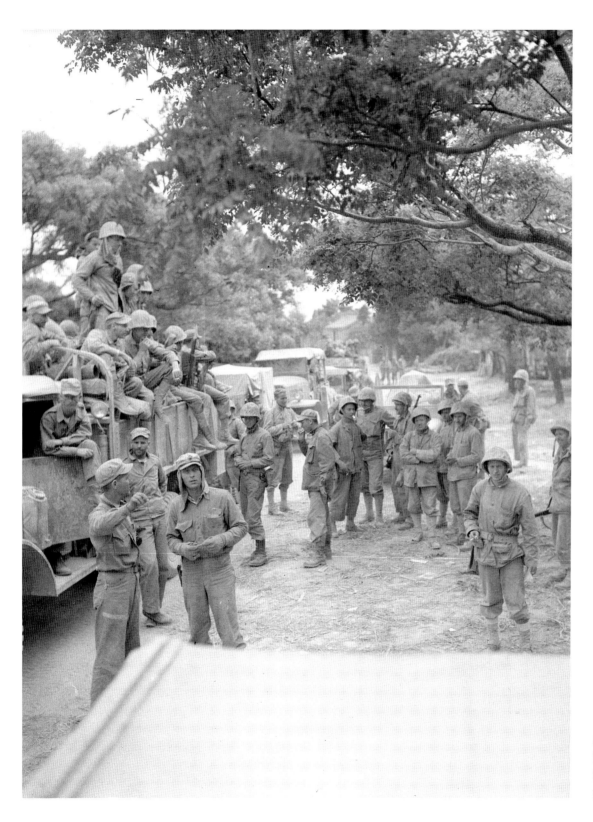

Members of the Fourth Marines
in Ishikawa shortly after the city
fell, Okinawa, 1945

WHi Image ID 115155

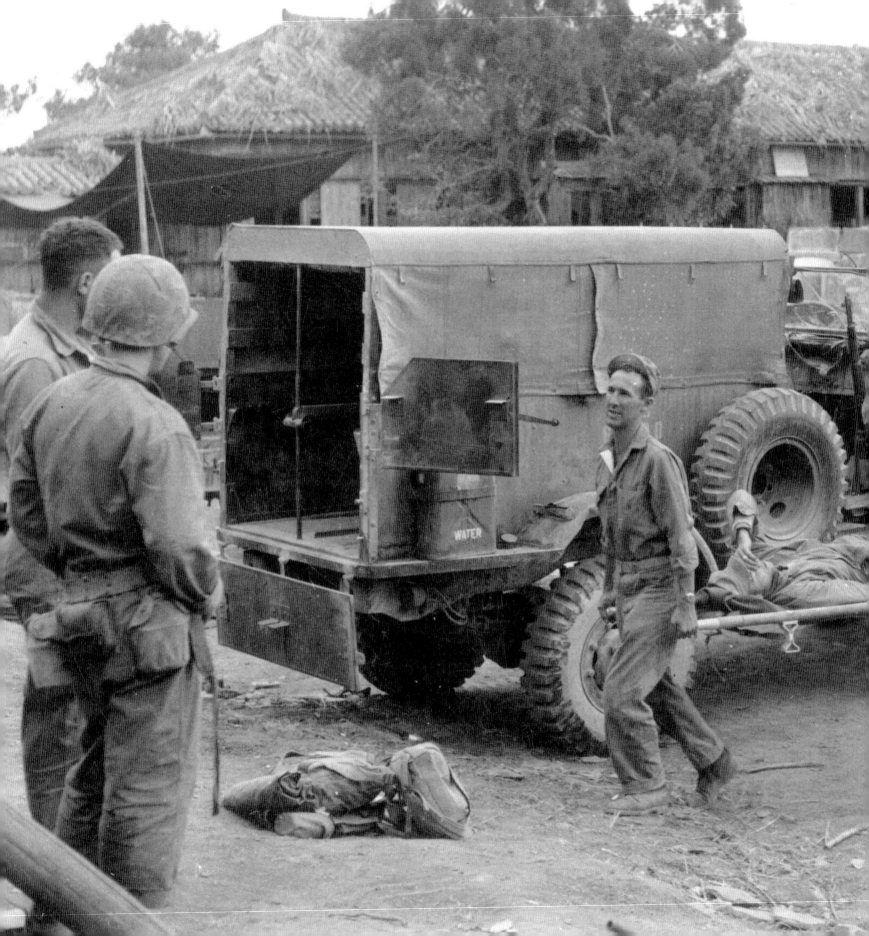

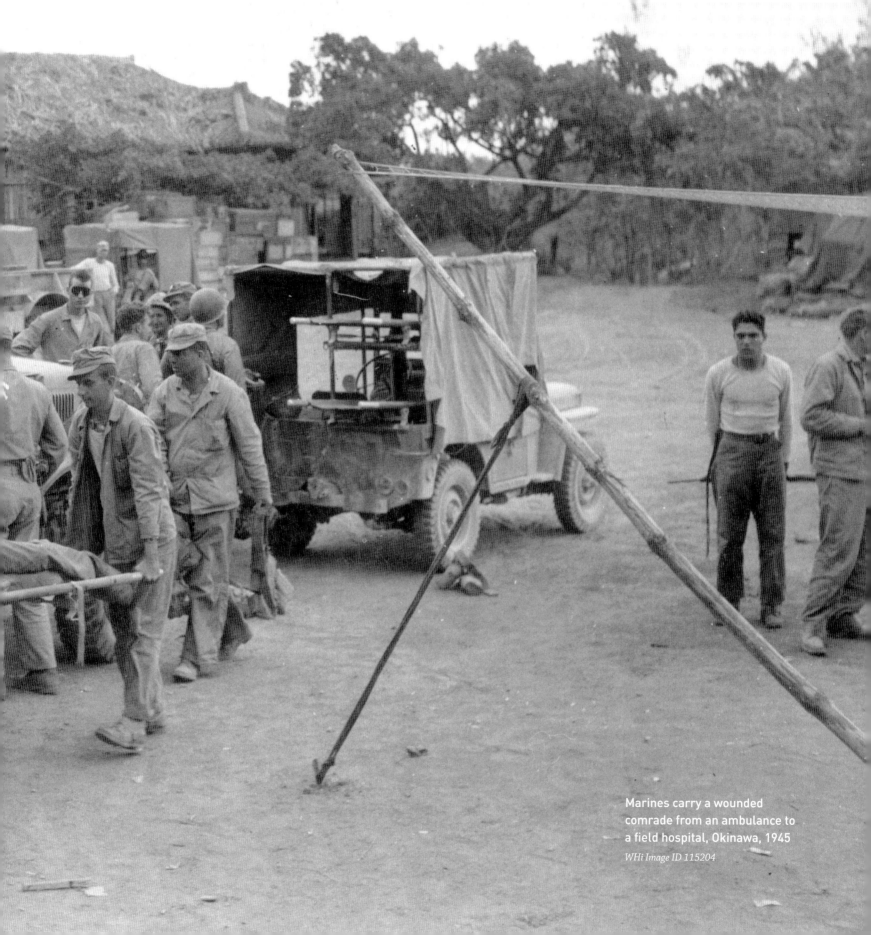

Marines carry a wounded comrade from an ambulance to a field hospital, Okinawa, 1945

WHi Image ID 115204

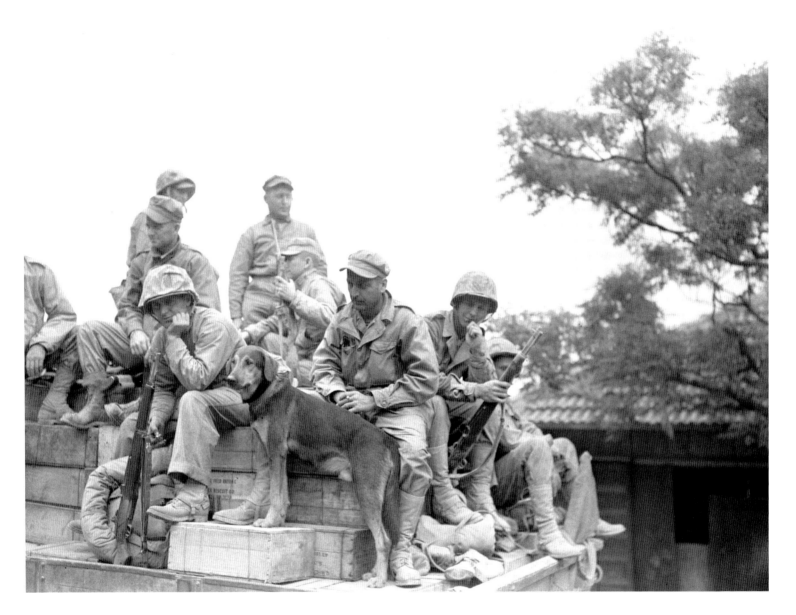

US Marines with a dog, just outside Ishikowa,
Okinawa, 1945. This image was taken hours after the
fall of Ishikowa, a village of about 400 people.

WHi Image ID 85177

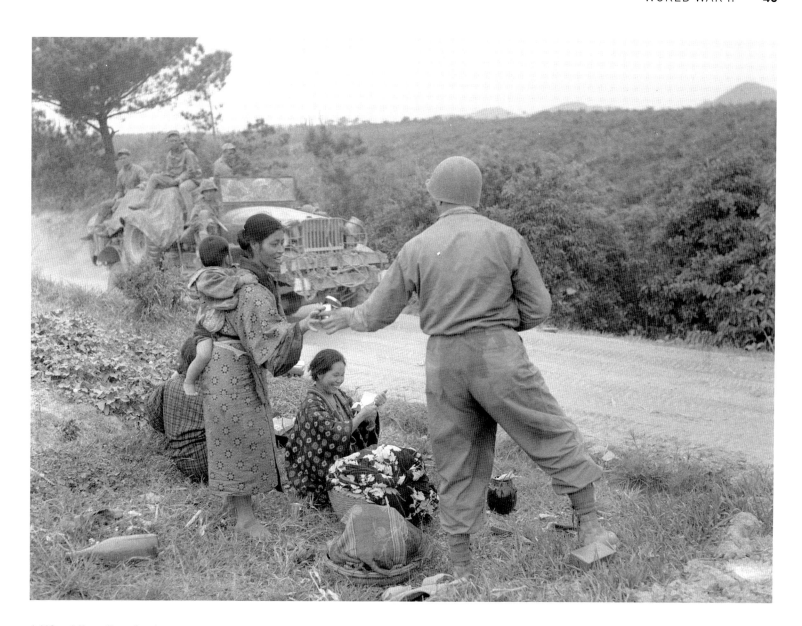

A US soldier offers food to
Japanese women gathered on
a roadside, Okinawa, 1945

WHi Image ID 115153

Dickey with her camera bag, in a photograph probably taken by Tony during their time in Europe.

Photo from the Meyer family personal collection

3

Relief Work

The wreckage resulting from man's inhumanity to man—whether from the time of Ghengis Khan or Adolph Hitler—was the litany I wrote and the subject I photographed. And the magnitude of relief devised never matched the magnitude of the suffering caused.

—Dickey Chapelle, *What's a Woman Doing Here?*

When Dickey returned home after the war with neither military press credentials nor a clear career path, she was desperate to find work. The fledgling teen magazine *Seventeen* assigned her to a story on a youth camp in Kentucky run by the American Friends Service Committee, a Quaker-affiliated peace organization. The story led to an even bigger opportunity to cover the international humanitarian effort in postwar Europe.

For six years Dickey and Tony traveled the world together taking publicity photos, first for the American Friends and later for other charitable organizations such as the International Rescue Committee, CARE, the World Health Organization, and the US government–led Point Four Program. In 1949, when dwindling support from relief agencies left them without a sponsor, Dickey and Tony created their own relief agency, called AVISO, which stood for American Voluntary Information Services Overseas.

The Chapelles drove around Europe in a truck that doubled as their living quarters. They also traveled across the Middle East and into Asia, working on stories in Jordan, Iran, Iraq, and India. In addition to documenting relief efforts around the world, Dickey also photographed world leaders, including young King Hussein of Jordan and the Indian prime minister, Jawaharlal Nehru. Their travels were documented in two *National Geographic* photo essays in 1953 and 1956. The pain and suffering they witnessed during this time left a tremendous impact; throughout Dickey's career, her compassion for victims of war would be evident in her work.

In 1953 Dickey and Tony finally returned to New York. Soon after, Dickey discovered Tony was having an affair. The couple separated, "both personally and professionally." Dickey wrote about their parting in her autobiography: "Several times, television interviewers and people who hear me lecture have asked me the same question about marriage. Can a woman be both a foreign correspondent and a wife? My answer—never at the same time." The couple eventually remained friends and kept in contact. Without Tony's interference, Dickey wanted to go back to covering war.

Dickey called on General Lemuel C. Shepherd, the Marine commander she met on Okinawa. Shepherd was now the US commandant of the Marine Corps in Washington, DC, and he agreed to help Dickey reinstate her military press credentials.

For the next ten years Dickey would cover wars around the world, documenting rebels, freedom fighters, cold warriors, and every branch of the US military. But the Marine Corps would remain her favorite. As she later wrote, "They taught me bone-deep the difference between a war correspondent and a girl reporter." ∎

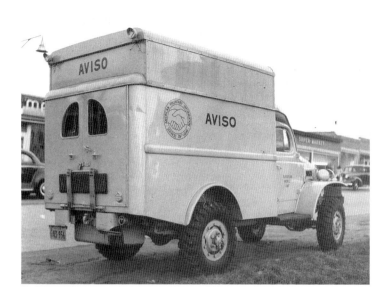

Left: In 1949 Dickey and Tony created their own relief agency called AVISO, or American Voluntary Information Services Overseas. The Chapelles traveled throughout Europe in a vehicle like this one, which served as their office and sleeping quarters.

WHi Image ID 115173

Below: A Quaker relief worker with Polish orphans, ca. 1946–48

Courtesy of the American Friends Service Committee

Right: Polish orphans, ca. 1946–48

Courtesy of the American Friends Service Committee

Opposite: The original caption for this photograph, which was published in *Seventeen* magazine in 1946, reads, "The young famine fighters of the Friends' summer work camp in the mountains of Kentucky observe silent grace." This photo shoot eventually led to the Chapelles' work in documenting relief efforts around the world, first for the American Friends Service Committee and later for other relief and US government agencies.

WHi Image ID 115393; reprinted with permission of Hearst Communications, Inc.

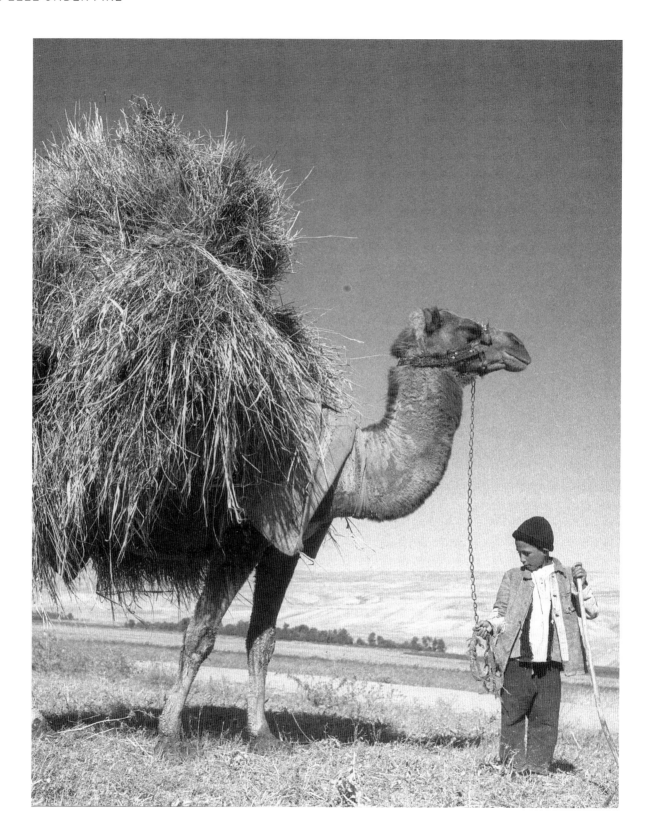

A boy leading a camel loaded with grain near Ardebil in the Azerbaijan province of Iran, 1952

WHi Image ID 115177

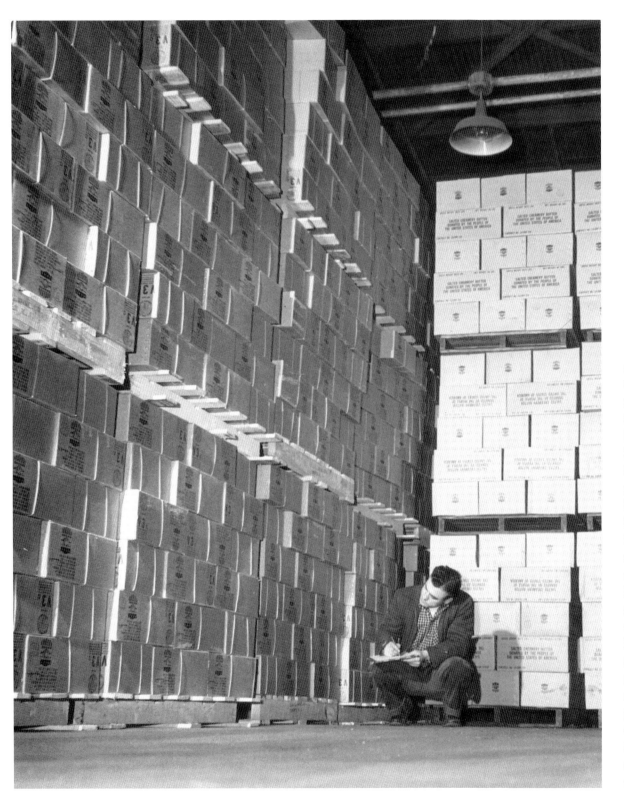

A man takes inventory of aid boxes loaded onto pallets in a Philadelphia warehouse, 1954. Dickey wrote, "Every 24 hours, more than 50,000 Food Crusade packages are readied for overseas shipping in the CARE warehouse in Philadelphia. The same boxcars which each morning bring in surplus food from government stocks all over the country leave the warehouse at midnight, each packed to the roof with completed CARE food packages." The boxes were then shipped to Europe, South America, and the Middle East.

WHi Image ID 115170

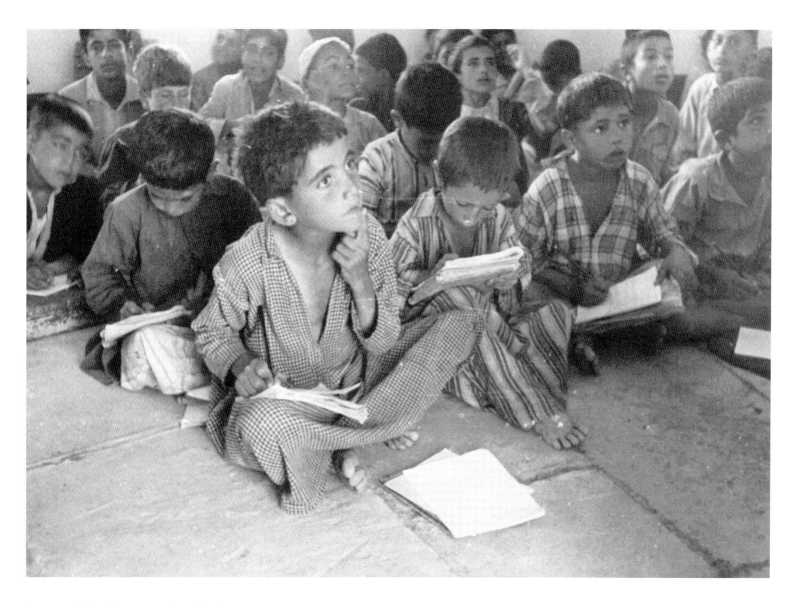

A group of Iraqi boys seated on the floor
of a school built with US aid, 1952

WHi Image ID 115178

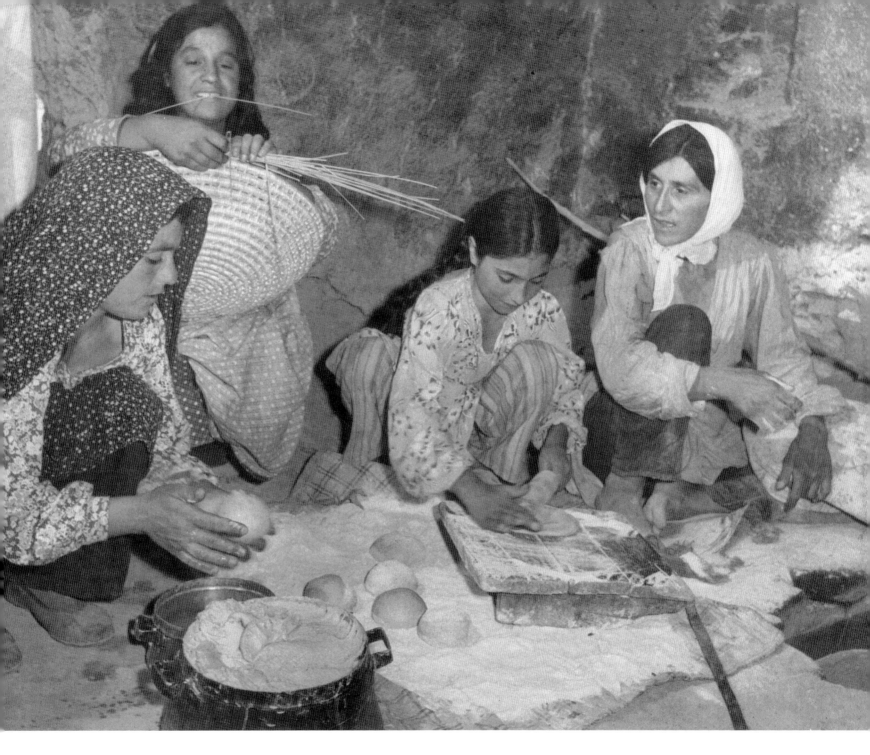

Iranian women making bread with
ingredients supplied by US aid, 1952

WHi Image ID 115360

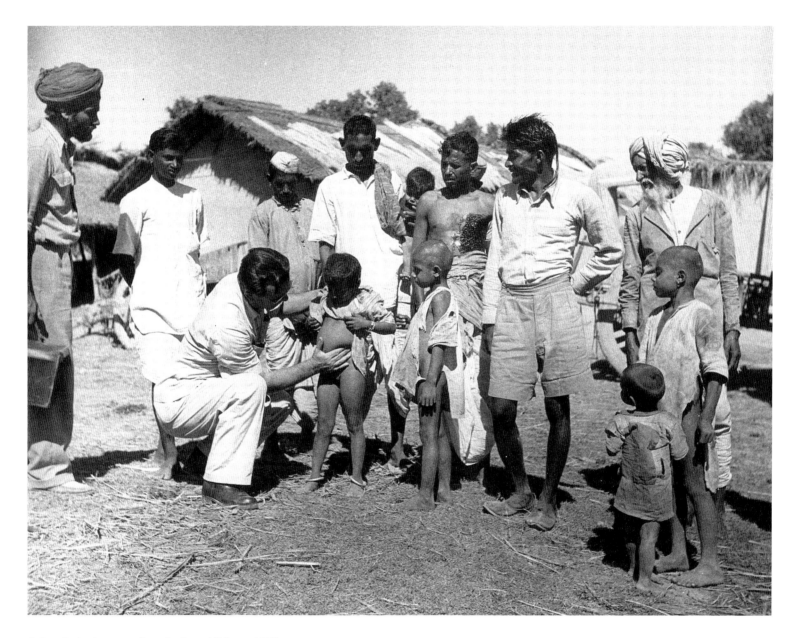

A Greek doctor examines Indian children, 1952

WHi Image ID 115368

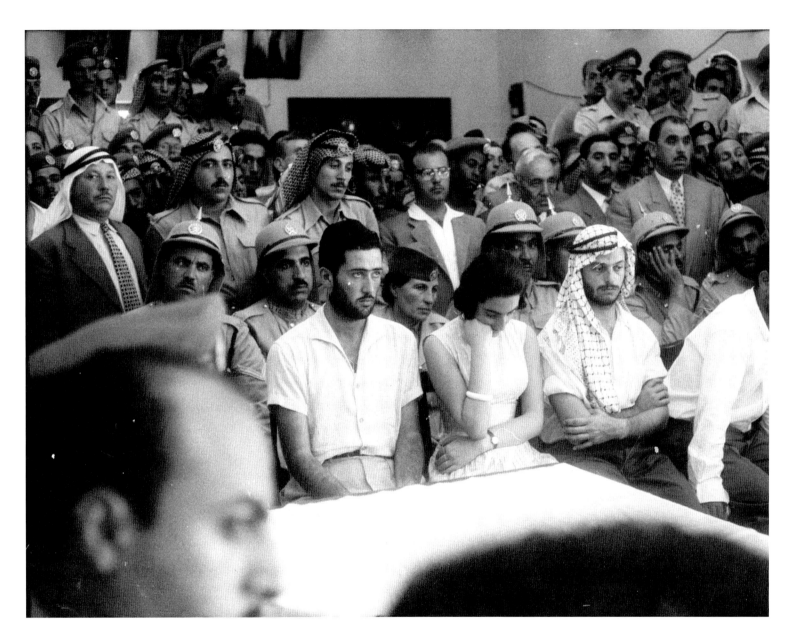

Two Jordanians, a man and a woman, seated in the front row of a
courtroom. One or both of them are on trial for treason, as other Jordanian
civilians and military officials observe from the background, 1958

WHi Image ID 115179

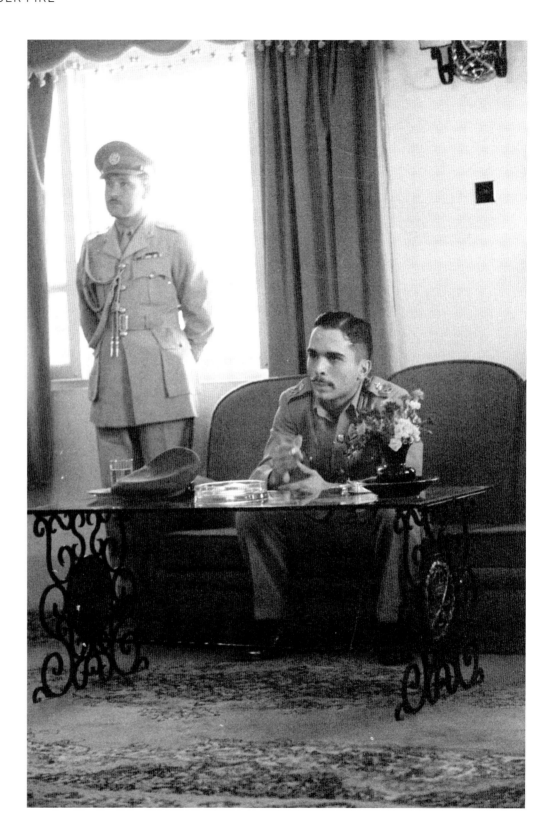

King Hussein of Jordan, 1958

WHi Image ID 115176

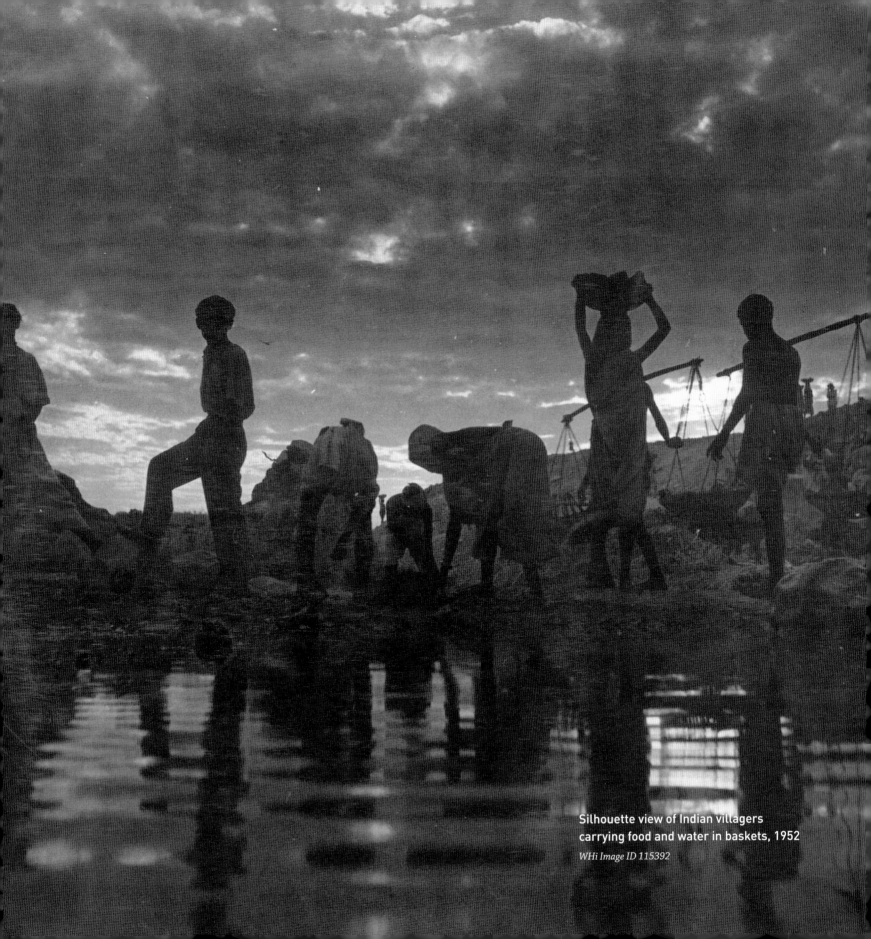

Silhouette view of Indian villagers
carrying food and water in baskets, 1952

WHi Image ID 115392

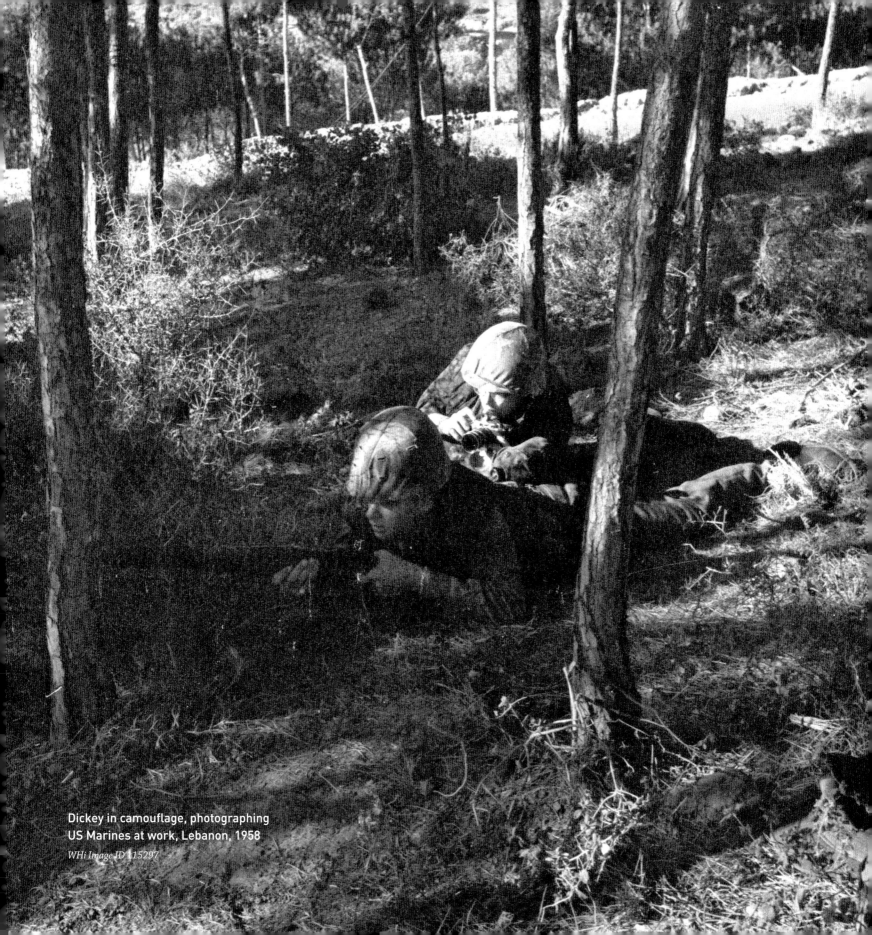

Dickey in camouflage, photographing
US Marines at work, Lebanon, 1958

WHi Image ID 115297

Bayonet Borders

It was the three of us—two freedom fighters and I—who had lost our way after many hours' trek across the Hungarian cornfields. Then had come the burst of gunfire from behind the snow-frosted haystack, Oli's disappearance, the quick capture of the one Hungarian and me, the icy moment of truth when the shouted command *Stoi!* meant I was now an American taking orders in Russian.

Boxed in by four riflemen, we were marched out behind the buildings. Here was another icy cart trail and we began to walk along it just as we'd walked through the darkness the night before. The pace was even and the men's silence, the sense of isolation, were just as great. It was afternoon by now, and a falling snow was filling in our light footprints.

The purple of twilight came before we reached a wide country crossing where two small sedans were parked as if they had been waiting for us. I could decipher the name of the make on the back of the nearest. *Pobeda*. Not a Magyar word. It means victory—in Russian.

—Dickey Chapelle, *What's a Woman Doing Here?*

Newly reinstated as a war correspondent, Dickey quickly set out to reestablish ties with the military. She actively promoted herself as the "Bayonet Border Reporter" and by her own account covered more than thirty fighting forces by 1959, including conflicts in Algeria, Cuba, Lebanon, and, later, the Dominican Republic.

In 1956, while on assignment for *Life* magazine, Dickey traveled to Austria to report on the uprising in neighboring Hungary. The Hungarians were revolting against Soviet occupation, and war had broken out between Hungarian freedom fighters and the Russian military.

Dickey knew the Russians were executing reporters as spies. And she did more than simply document the uprising—she brought penicillin into Austria for the Hungarian refugees crossing the border. Dickey recognized something familiar in the faces of the refugees fleeing the war—they reminded her of the villagers she had seen on Okinawa, traumatized by conflict.

While transporting penicillin with two Hungarian companions in December 1956, Dickey was captured by a Russian patrol and turned over to the Hungarian secret police, who imprisoned her in Budapest for almost two months. She spent most of that time in solitary confinement, with numerous interrogations under the constant threat of execution. During her captivity Dickey considered whether her work was worth the danger. Was one photograph of a freedom fighter delivering penicillin to a doctor worth being imprisoned or killed?

In the end, she decided, "The answer to the question was simply yes. I believed the picture I'd been trying to make would have moved someone who saw it to provide new aid to the freedom fighters."

The Hungarians had hoped to execute her. But Dickey had cleverly tucked her small Minox camera into a glove and dropped it out a car window when she was taken prisoner. Without a camera or film to prove Dickey was a spy, and with mounting pressure from the United States, the Hungarian government convicted her of illegal border crossing and let her go.

Dickey was now known to rebel leaders around the world. During the 1957 Algerian war against France, rebellion leaders from the Algerian Federation of National Liberation smuggled her into Algeria so she could help them tell the world their side of the story. Dickey photographed the war from the rebels' point of view and observed the trial and execution of a young Algerian traitor. When Dickey asked the Algerians why they had chosen her, she was told that no one else would go.

In 1958 *Reader's Digest* sent Dickey to cover the revolution in Cuba, where she had unfettered access to Fidel Castro, his brother Raul, and their inner circle of revolutionary forces. At the time Dickey believed the Castros were legitimate freedom fighters trying to overthrow the authoritarian, US-backed Batista government. Little did she know that upon winning the revolution, Castro would institute his own authoritarian government and repress millions of Cubans for decades. Dickey later became a supporter of the US-based anti-Castro movement, although her photos of that effort never received the same attention as her photos of the revolution.

In 1958 Dickey also covered the US Marine occupation of Lebanon, a rare conflict in which there were no US or Lebanese casualties. And in 1965, while waiting for her final assignment to return to Vietnam, Dickey traveled to Santo Domingo to document the second US occupation of the Dominican Republic for the *National Observer*. This campaign—in which 172 American soldiers were wounded and 44 killed—has largely been overshadowed in the United States by the larger and deadlier conflict in Vietnam.

The photographs from Dickey's "Bayonet Border" period are an important reminder of the human costs of fighting the so-called "small wars" that are sometimes forgotten in popular memory. Dickey's experience in covering these wars increased her military knowledge and her reputation as a war correspondent. Yet her reporting from Vietnam would have the greatest impact on her career. ■

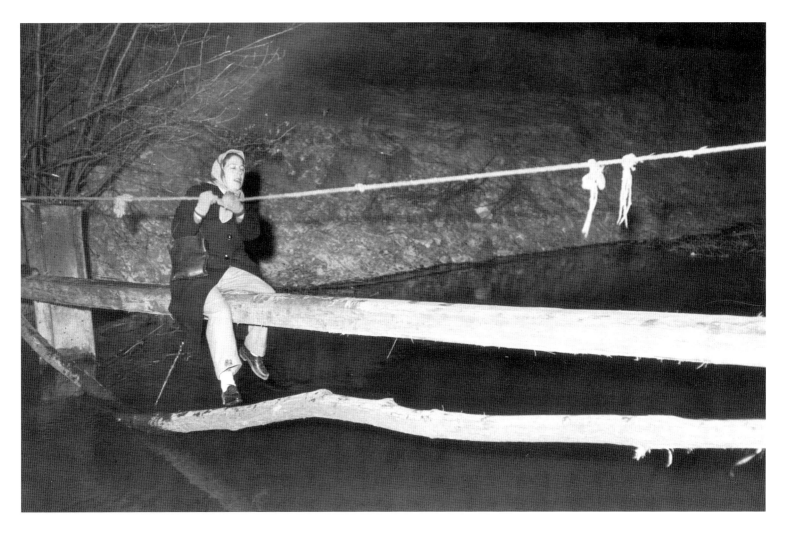

A Hungarian woman crosses an improvised bridge into Austria in 1956. This and the following image originally appeared in *Life Magazine* in December 1956.

WHi Image ID 32741

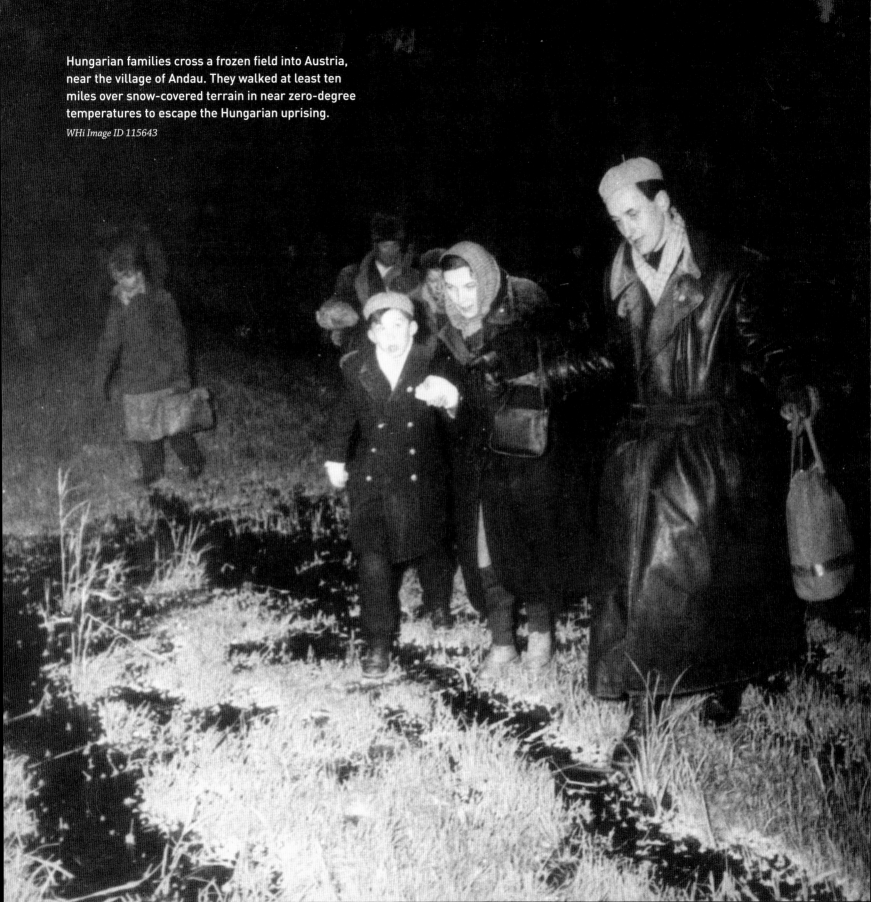

Hungarian families cross a frozen field into Austria, near the village of Andau. They walked at least ten miles over snow-covered terrain in near zero-degree temperatures to escape the Hungarian uprising.

WHi Image ID 115643

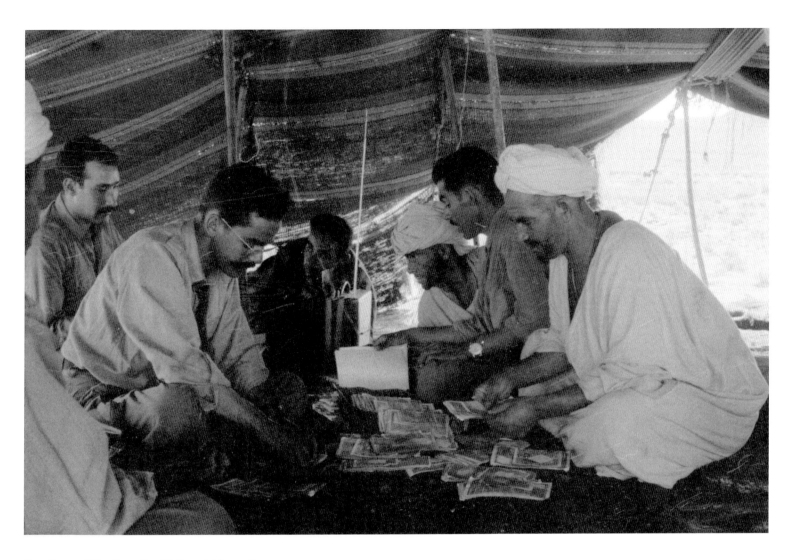

Members of the Algerian National Liberation
Front meet in a tent to plan strategy, 1957

WHi Image ID 85482

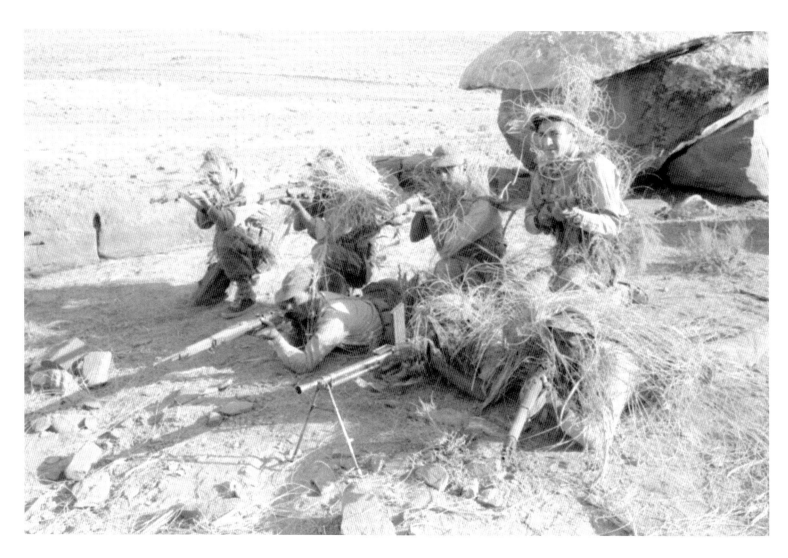

Algerian fighters wearing brush as camouflage, 1957

WHi Image ID 85593

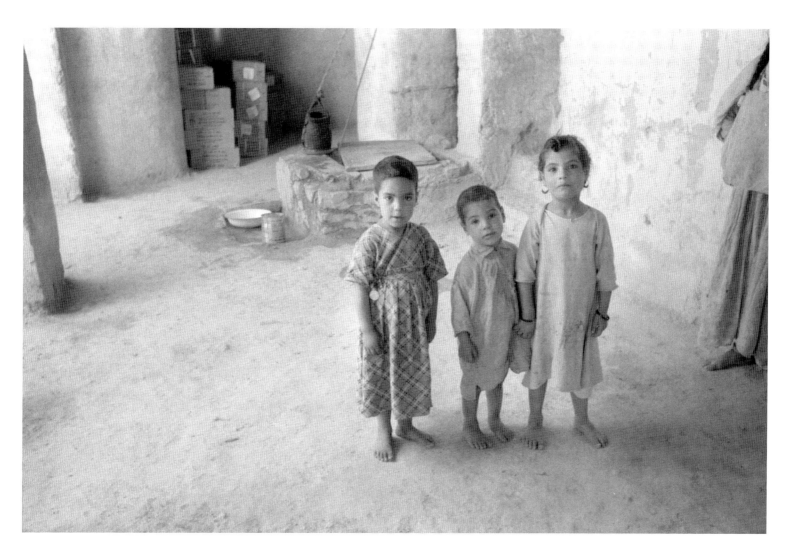

Three Algerian children stand near their home, 1957

WHi Image ID 85518

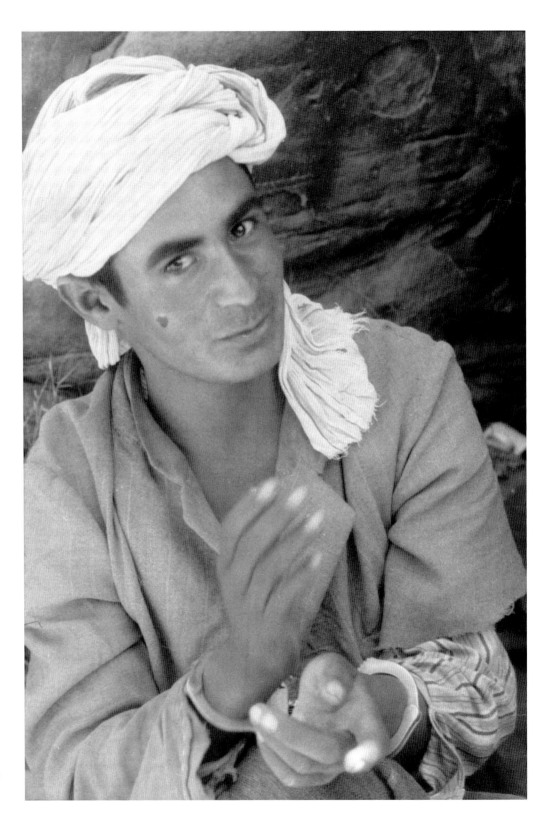

An Algerian traitor who claimed to have killed women and children sits handcuffed, waiting for his trial by the Algerian National Liberation Front, 1957

WHi Image ID 85793

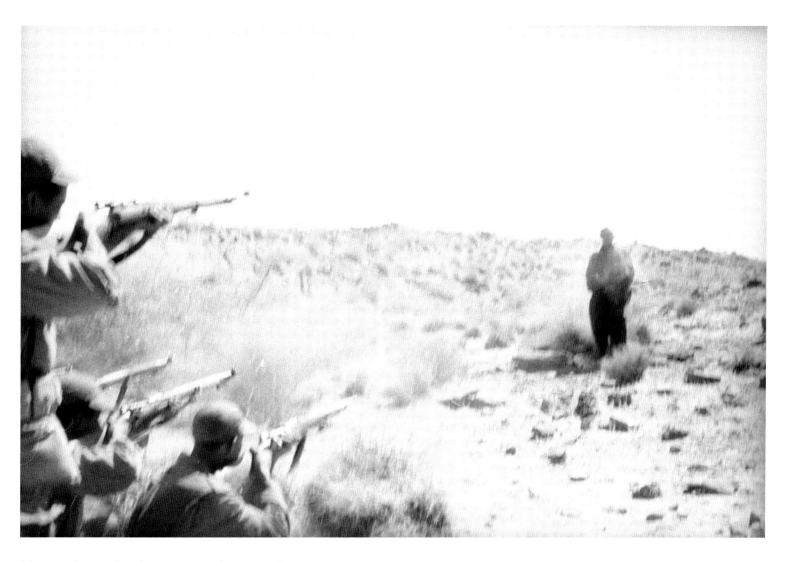

After a guilty verdict, the young man is executed
by an Algerian rebel firing squad, 1957

WHi Image ID 12156

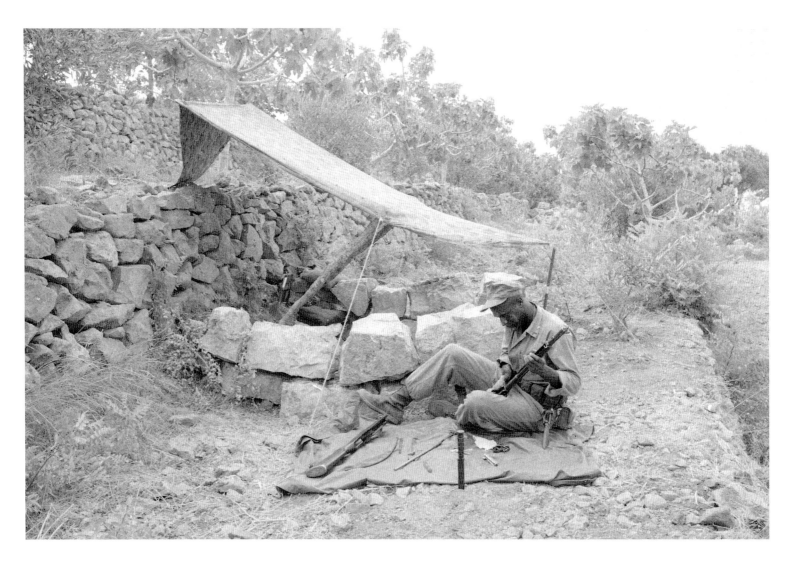

A soldier cleaning his rifle, Lebanon, 1958

WHi Image ID 115306

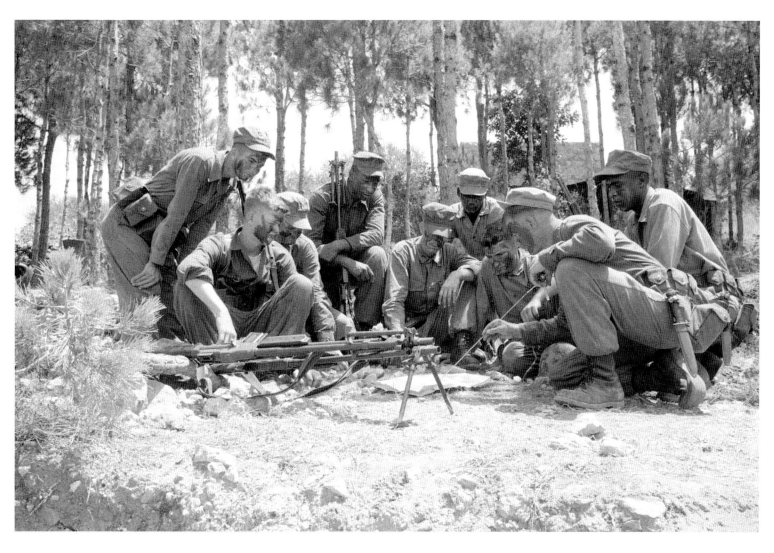

Soldiers with camouflage face paint gather around a map, Lebanon, 1958

WHi Image ID 115304

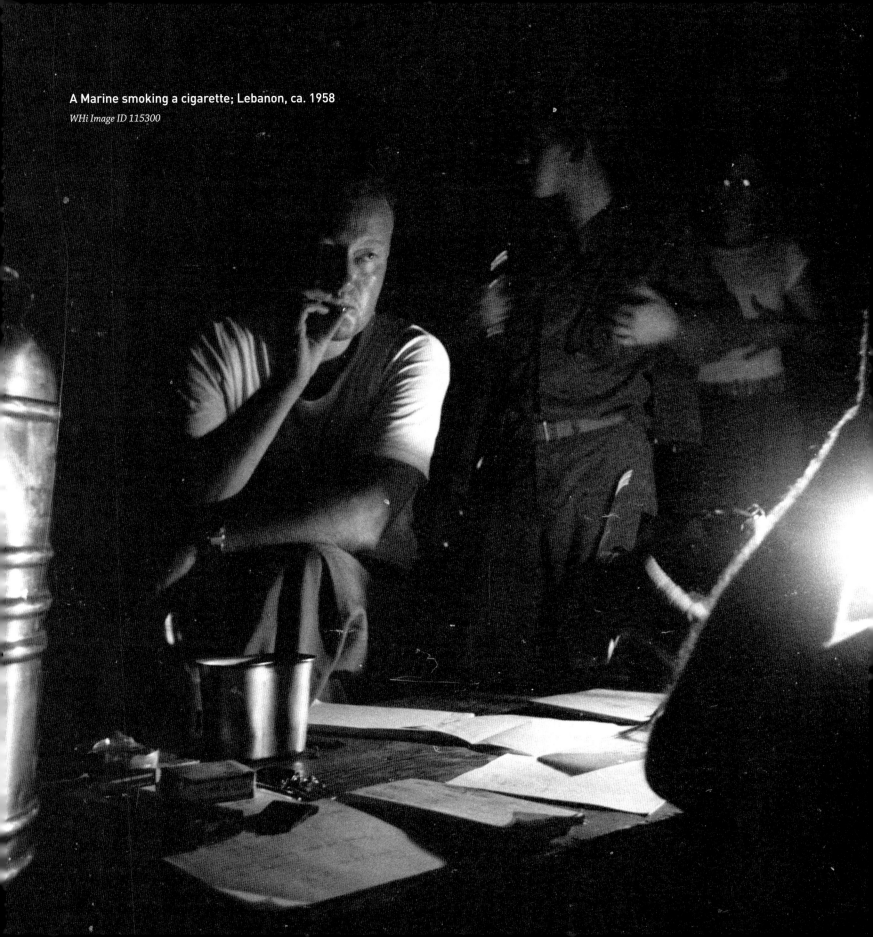

A Marine smoking a cigarette; Lebanon, ca. 1958

WHi Image ID 115300

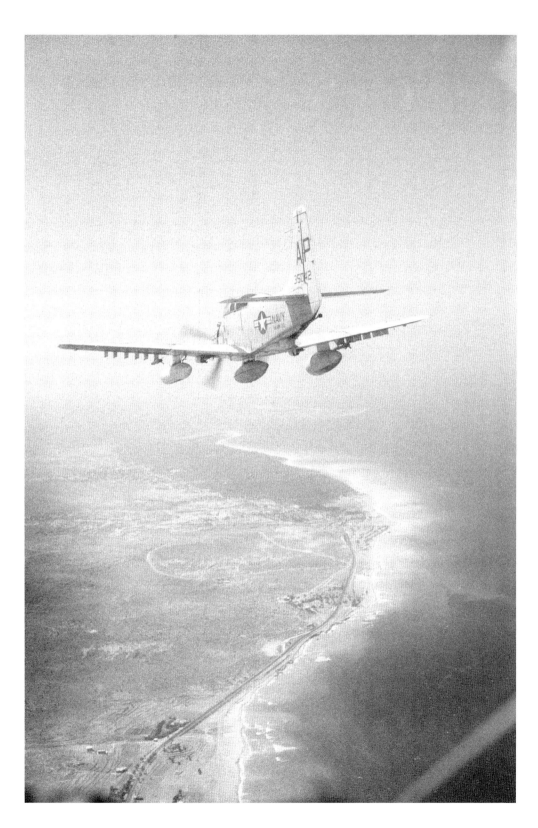

A US Navy carrier-based plane flies over the landscape of Lebanon, 1958; Dickey likely took this photograph from inside a helicopter.

WHi Image ID 115298

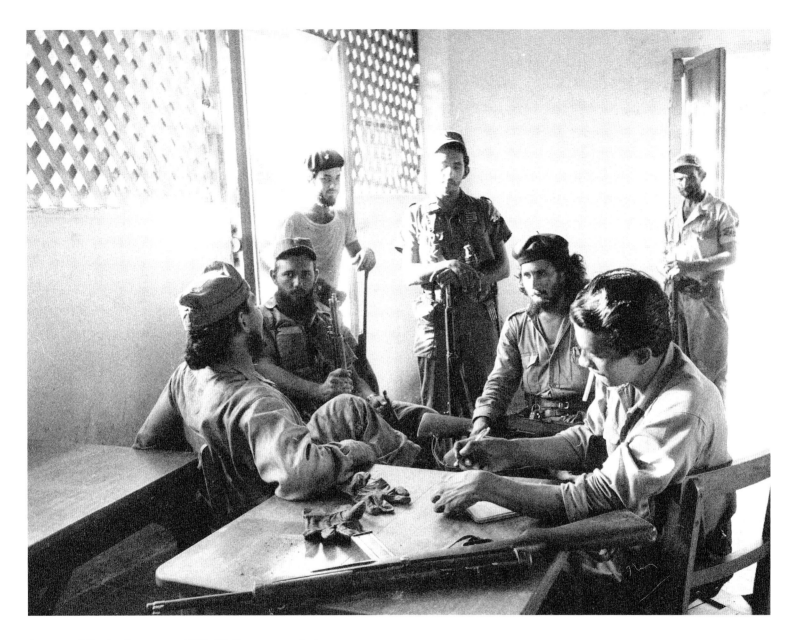

A group of Castro forces, ca. 1958–59; the man seated
second from right is possibly Ernesto Che Guevara.

WHi Image ID 115283

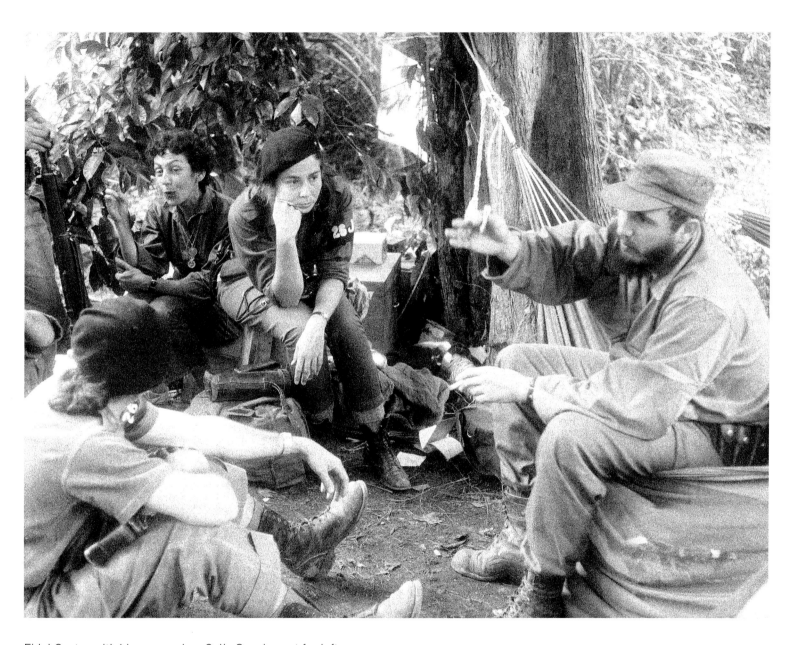

Fidel Castro with his companion, Celia Sanchez, at far left,
seated next to Vilma Espin, later Mrs. Raul Castro, ca. 1958–59

WHi Image ID 32774

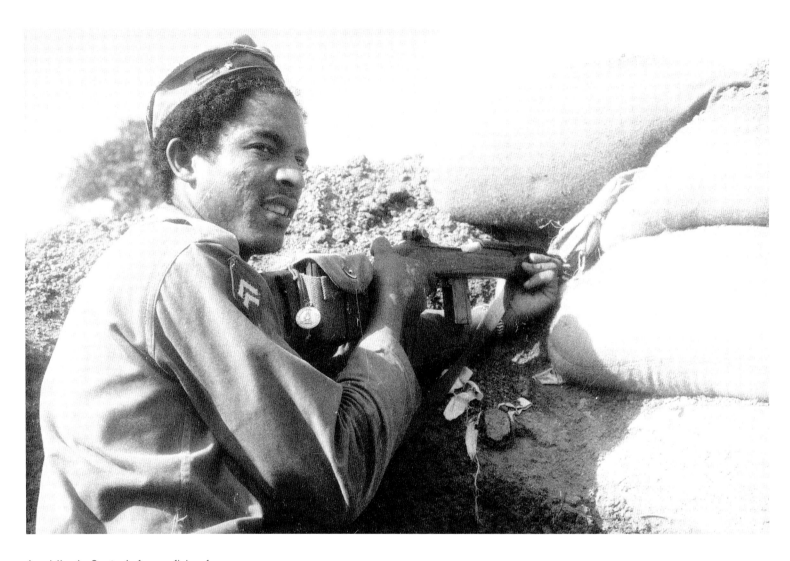

A soldier in Castro's forces firing from a position known as "the hole," during the battle for the village of LaMaya, Cuba, 1958

WHi Image ID 115239

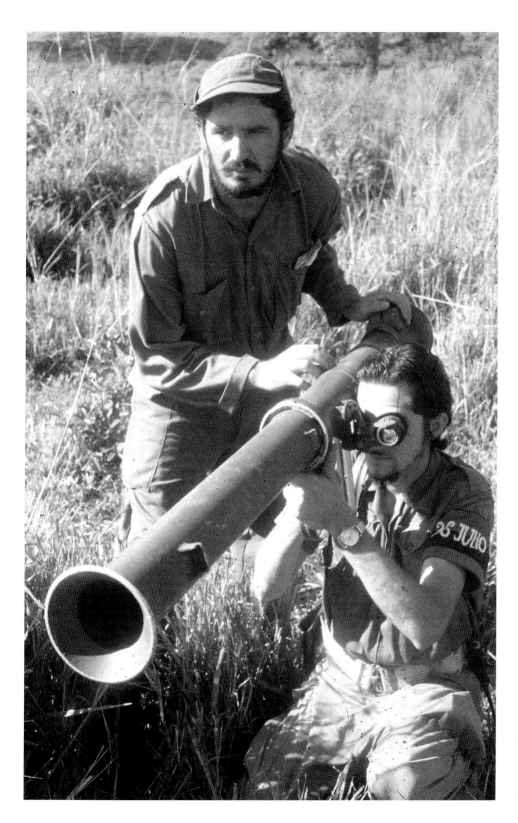

Fidel (left) and Raul Castro posing with a bazooka during the Cuban Revolution, Oriente Province, Cuba, 1958

WHi Image ID 85297

Three Cuban rebels during the Cuban revolution, ca. 1958–59.
The men are thought to be propagandists for Castro's 26th of
July Movement, organized to overthrow the Batista dictatorship.

WHi Image ID 115276

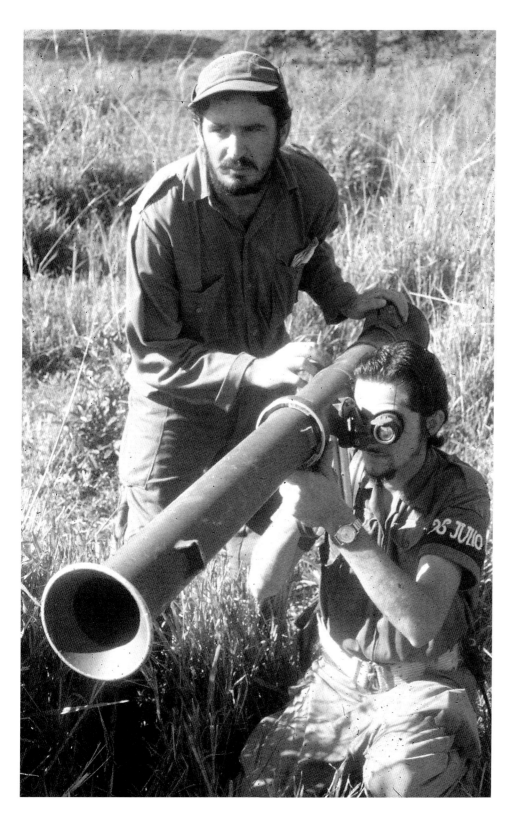

Fidel (left) and Raul Castro posing with a
bazooka during the Cuban Revolution, Oriente
Province, Cuba, 1958

WHi Image ID 85297

Three Cuban rebels during the Cuban revolution, ca. 1958–59.
The men are thought to be propagandists for Castro's 26th of
July Movement, organized to overthrow the Batista dictatorship.

WHi Image ID 115276

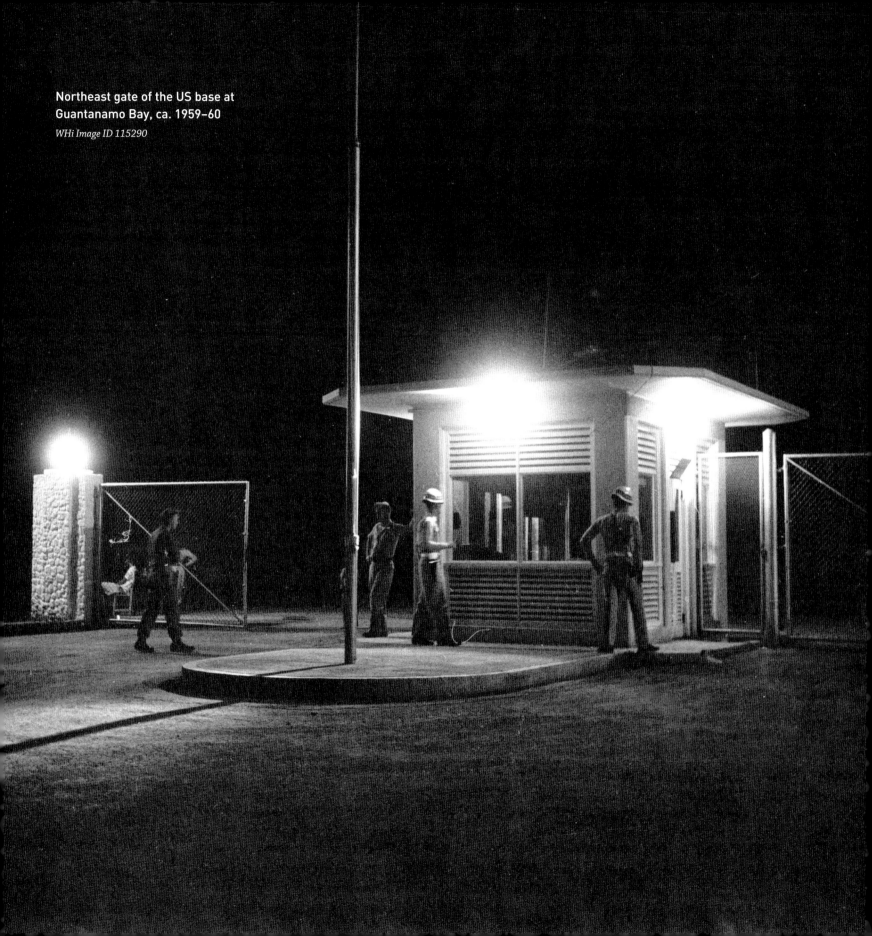

Northeast gate of the US base at
Guantanamo Bay, ca. 1959–60

WHi Image ID 115290

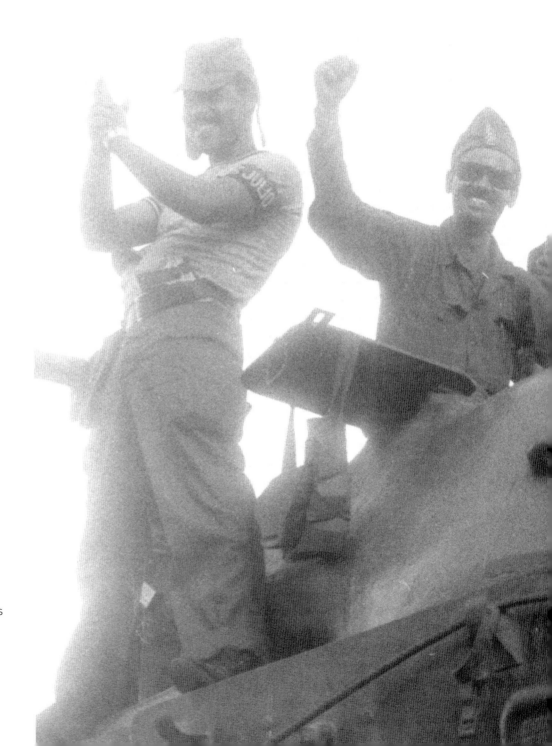

Cuban revolutionaries celebrate Fidel Castro's
arrival in Havana at the end of the Cuban
revolution, 1959

WHi Image ID 84524

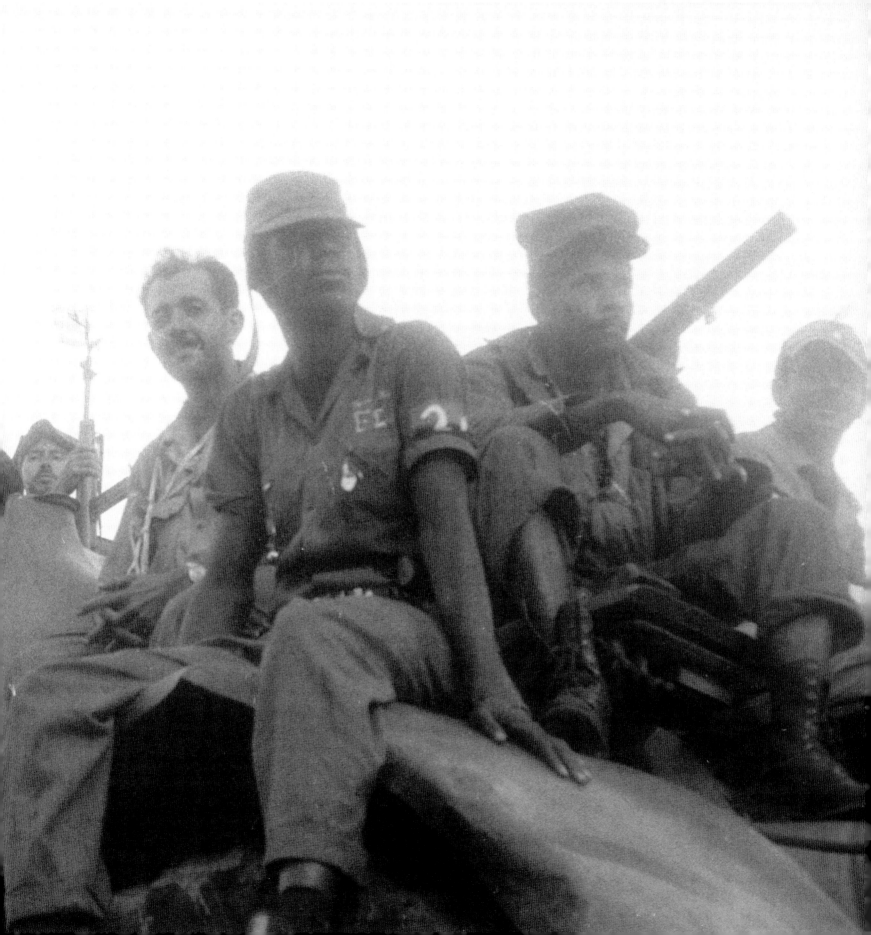

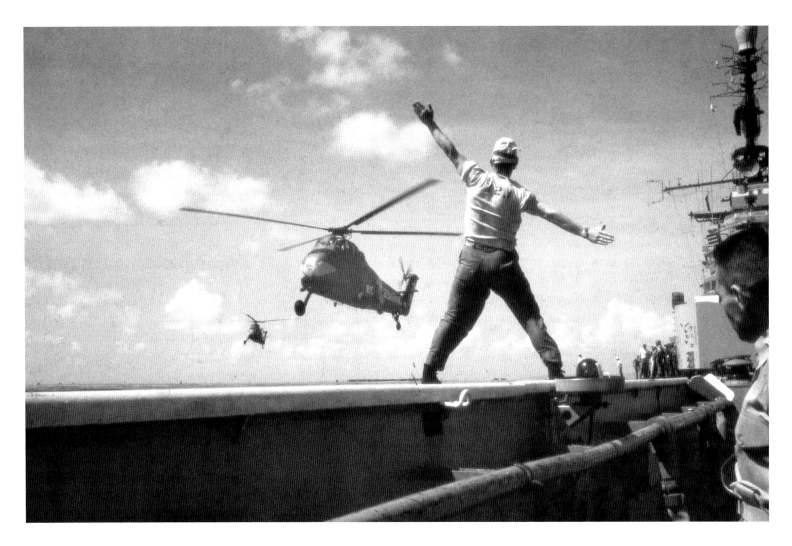

A crewman on a US Navy carrier signals to the pilot of an incoming Marine Corps CH-34 Choctaw helicopter, 1950s

WHi Image ID 11729

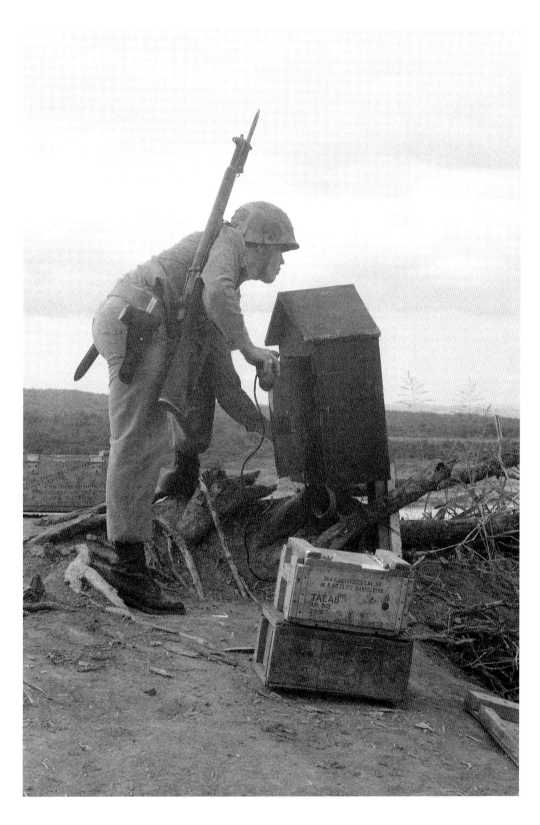

A Marine sentry uses a field call box,
Guantanamo Bay, Cuba, 1960

WHi Image ID 115235

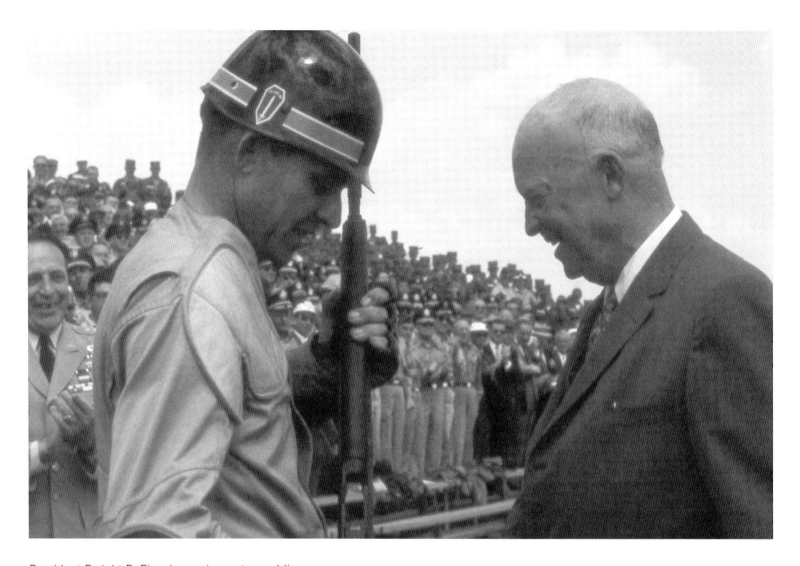

President Dwight D. Eisenhower inspects a soldier
during an exhibition at Fort Benning, Georgia, 1960

WHi Image ID 11732

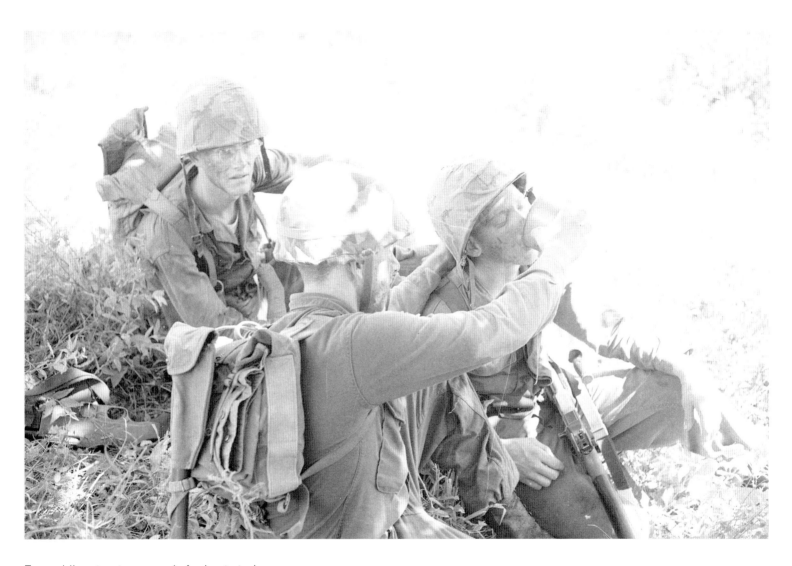

Two soldiers treat a comrade for heat stroke
on the island of Vieques, Puerto Rico, 1961

WHi Image ID 115234

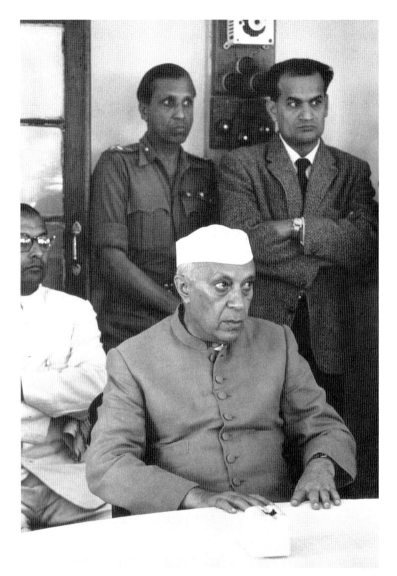

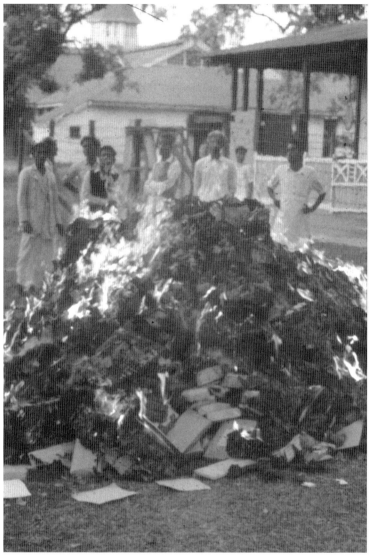

Above left: Indian Prime Minister Pandit Jawaharlal Nehru, seated at a table for a press conference, 1962

WHi Image ID 115372

Above right: A bank burns a pile of money during the Sino-Indian War in Tezpur, Assam, India, 1962

WHi Image ID 84397

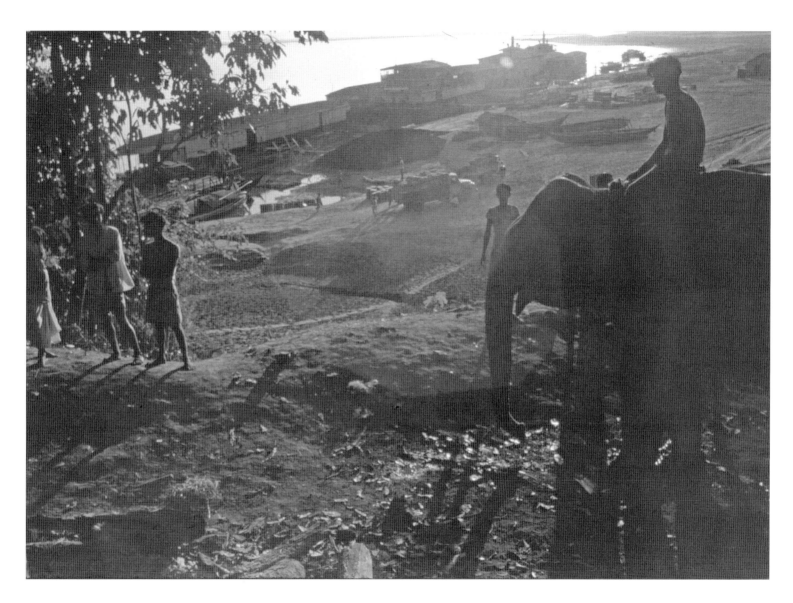

An elephant and rider in India overlook
a port filled with ships, 1963

WHi Image ID 116955

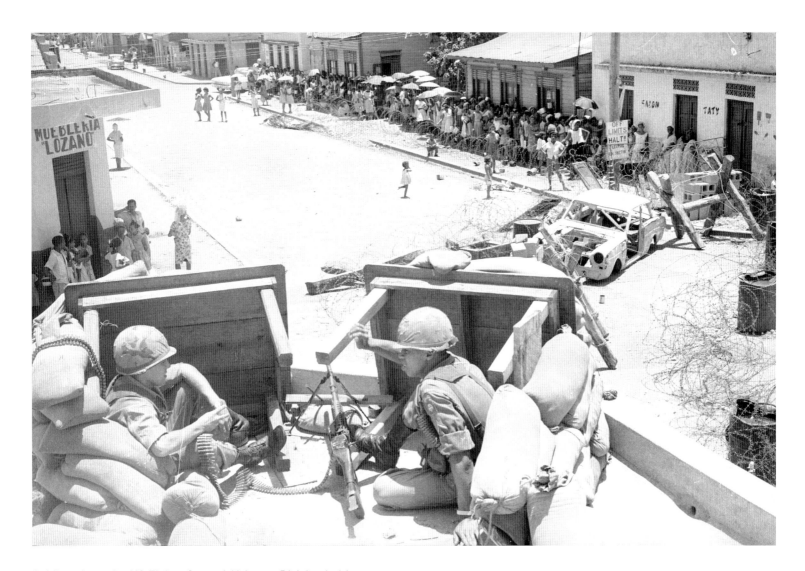

Soldiers from the US Eighty-Second Airborne Division hold
their position near a blockaded street in Santo Domingo during
Operation Power Pack, while a large group of civilians watch
from the opposite side of the road, Dominican Republic, 1965

WHi Image ID 115432

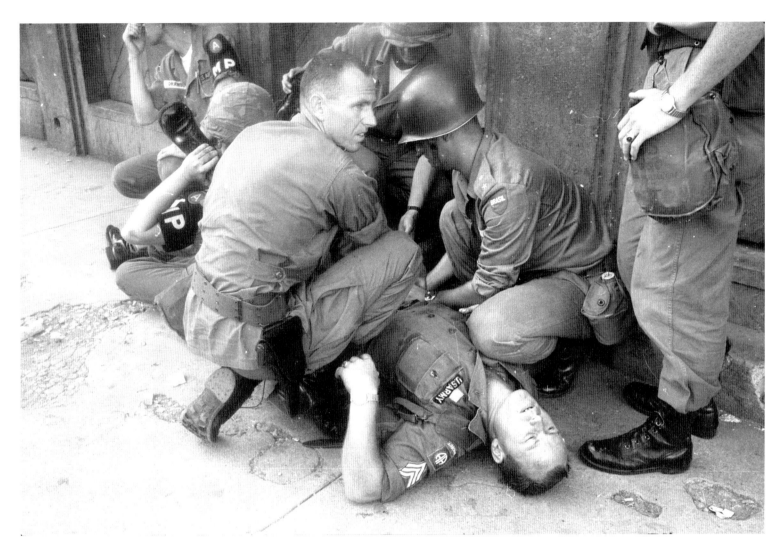

A US paratrooper receives first aid from US military police
and a Brazilian officer while he waits for medics after
being shot through the thigh by a rebel, Santo Domingo,
Dominican Republic, 1965

WHi Image ID 115429

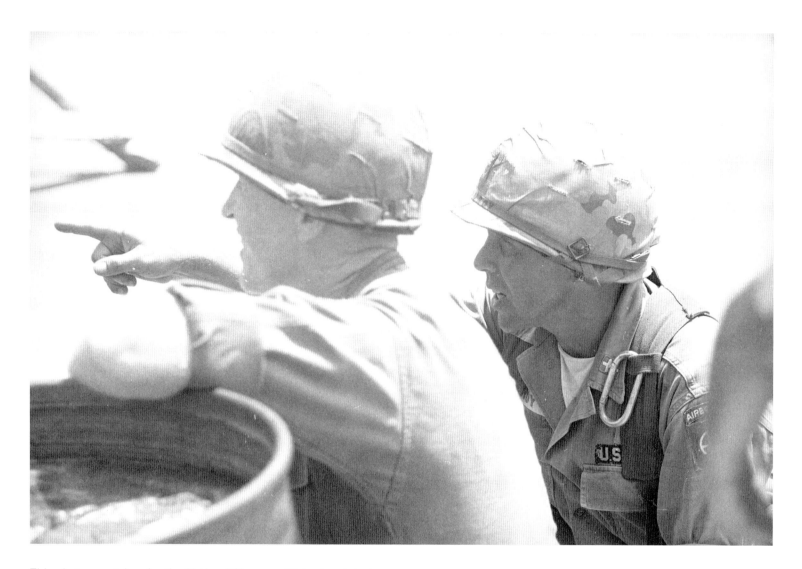

This photo was taken for the *National Observer*. Dickey's original caption reads, "Behind the barrels at Duarte and Henrique streets just before the planned advance, the paratroop chaplain (see cross on collar) briefs a colleague," Santo Domingo, 1965

WHi Image ID 115434

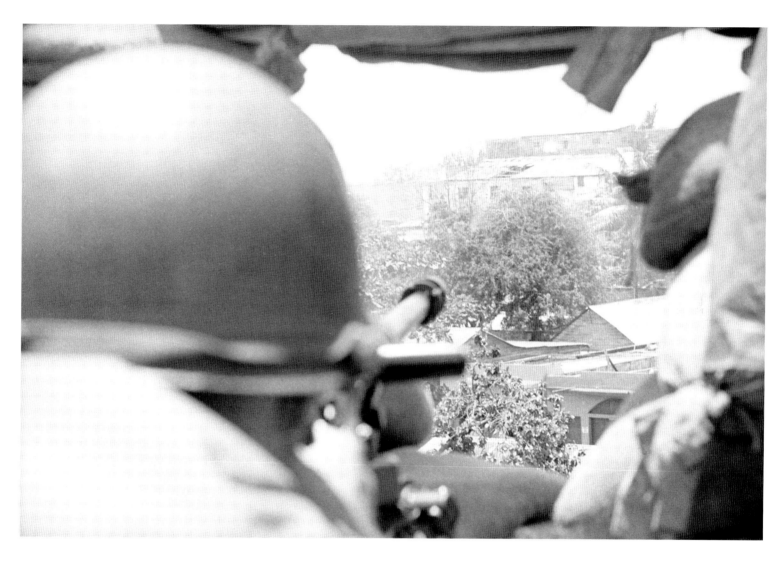

Soldiers with the Eighty-Second Airborne fire at snipers through
a window of Observation Post #1, Santo Domingo, 1965

WHi Image ID 115238

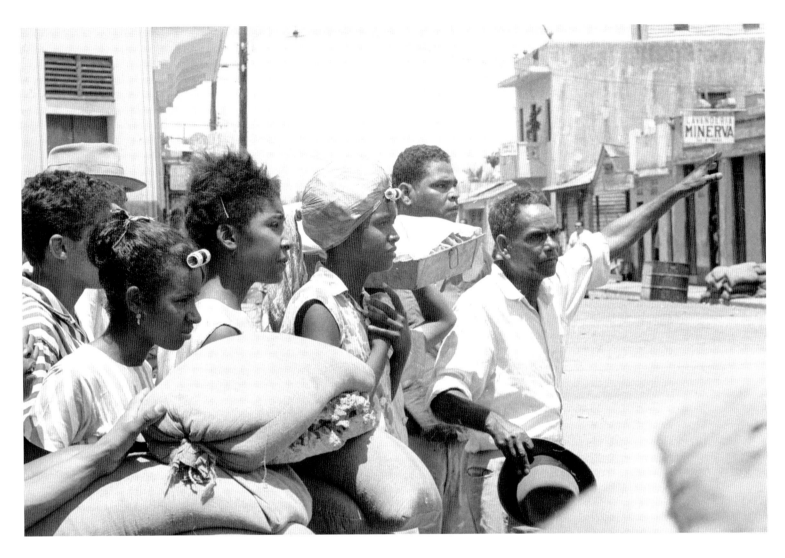

Above: The Dominicans pictured here lived in a rebel sector and were allowed to evacuate prior to a US advance into the area, Santo Domingo, 1965

WHi Image ID 115293

Opposite: Paratrooper Captain E. F. McGushin dances with a class of fourth grade girls at a recess in Santo Domingo. His company organized classes for 720 children and worked to keep children off the streets to avoid the fighting after their teachers fled the city, 1965

WHi Image ID 115236

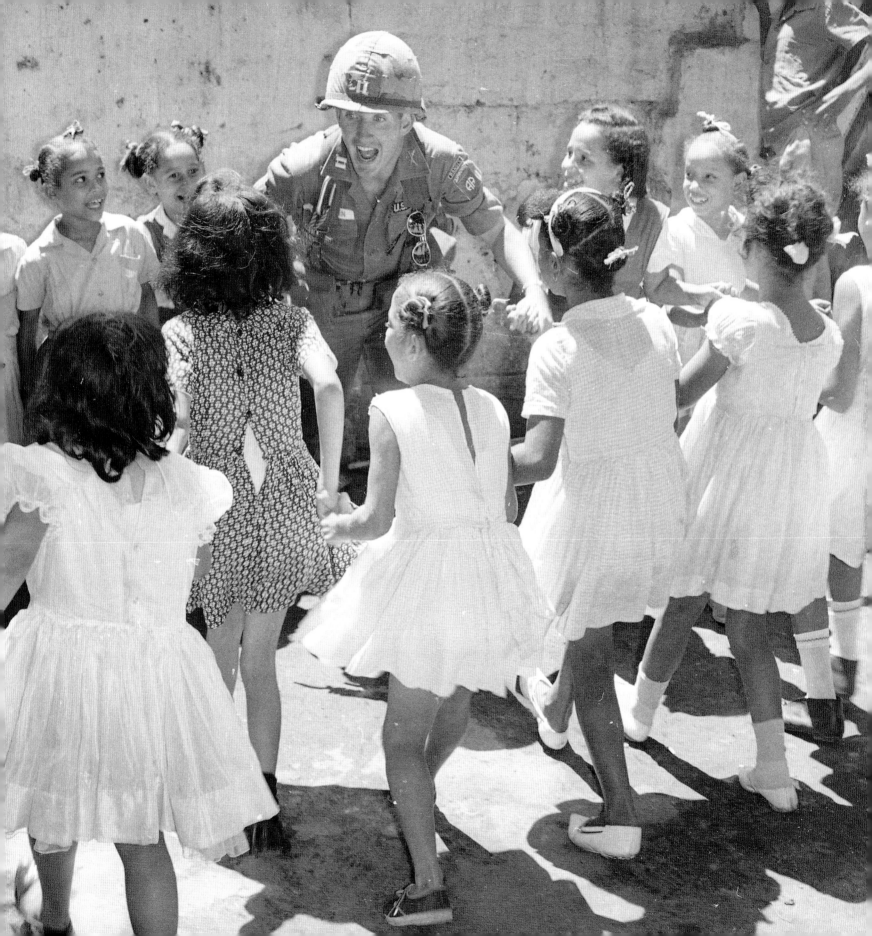

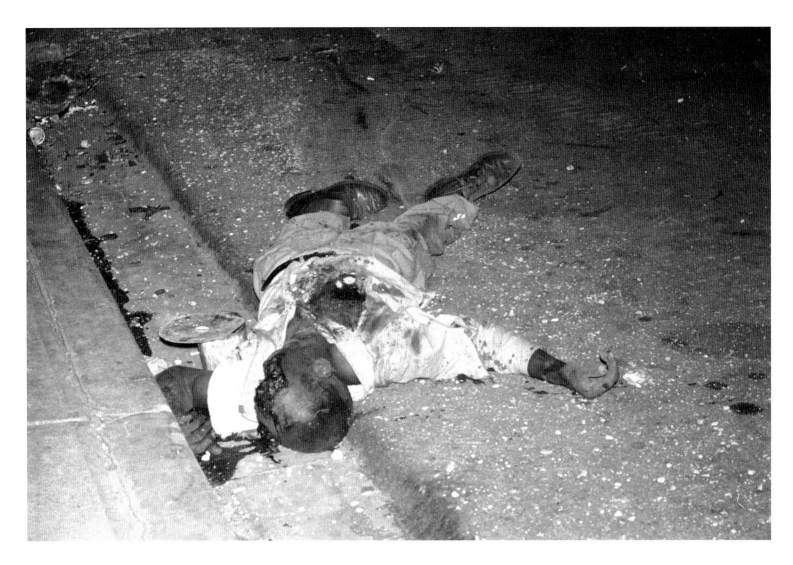

A body lies in a Santo Domingo street,
showing the savagery of the fighting in
the Dominican Republic civil war, 1965

WHi Image ID 115882

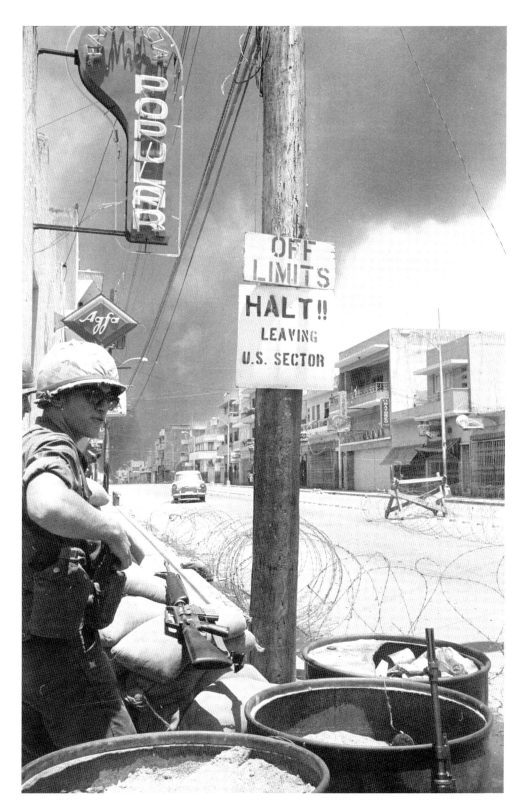

A guard stands at the restricted intersection of Henrique and Duarte Streets, at the border of the US section of Santo Domingo, 1965

WHi Image ID 115278

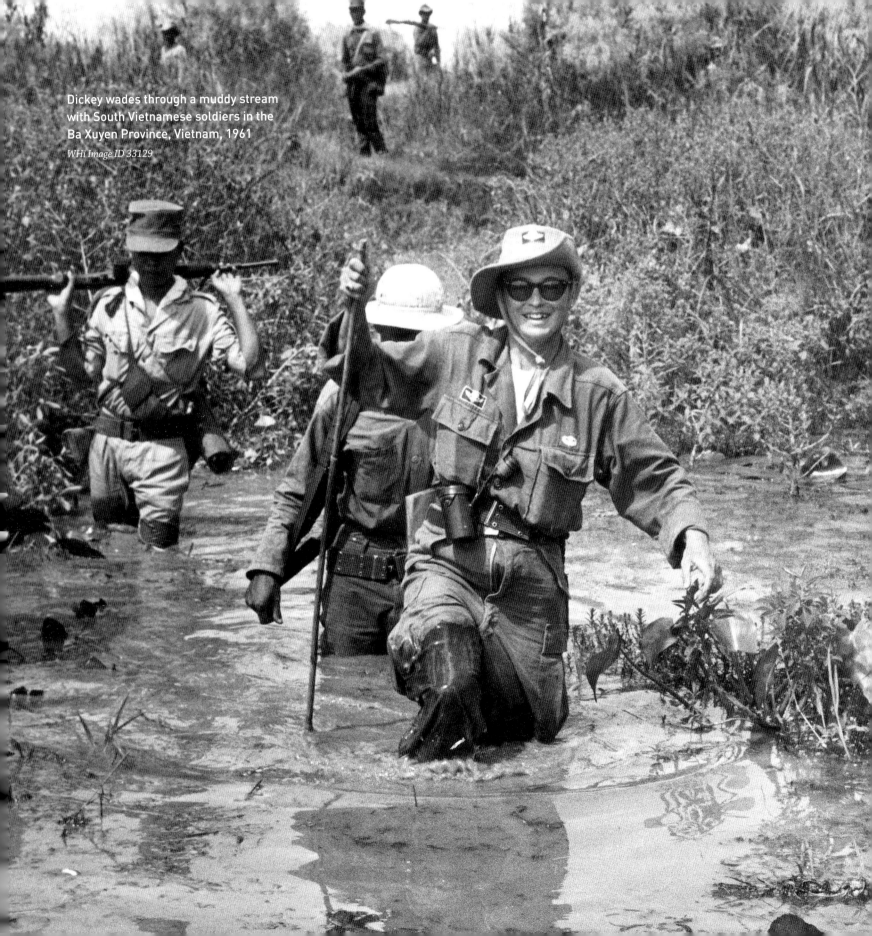

Dickey wades through a muddy stream with South Vietnamese soldiers in the Ba Xuyen Province, Vietnam, 1961

WHi Image ID 33129

Vietnam

Dear General Greene:

Not without the sin of pride, let me report that your insignia has been sloshed through another amphibious landing against the enemy. This time it was with the Vietnamese Marines from junks of the Vietnamese Navy. It occurred one January dawn in Phuoc Tuy province and sadly, as you no doubt heard from Colonel Nesbitt, we scared 'em so bad we couldn't find 'em to finish 'em.

—Letter from Dickey Chapelle to General Wallace Greene,

commandant of the US Marine Corps, April 4, 1965

Dickey arrived in Vietnam in 1961 with an assignment from *Reader's Digest* to cover US advisors in Vietnam and Laos in the still-early stage of the war. She was forty-two years old, an age at which most military veterans were no longer actively fighting wars.

She returned to the United States in 1962 to promote her autobiography, *What's a Woman Doing Here?* It was a modest seller, but its reporting earned her the Overseas Press Club's George Polk Award.

Dickey returned to Vietnam later in 1962, on an assignment for *National Geographic.* Her story "Helicopter War in Vietnam" was selected for the magazine's November 1962 cover. The story included her photograph of South Vietnamese soldiers crowded around a US Marine advisor holding a weapon at the door of a helicopter. This was the first published photograph proving that US advisors were actively engaging in combat operations. The photo won the 1963 Photograph of the Year award given by the National Press Photographers Association.

In spite of this recognition, Dickey scrambled to find work, as the war in Vietnam was becoming increasingly unpopular. She often resorted to working for less pay than her male counterparts in order to continue getting assignments. Dickey returned to Vietnam twice more, once in 1964 for *National Geographic* to cover the work of US advisors with the Vietnamese navy's Junk Force, and again in 1965 after returning from the Dominican Republic.

Dickey's 1965 trip would be her fourth and final. On assignment for the *National Observer* and New York's WOR Radio, she was attached to the Seventh Marines, who were engaged in a clear-and-destroy mission called Operation Black Ferret. Other international reporters were there, too, including the veteran Vietnamese-French photographer Henri Huet, on assignment for the Associated Press.

On November 4, 1965, Dickey was with a Marine patrol ten miles south of Chu Lai near the Song Tra Bong River when a young Marine on point at the head of the formation accidentally stepped into a tripwire made from nylon fishing line, triggering a grenade and an 82 mm mortar. Shrapnel from the explosion wounded five Marines and a Navy Corpsman and severed Dickey's carotid artery. A Navy chaplain, Lieutenant John McNamara, knelt over Dickey's body and gave her last rites. Henri Huet captured this moment with a stark and somber photograph that would become an iconic image of the Vietnam War.

A day later, General Wallace M. Greene Jr., the Commandant of the Marine Corps, released this message:

All U.S. Marines the world over mourn the death of Dickey Chapelle who died of wounds received while covering combat operations by Marines in South Vietnam on November 4, 1965. She was not only a skilled, dedicated newspaperwoman, but she was an exemplary patriot whose great love for her country was an inspiration to all who knew her and worked with her. It has been said by her media colleagues that she died with the men she loved. It must also be said that affection, admiration and respect was mutual. She was one of us, and we will miss her. ∎

Soldiers watch an Air America helicopter
land in Ban Hat Bay, Laos, 1961

WHi Image ID 32770

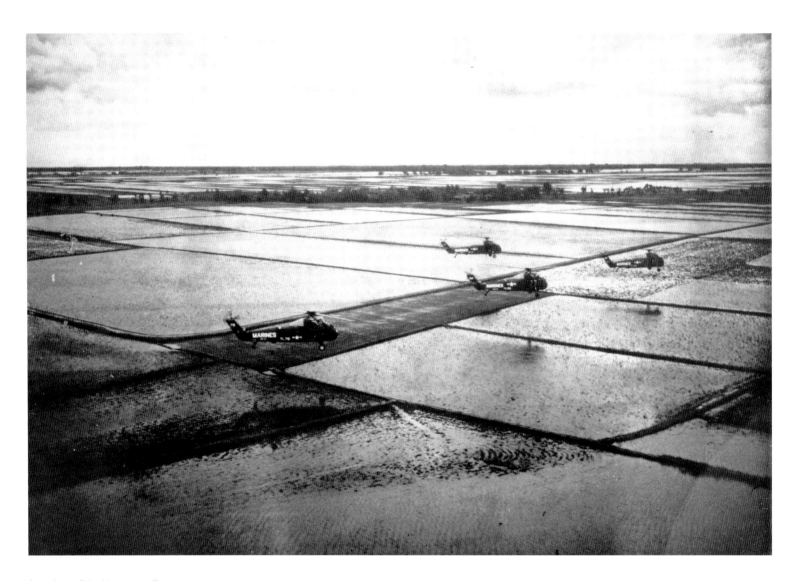

Opposite: US helicopters fly over
rice fields, Vietnam, ca. 1961

WHi Image ID 75427

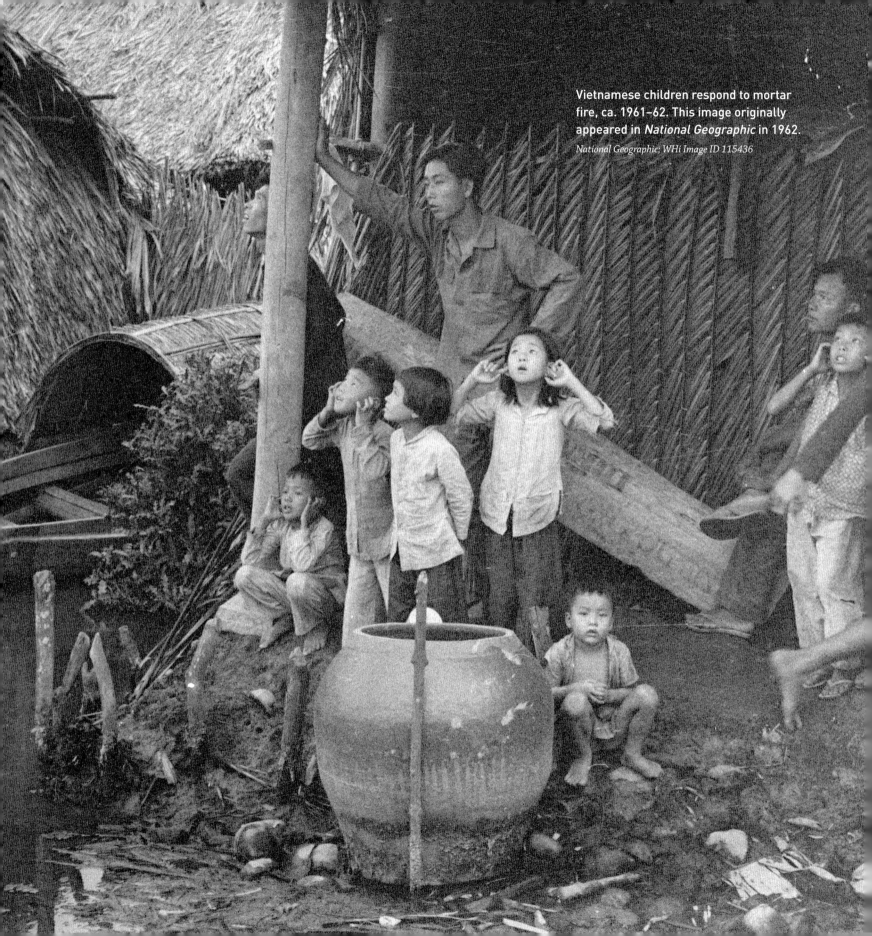

Vietnamese children respond to mortar fire, ca. 1961–62. This image originally appeared in *National Geographic* in 1962.

National Geographic; WHi Image ID 115436

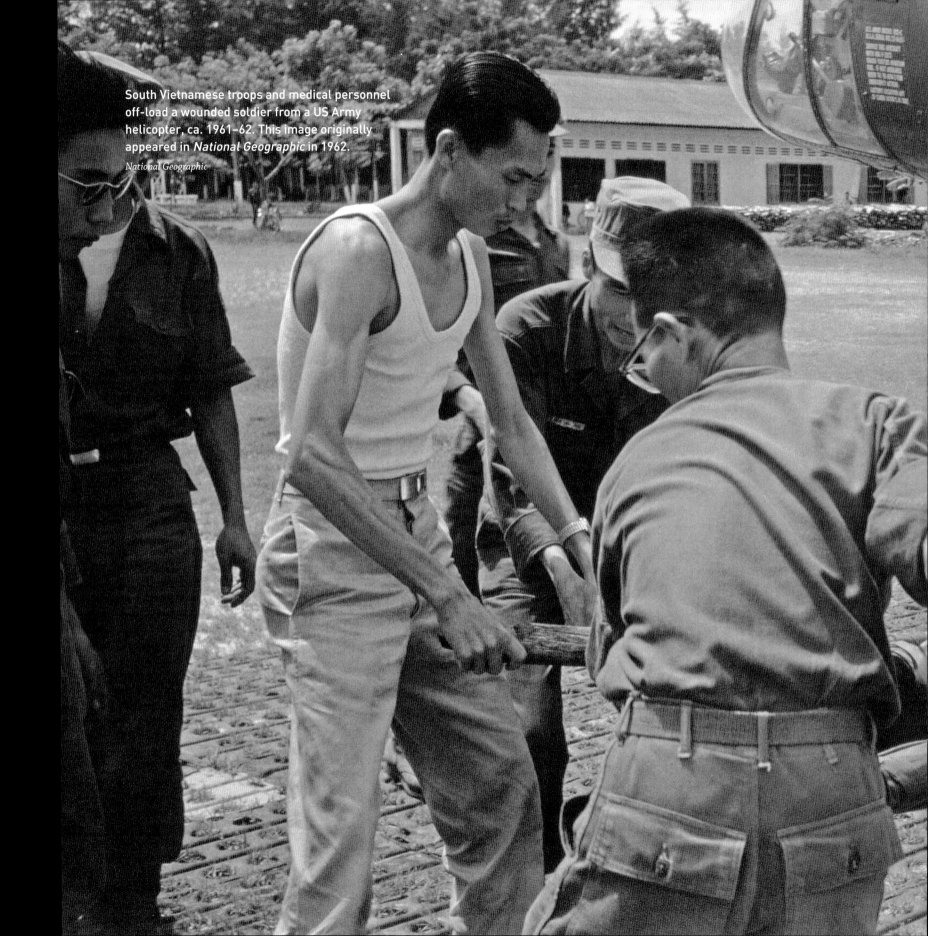

South Vietnamese troops and medical personnel off-load a wounded soldier from a US Army helicopter, ca. 1961–62. This image originally appeared in *National Geographic* in 1962.

National Geographic

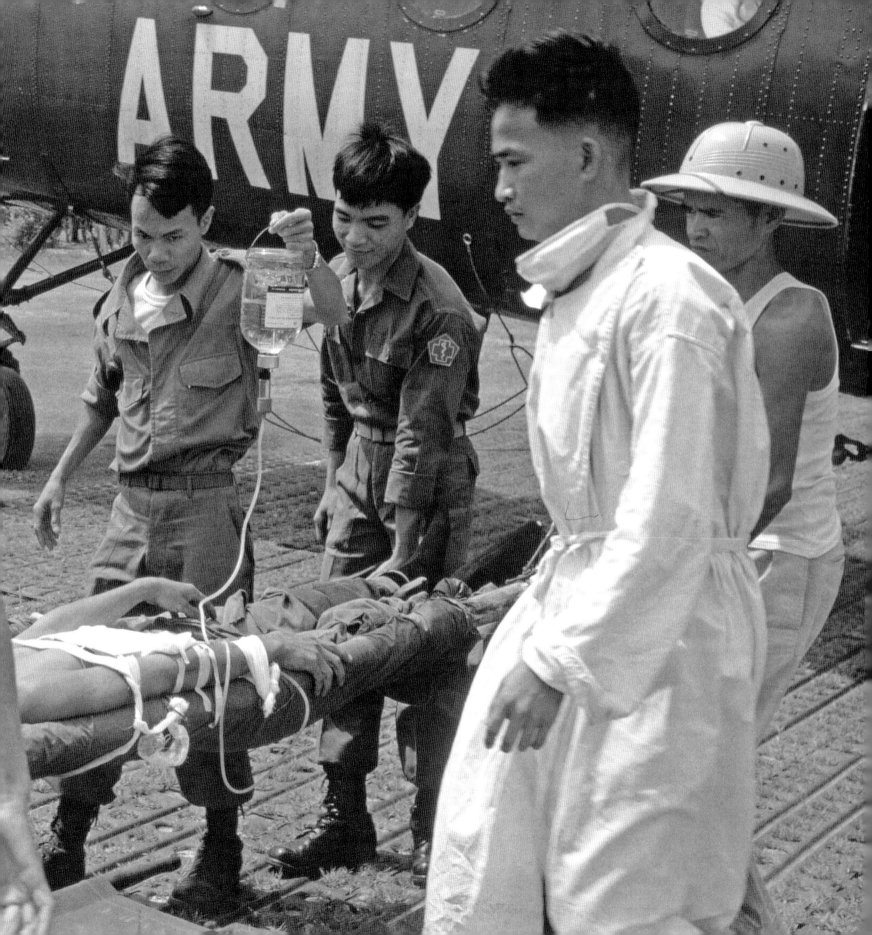

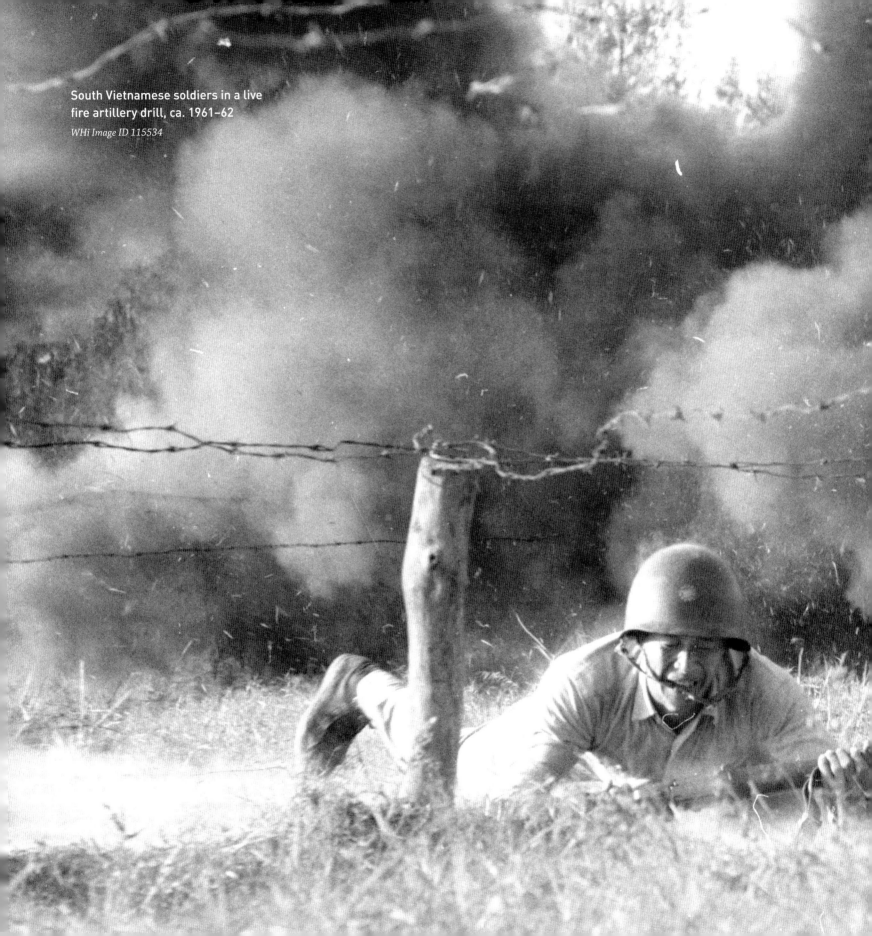

South Vietnamese soldiers in a live
fire artillery drill, ca. 1961–62

WHi Image ID 115534

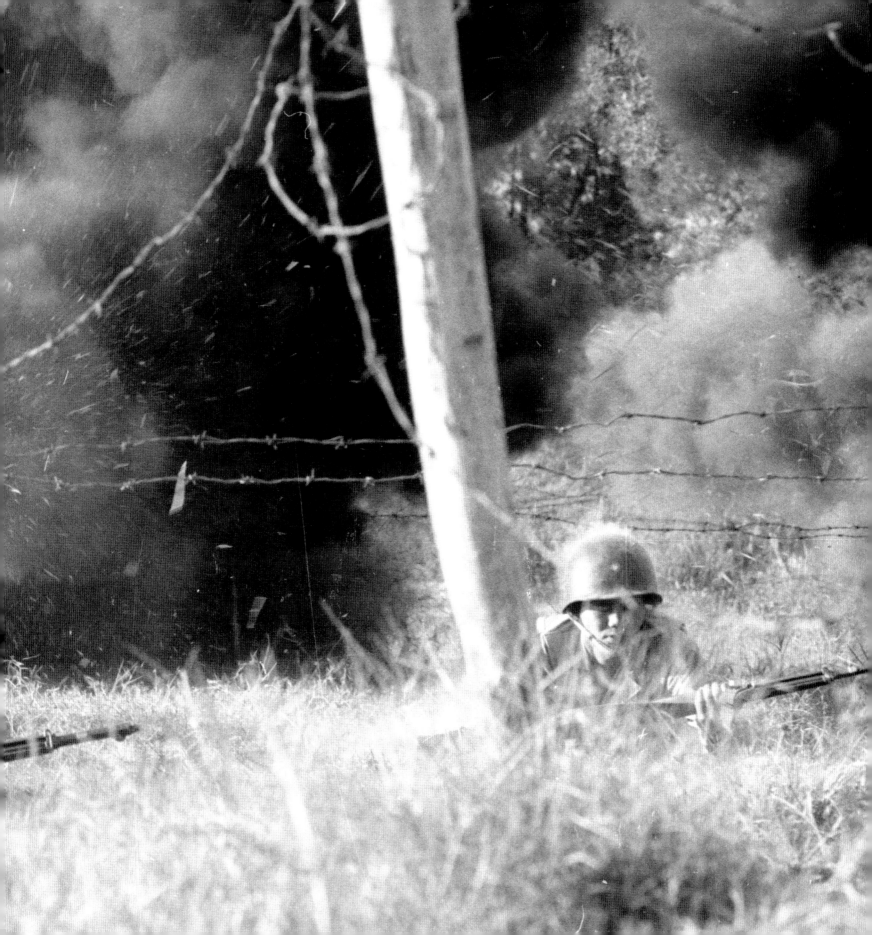

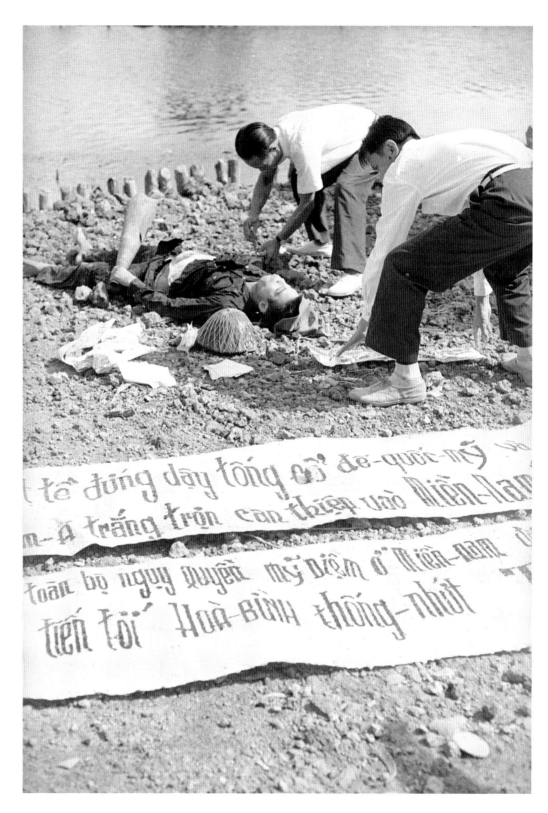

Vietnamese villagers with a dead
Vietcong attacker and banners of North
Vietnamese propaganda, which read
in part, "...must stand up to kick out
America...which is white intervention
in the South...," ca. 1961–62

WHi Image ID 115453

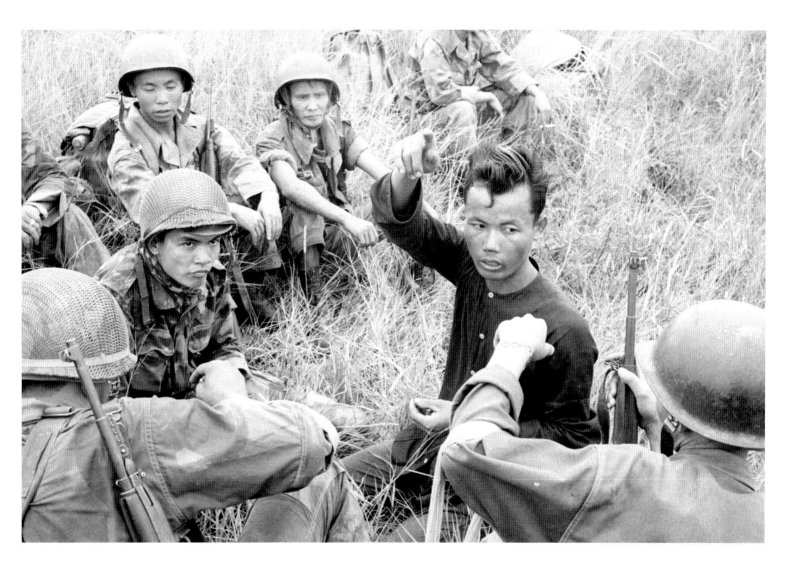

Vietnamese soldiers interrogate
suspected Vietcong, ca. 1961–62

WHi Image ID 115449

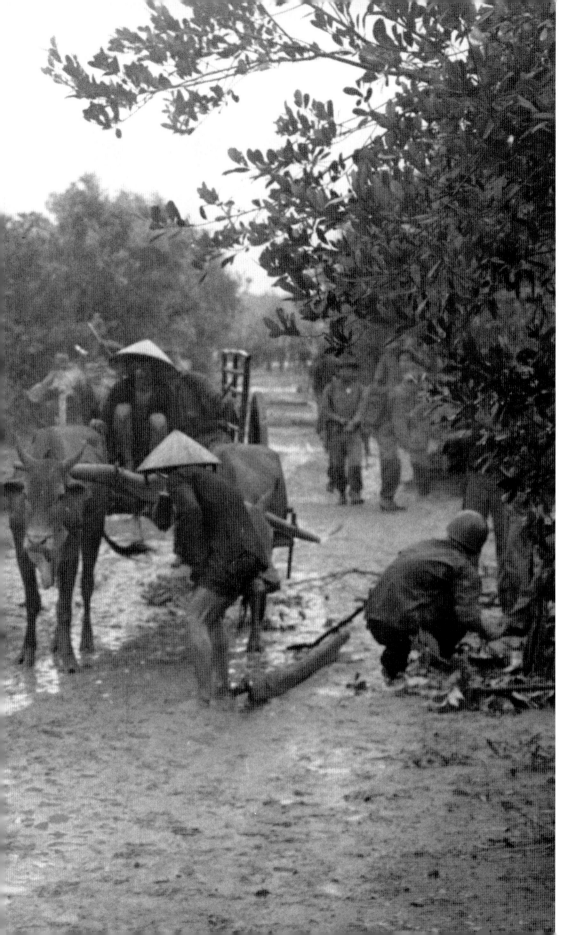

Water buffalo pull a cart near Vietnamese troops in the field, ca. 1961–62

WHi Image ID 115457

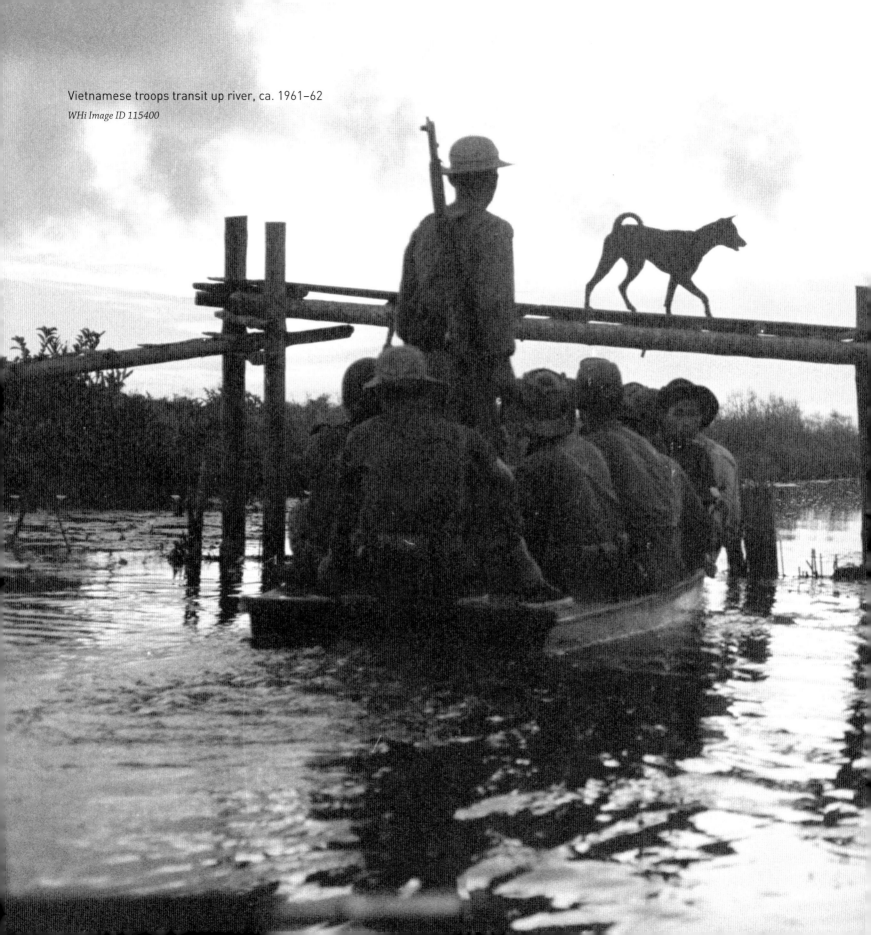

Vietnamese troops transit up river, ca. 1961–62

WHi Image ID 115400

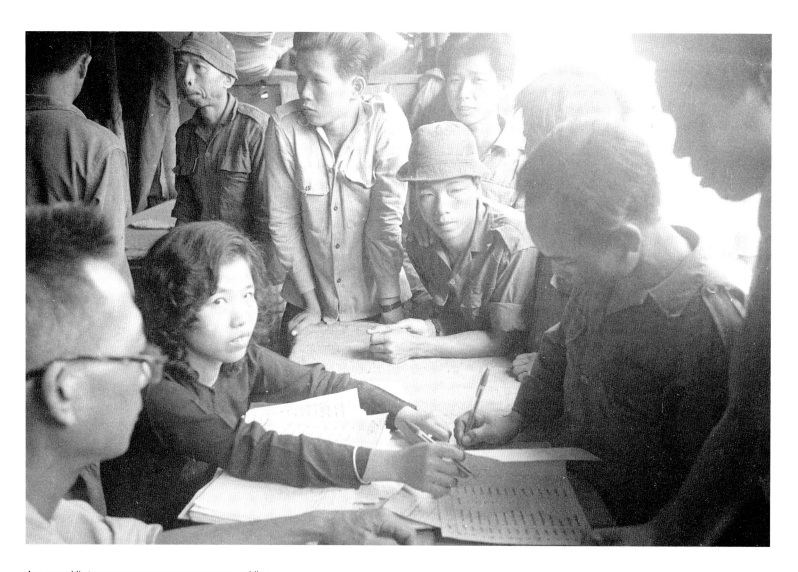

A young Vietnamese paymaster oversees Vietnamese
militia signing for their pay, ca. 1961–62

WHi Image ID 115468

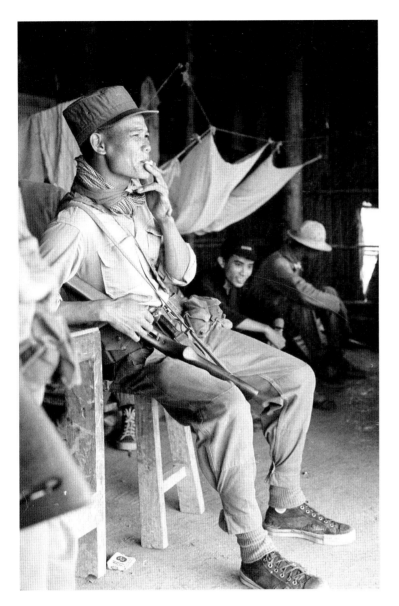

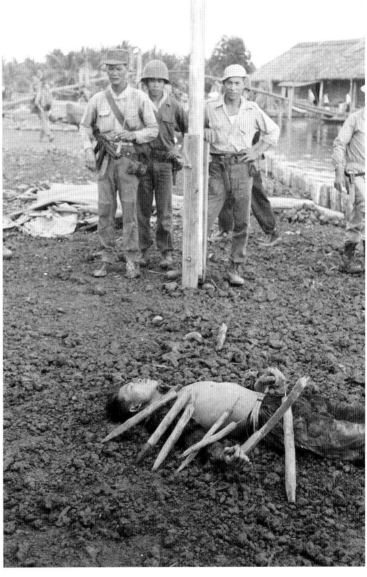

Left: A Vietnamese soldier takes a cigarette break, ca. 1961–62

WHi Image ID 115437

Right: Vietnamese soldiers display the body of a dead Vietcong arranged with the punji sticks— sharpened bamboo stakes sometimes doused with poison and used to make booby traps—he had been planting, ca. 1961–62

WHi Image ID 115394

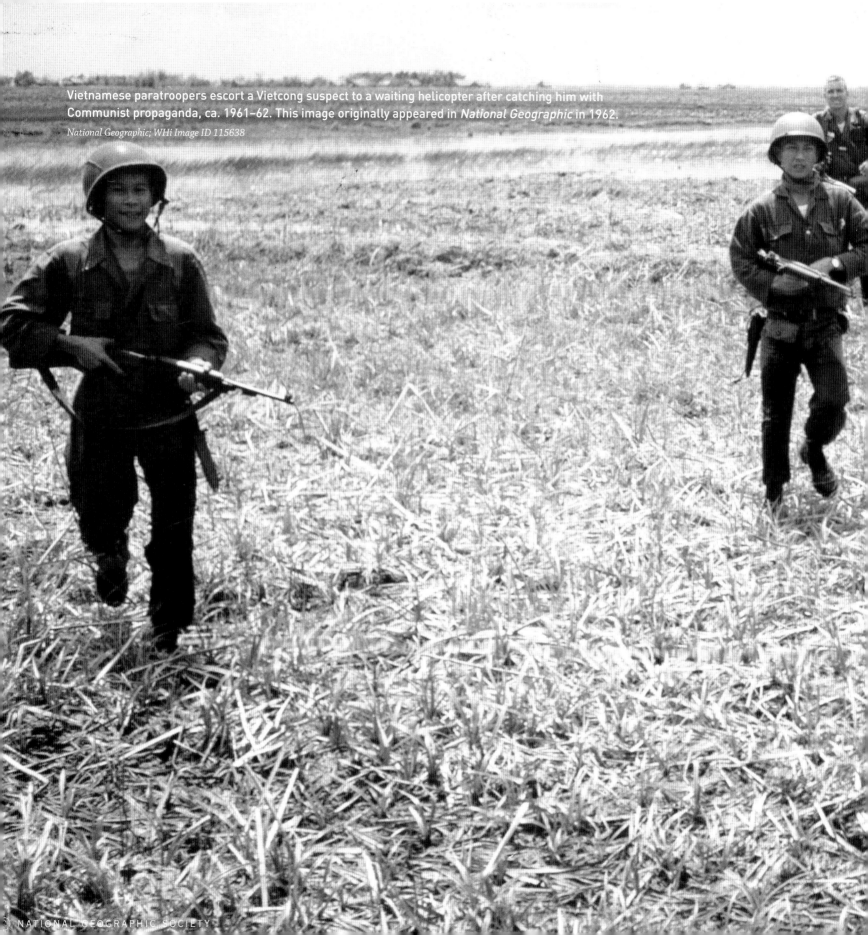

Vietnamese paratroopers escort a Vietcong suspect to a waiting helicopter after catching him with Communist propaganda, ca. 1961–62. This image originally appeared in *National Geographic* in 1962.

National Geographic; WHi Image ID 115638

NATIONAL GEOGRAPHIC SOCIETY

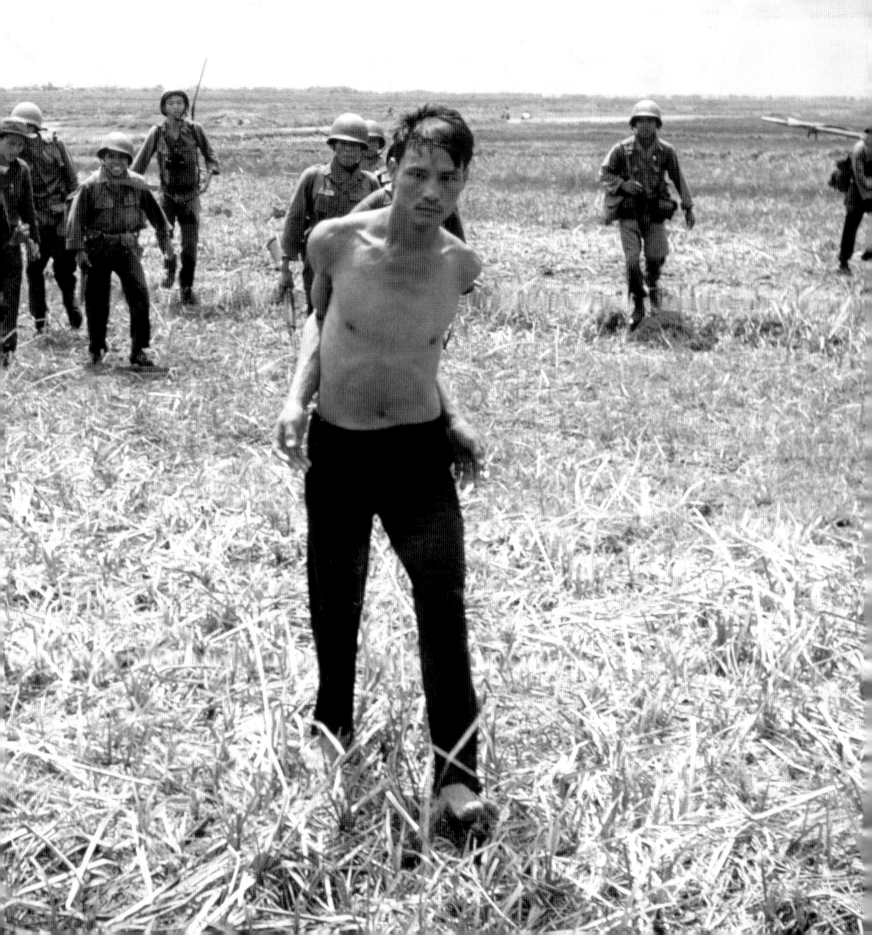

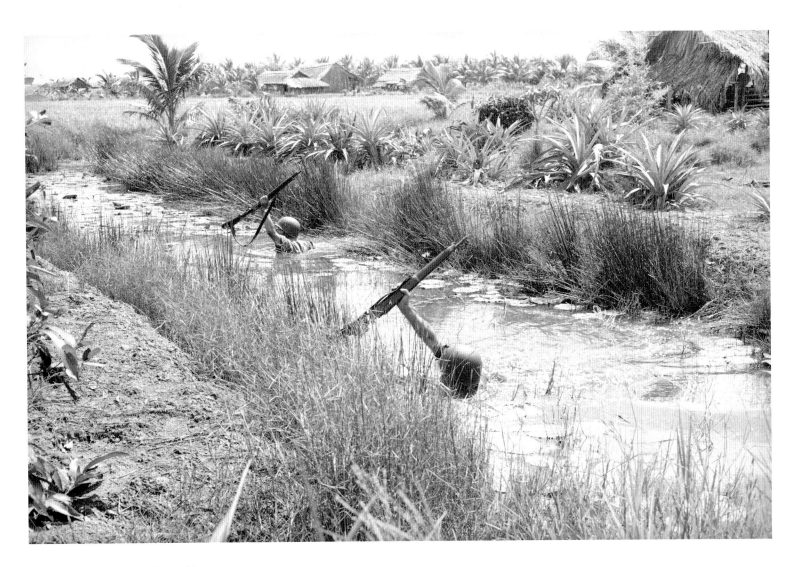

Vietnamese troops positioned in a stream
and ready to attack, ca. 1961–62

WHi Image ID 115460

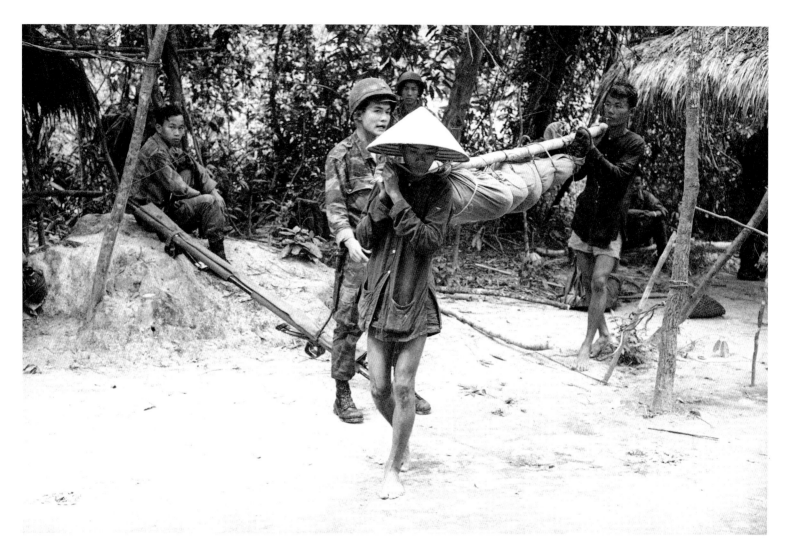

Villagers carry the body of fallen soldier, ca. 1961–62

WHi Image ID 115520

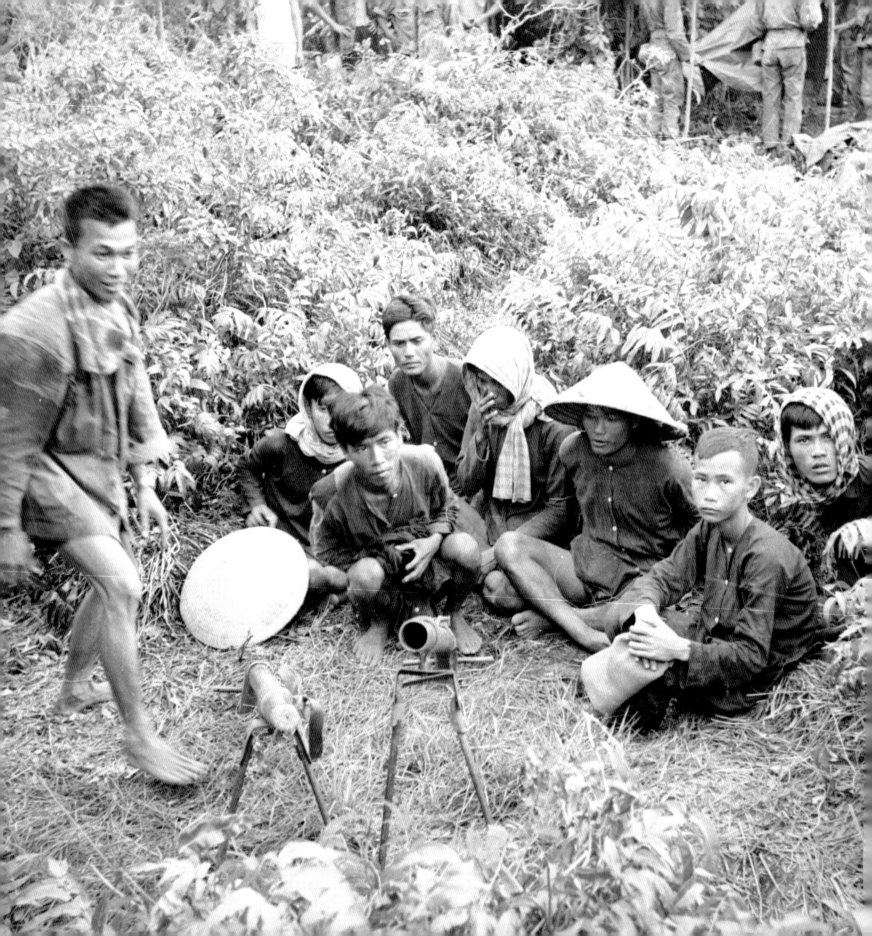

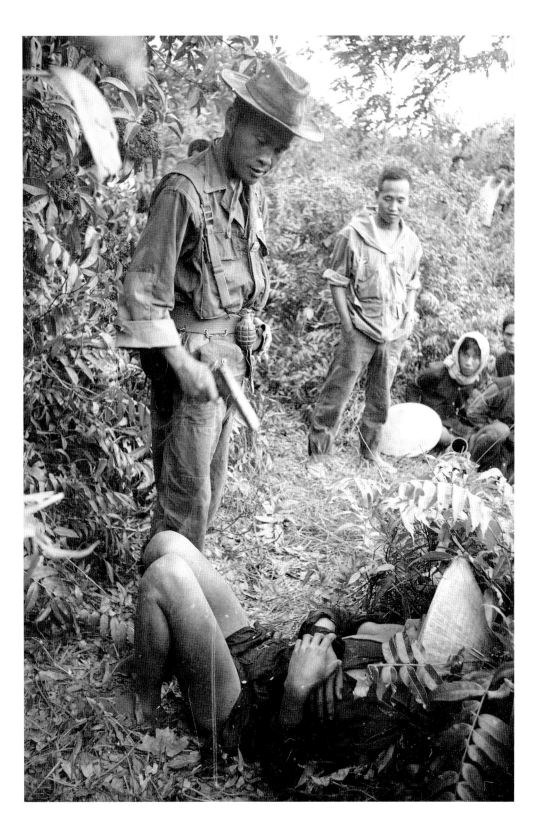

Left: South Vietnamese troops interrogate Vietcong, 1962

WHi Image ID 115474

Opposite: Captured Vietcong wait for interrogation, 1962

WHi Image ID 115477

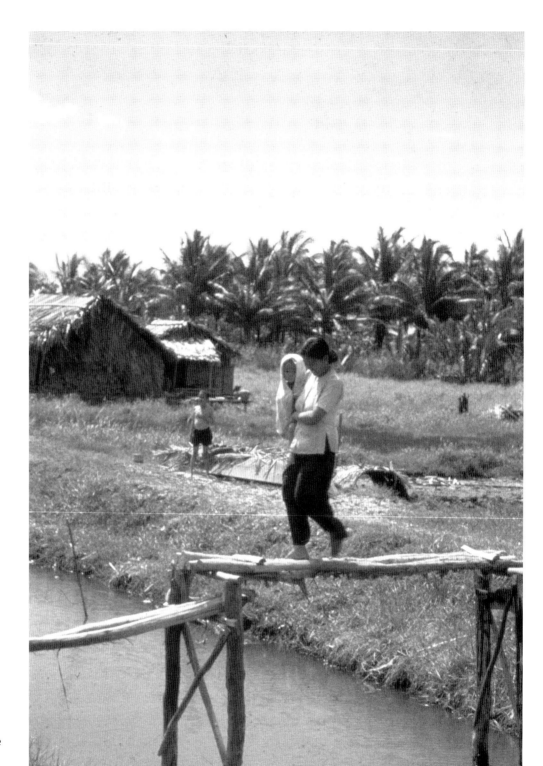

A woman and child cross a log footbridge over a canal in the Vietnamese countryside, ca. 1962

WHi Image ID 86884

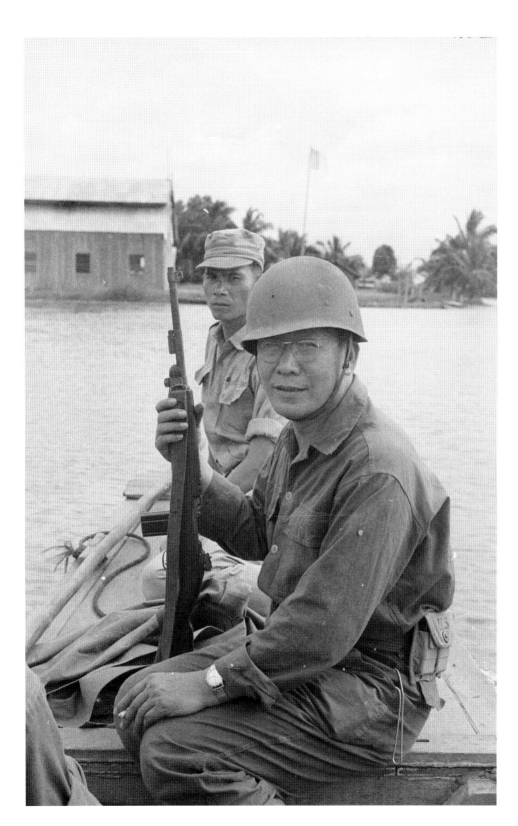

Father Hoa, known as the fighting priest of Vietnam, is shown here dressed for combat. Hoa set up a defensive perimeter near Binh Hung, Vietnam, and created his own militia, dubbed the "Sea Swallows." Chapelle's story of Father Hoa and the Sea Swallows appeared in a 1962 issue of *National Geographic*.

National Geographic; WHi Image ID 115398

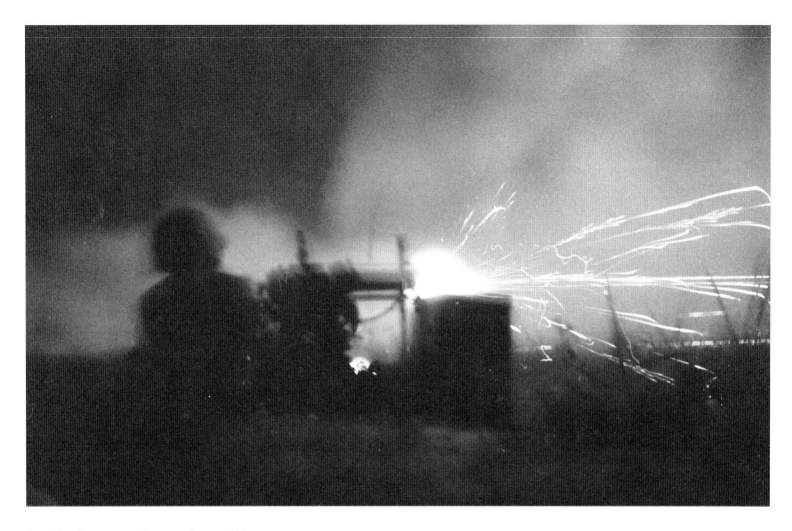

A soldier fires a machine gun, Laos, 1961

WHi Image ID 117211

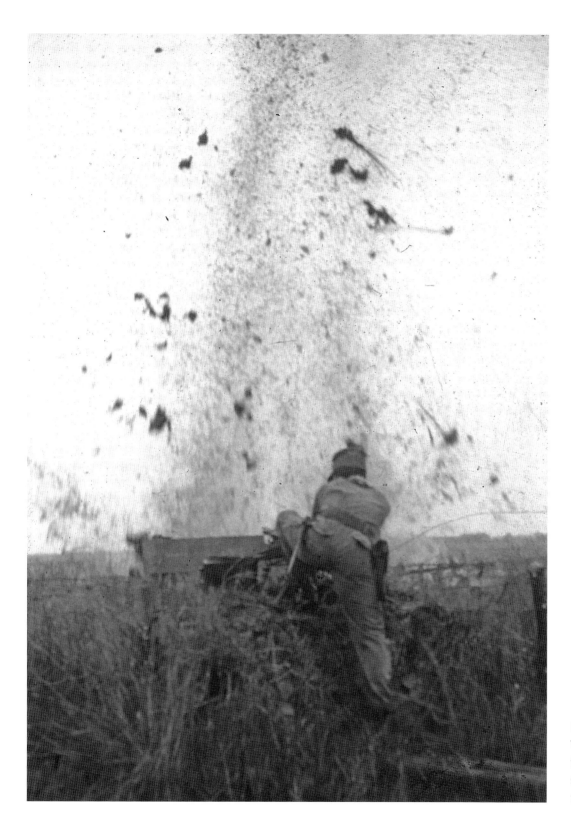

Members of the South
Vietnamese Sea Swallows militia
fire a mortar during a training
session at Binh Hung, 1961
WHi Image ID 116947

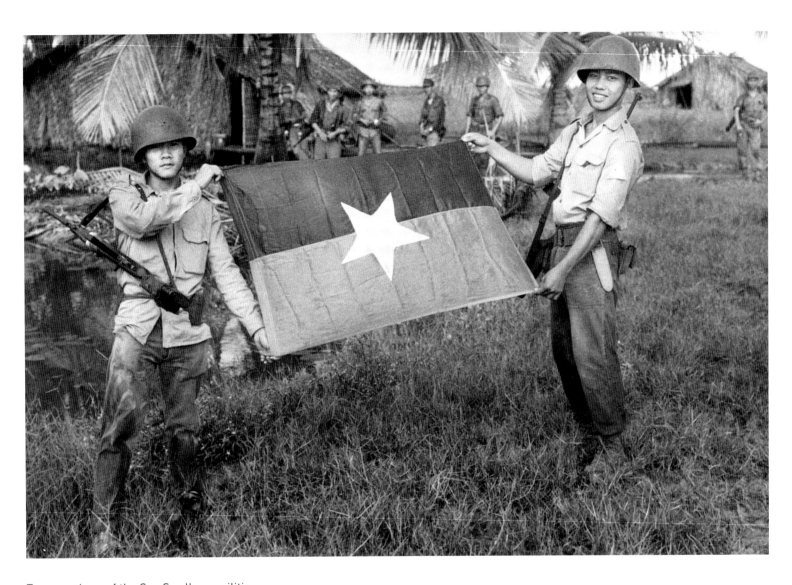

Two members of the Sea Swallows militia
display a captured Vietcong flag, ca. 1961–62

WHi Image ID 33127

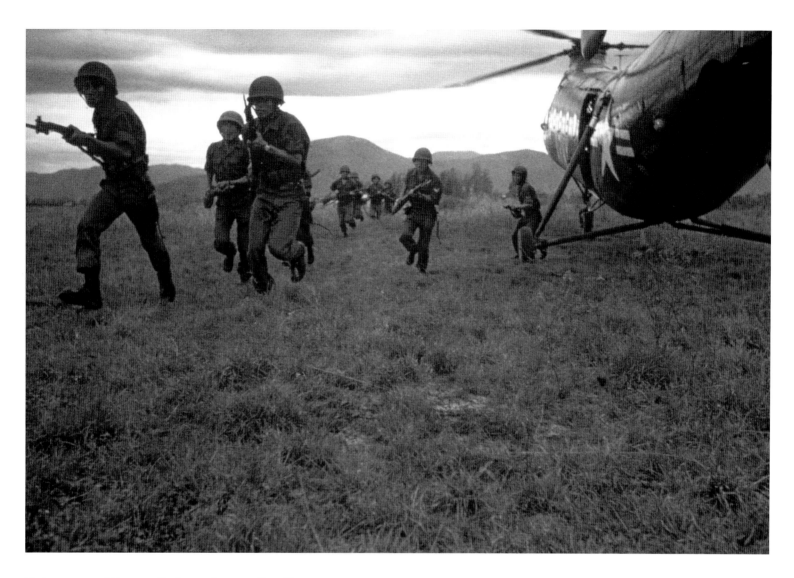

Vietnamese soldiers, on their way to assault a village
near Soc Tranh suspected of harboring Vietcong,
disembark from US Army helicopters, 1962

WHi Image ID 86868

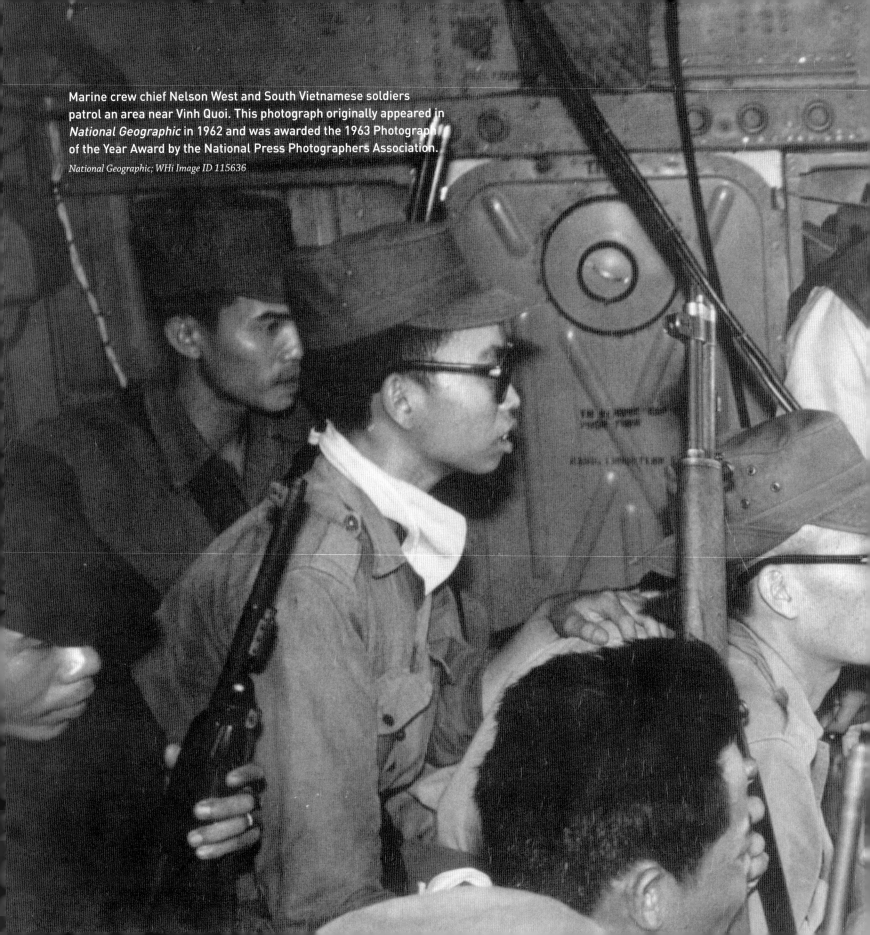

Marine crew chief Nelson West and South Vietnamese soldiers patrol an area near Vinh Quoi. This photograph originally appeared in *National Geographic* in 1962 and was awarded the 1963 Photograph of the Year Award by the National Press Photographers Association.

National Geographic; WHi Image ID 115636

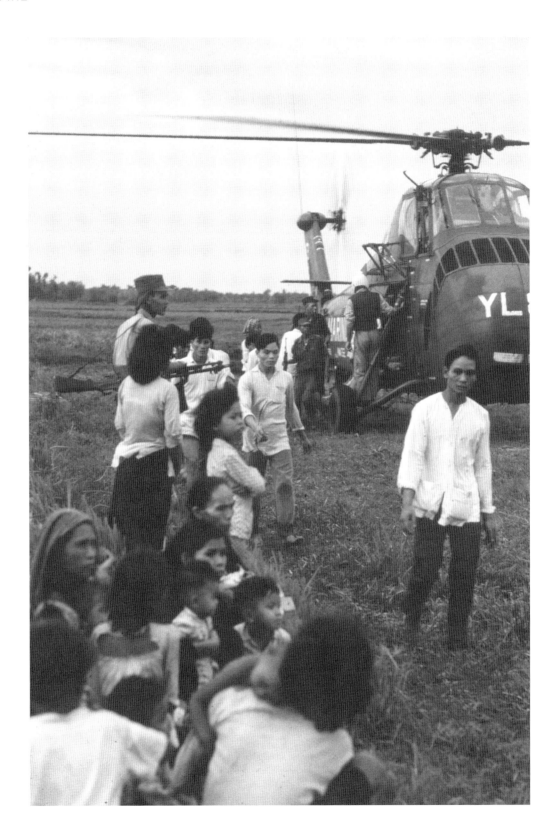

Survivors of a Vietcong attack on the village of Vinh Quoi gather around a US Marine helicopter that has arrived to airllift the villagers. This image originally appeared in *National Geographic* in 1962.

National Geographic; WHi Image ID 86711

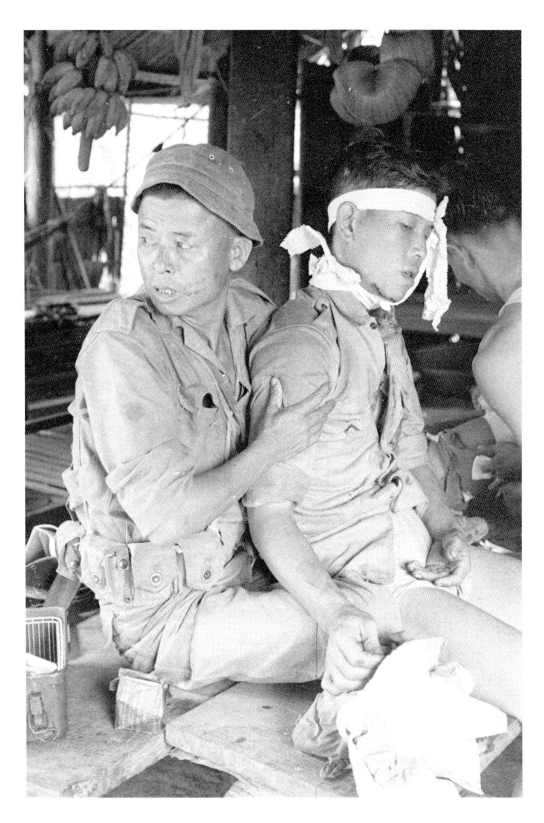

A Vietnamese soldier with his wounded
comrade, ca. 1961–64

WHi Image ID 115396

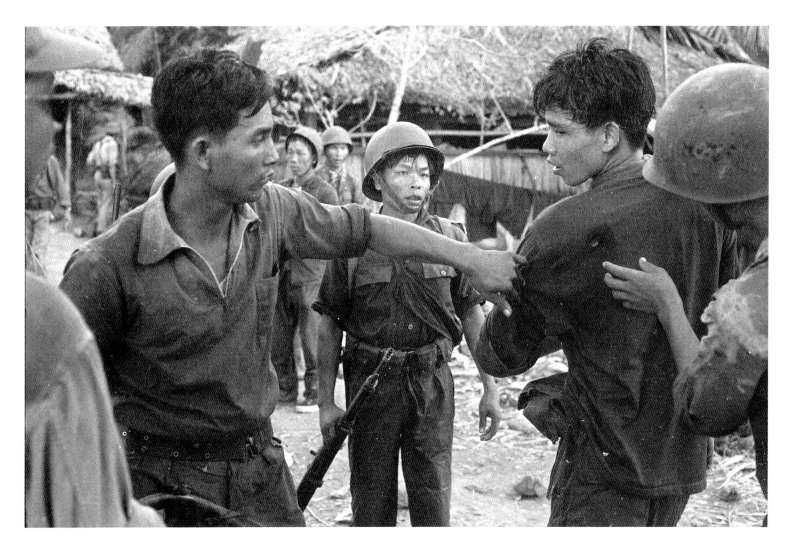

South Vietnamese soldiers inspect the
wound of a comrade, date unknown

WHi Image ID 115471

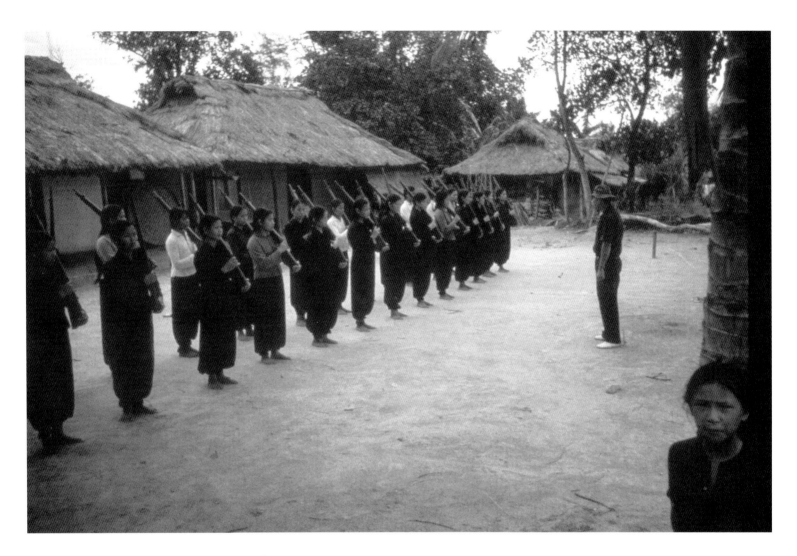

A group of Vietnamese women train with rifles
in a village near the Laotian border, ca. 1962

WHi Image ID 86762

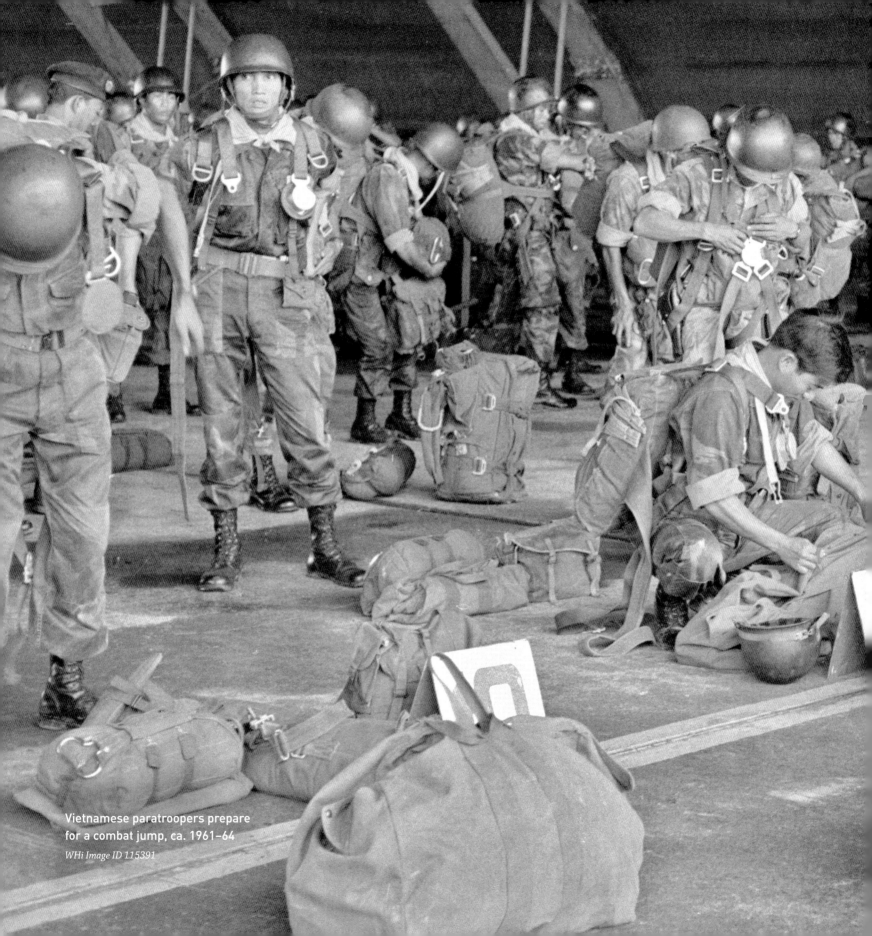

Vietnamese paratroopers prepare
for a combat jump, ca. 1961–64

WHi Image ID 115391

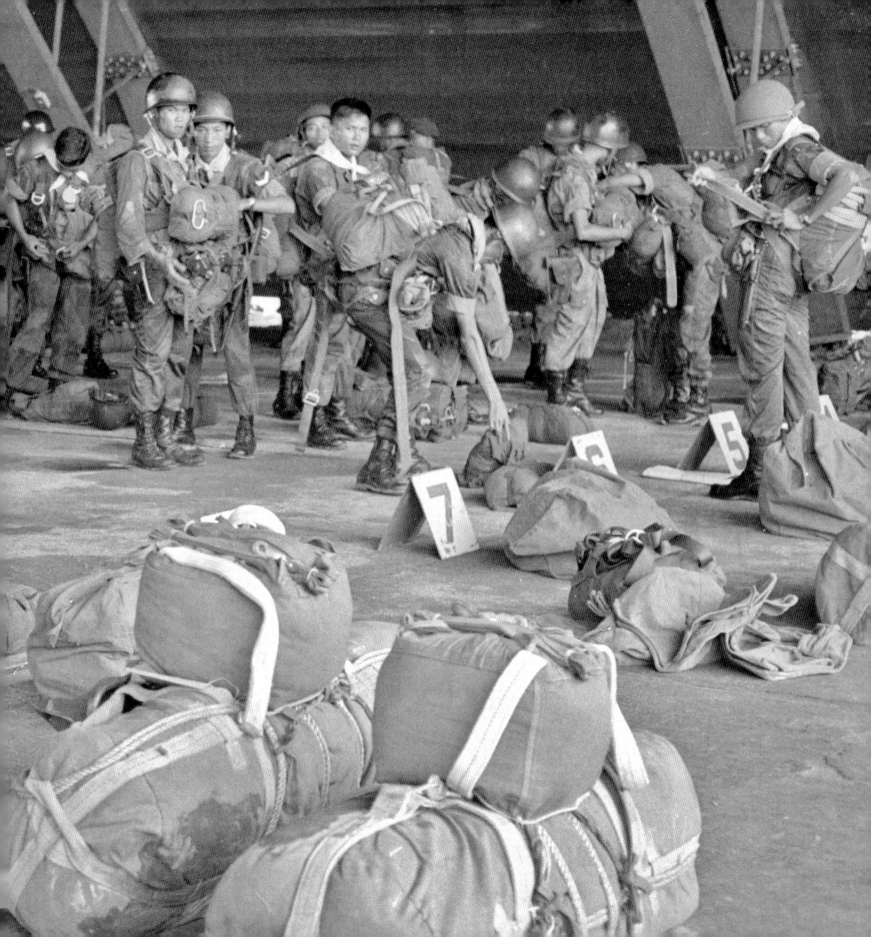

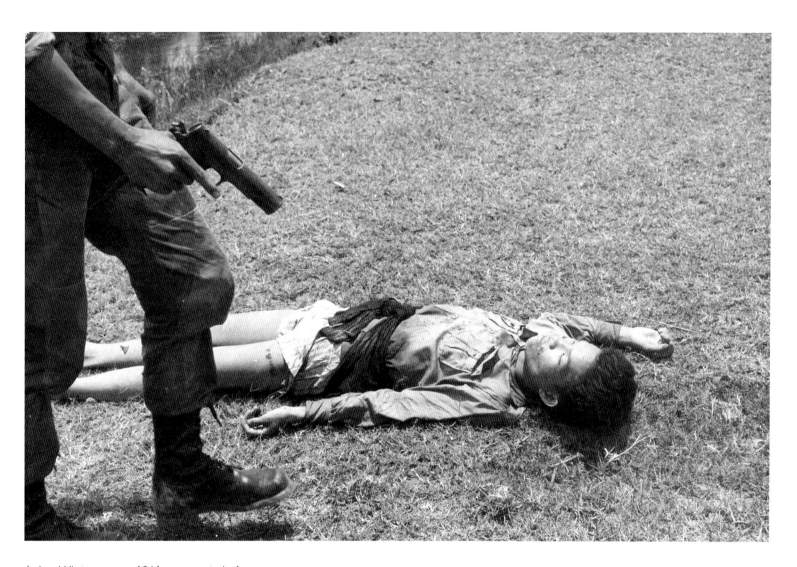

A dead Vietcong, ca. 1961; moments before
Dickey took this photo, the Vietnamese
paratrooper with the pistol shot him in the head.

WHi Image ID 32771

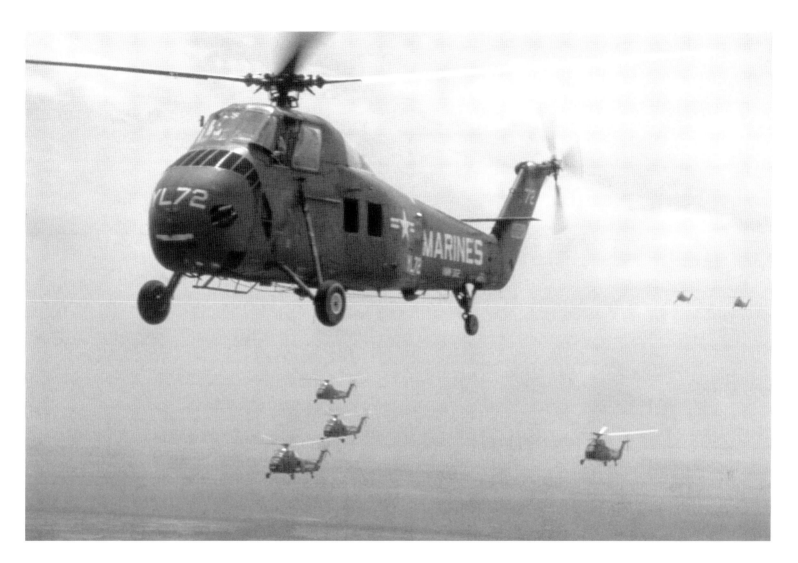

A squadron of Marine helicopters flies over
Vietnam, ca. 1964. This image originally
appeared in *National Geographic* in 1966.

National Geographic; WHi Image ID 86877

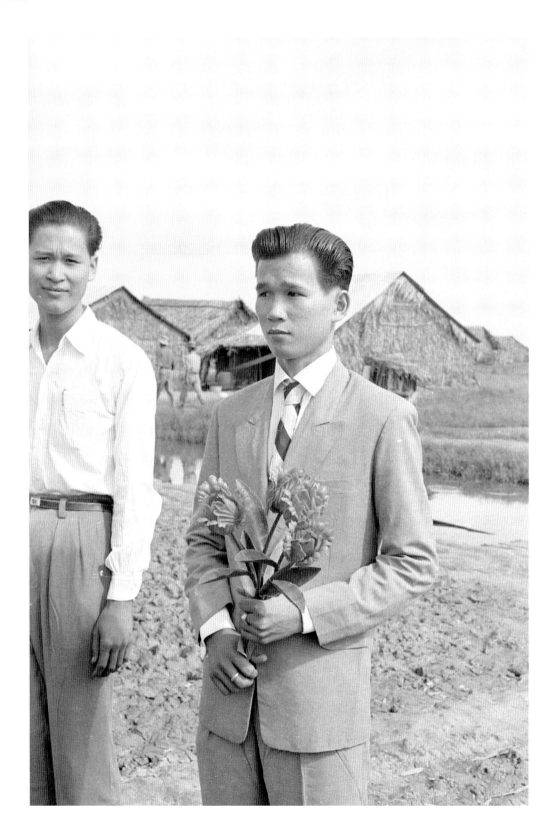

A squad leader in the Vietnamese army on his wedding day in the village of Binh Hung, 1961

WHi Image ID 115395

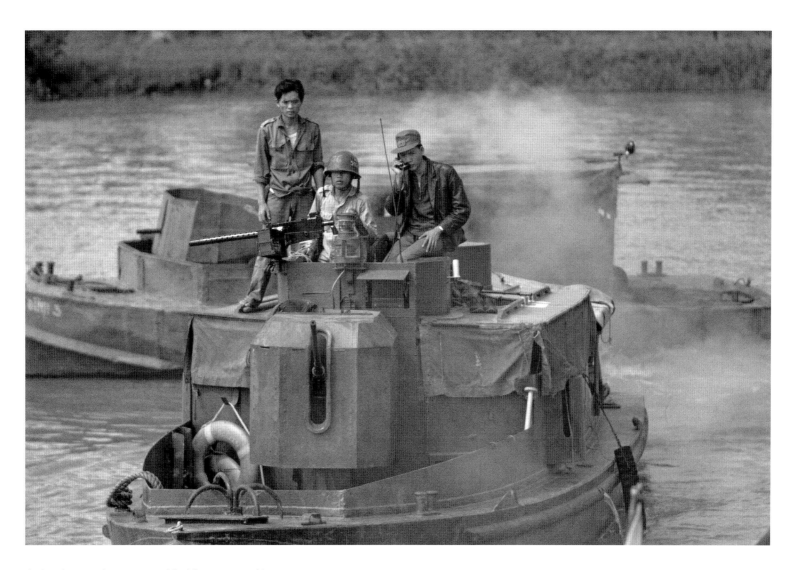

A riverine gunboat steered by Vietnamese Navy
with US Navy advisors, 1964. This image originally
appeared in *National Geographic* in 1966.

National Geographic

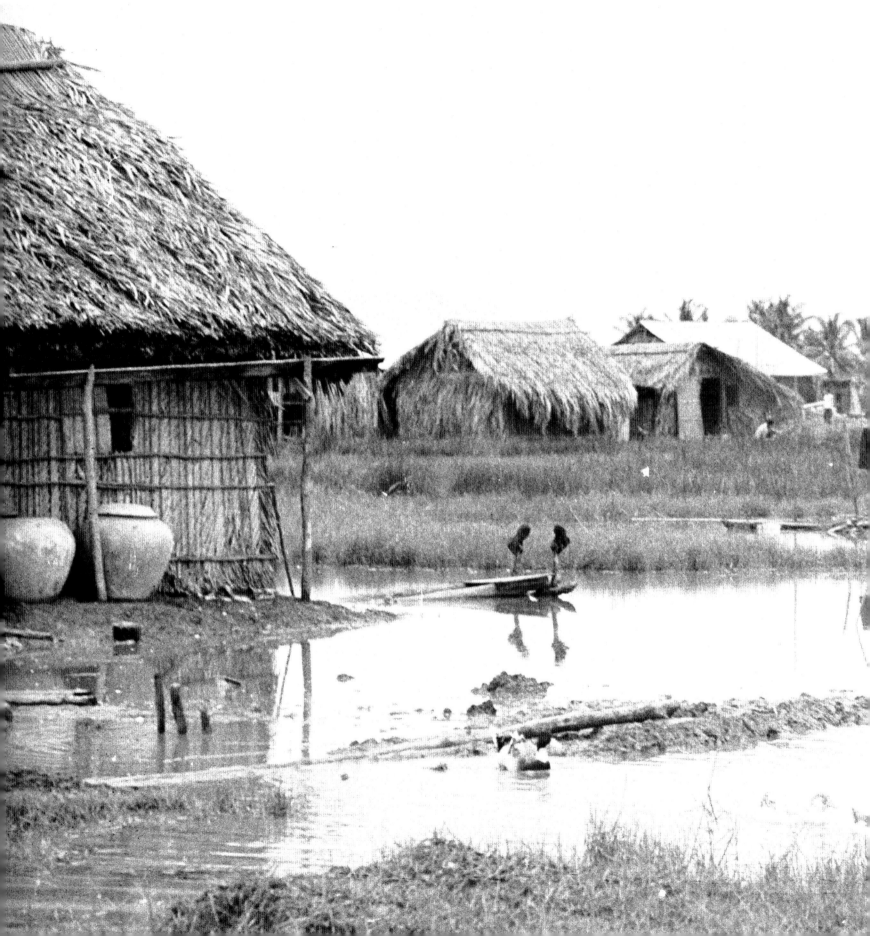

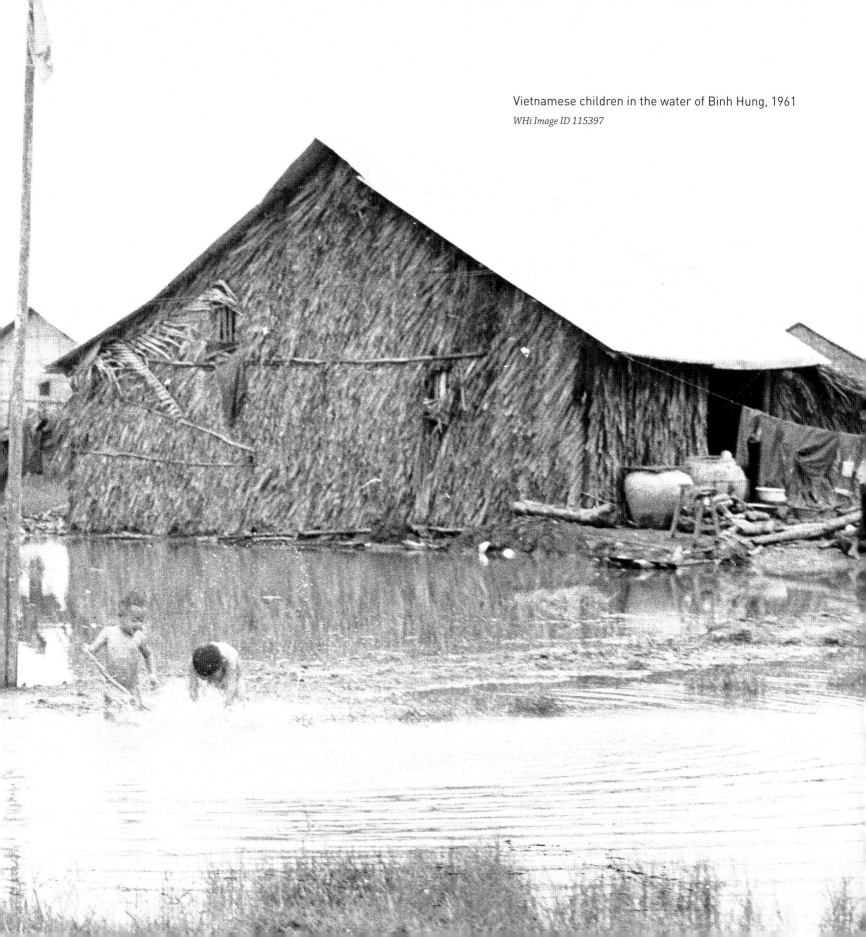

Vietnamese children in the water of Binh Hung, 1961

WHi Image ID 115397

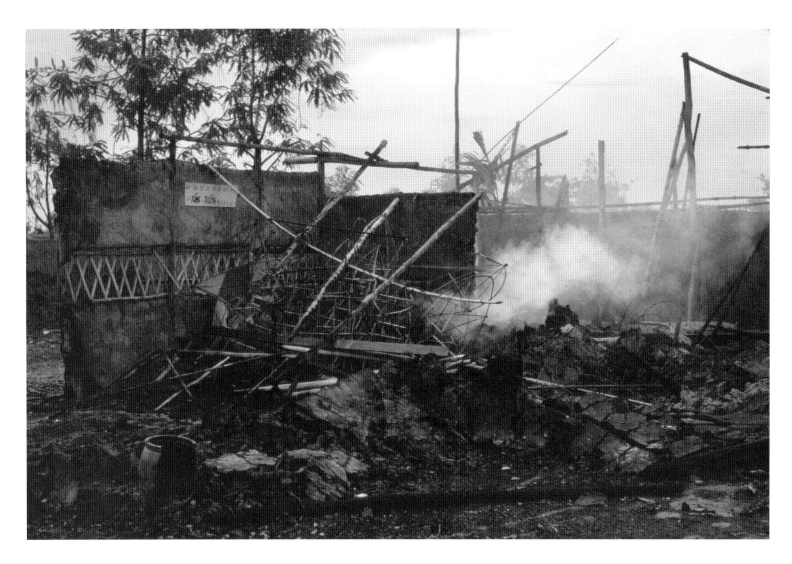

Smoking rubble from a building destroyed
by South Vietnamese Marines, 1962

WHi Image ID 86391

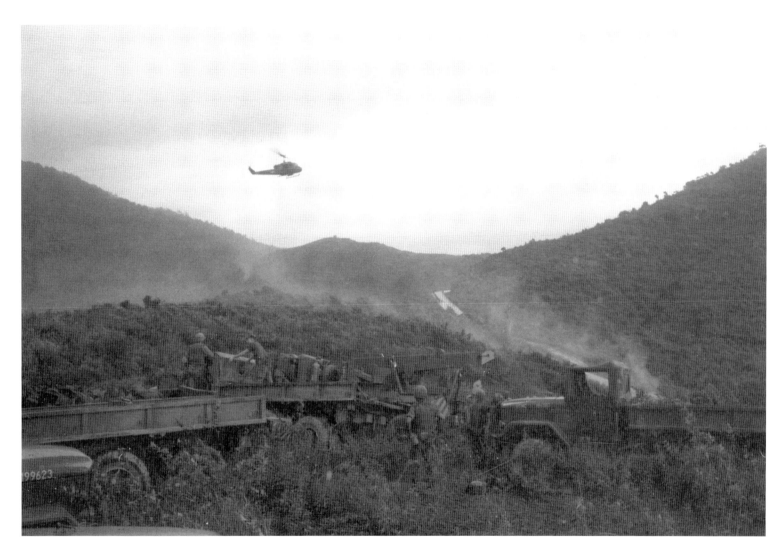

A lone helicopter flies over
troops hauling cargo, 1965

WHi Image ID 115870

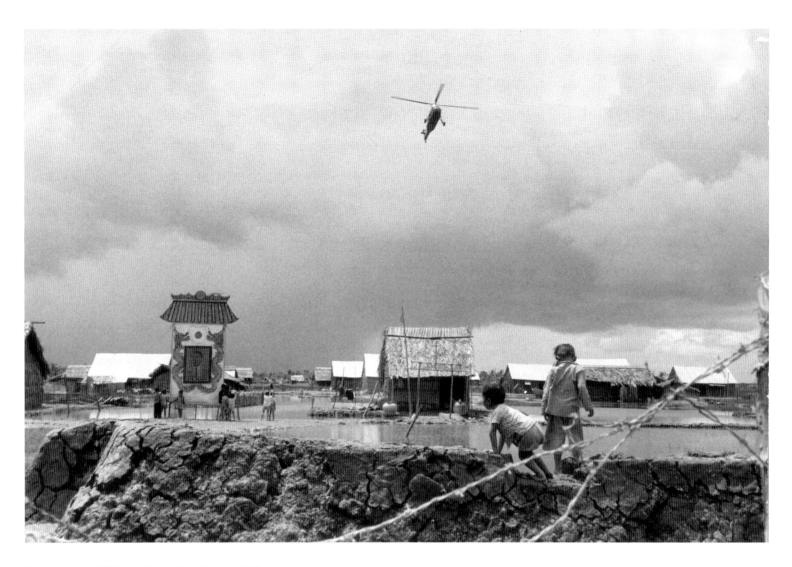

Vietnamese children play in the village of Binh Hung
as a US helicopter flies overhead, ca. 1961–65

WHi Image ID 115612

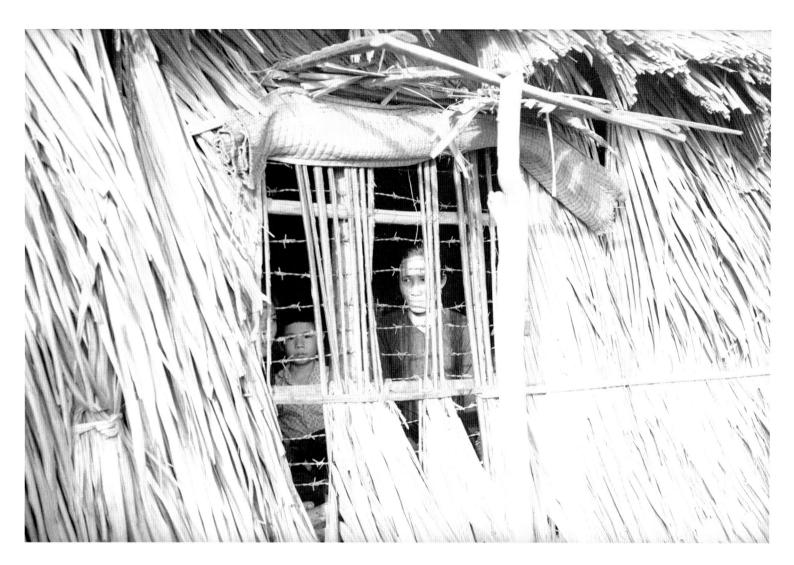

Villagers look out from behind
barbed wire, ca. 1961–65

WHi Image ID 115399

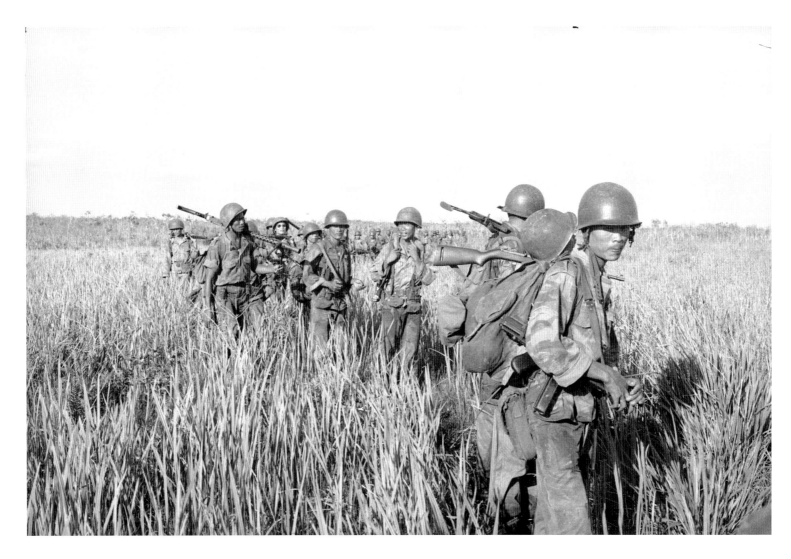

Vietnamese troops move through
razor grass field, ca. 1961–65

WHi Image ID 115522

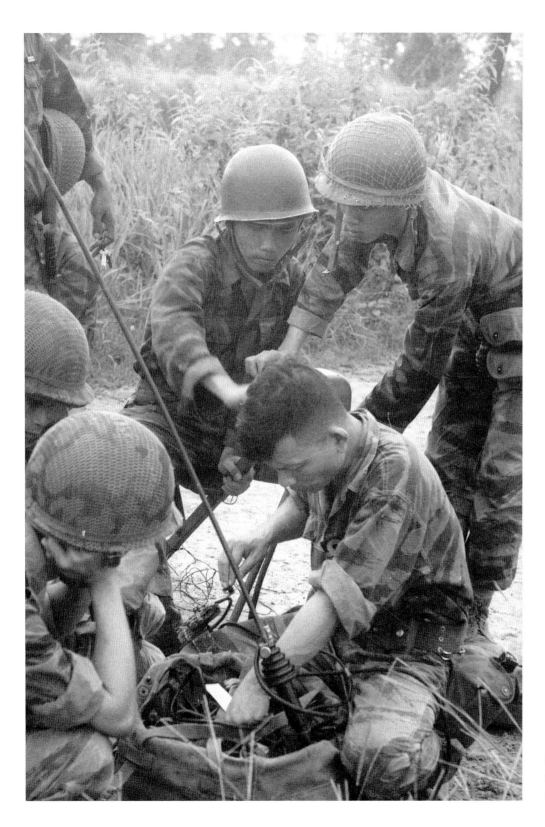

South Vietnamese troops operating a
radio in the field, ca. 1961–65

WHi Image ID 115463

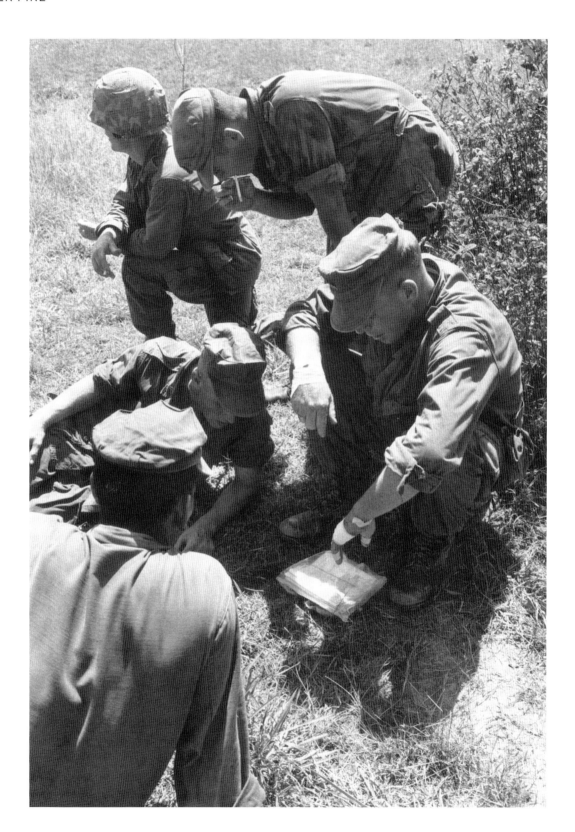

Marines in the field pause to consult
the map, 1965

WHi Image ID 115707

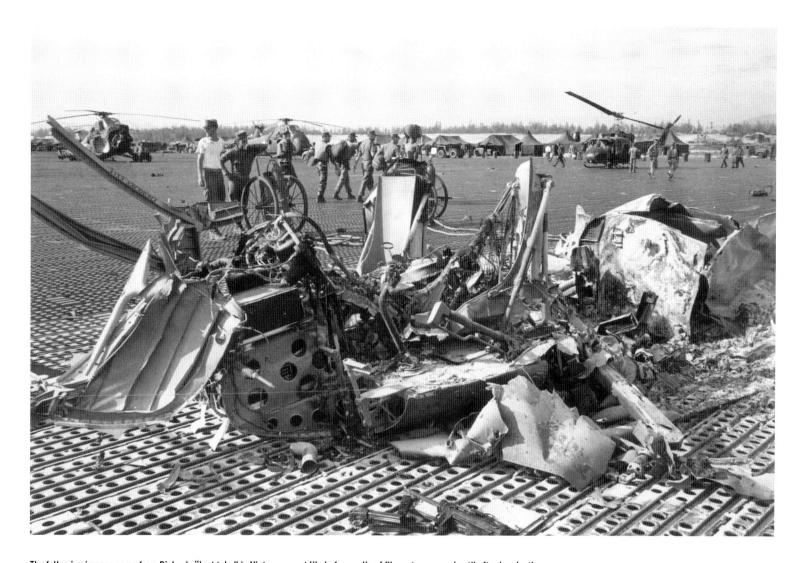

The following images come from Dickey's "last take" in Vietnam, most likely from rolls of film not processed until after her death.

The wreckage of a crashed US helicopter at
an airbase in Vietnam, 1965

WHi Image ID 115610

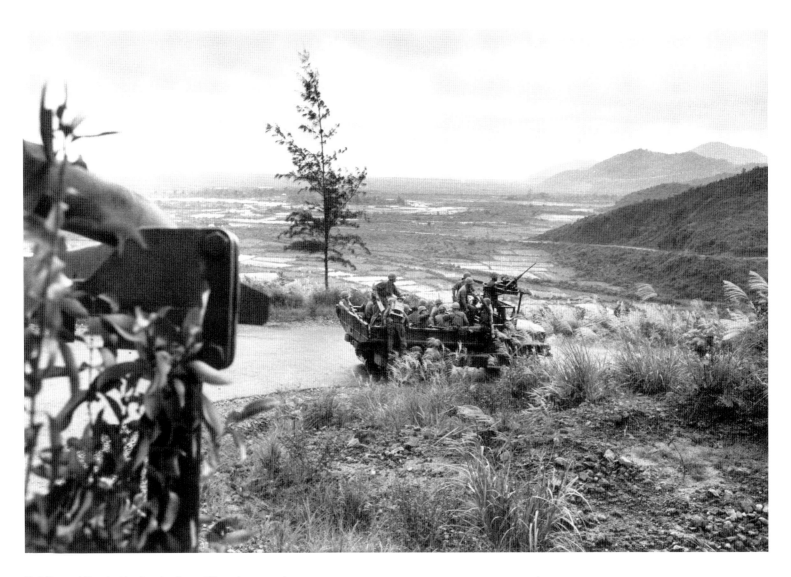

Soldiers riding in the back of a military transport
truck along a hillside road, ca. 1961–65

WHi Image ID 115592

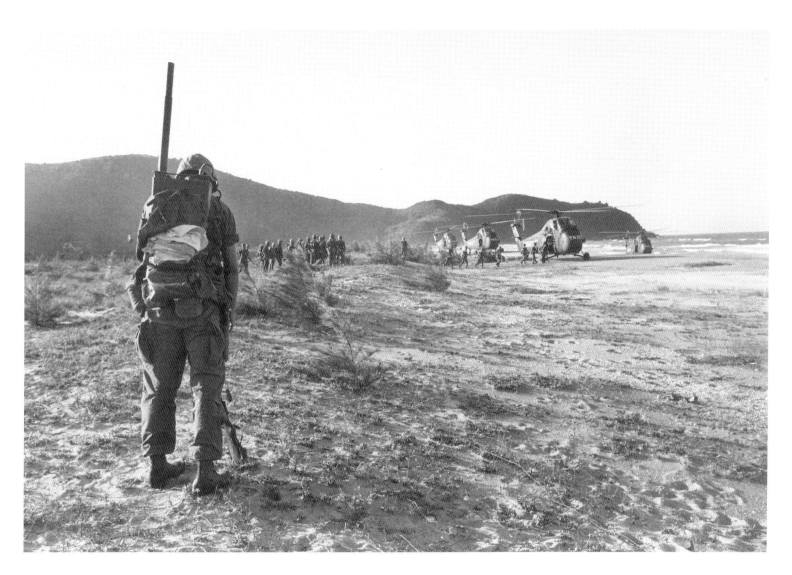

Marines wait to load helicopters, 1965

WHi Image ID 115597

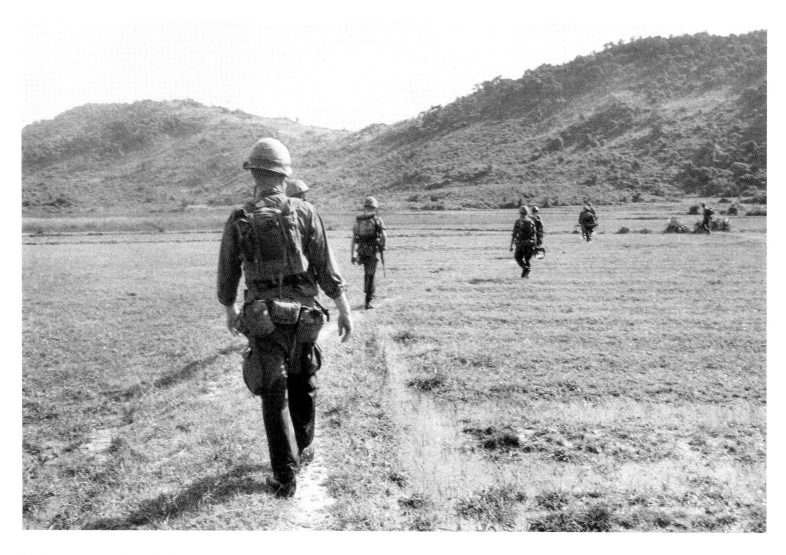

Marines on a search-and-clear
operation near Da Nang, 1965

WHi Image ID 115608

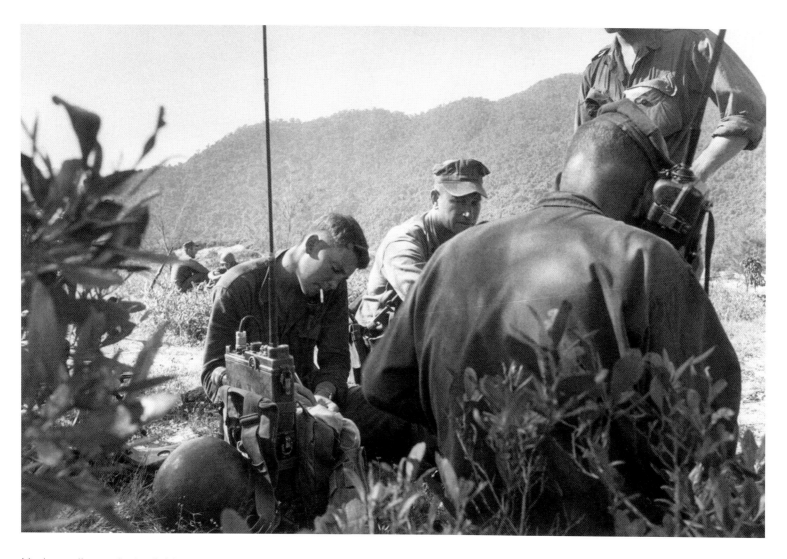

Marine radiomen in the field
checking their equipment, 1965

WHi Image ID 115595

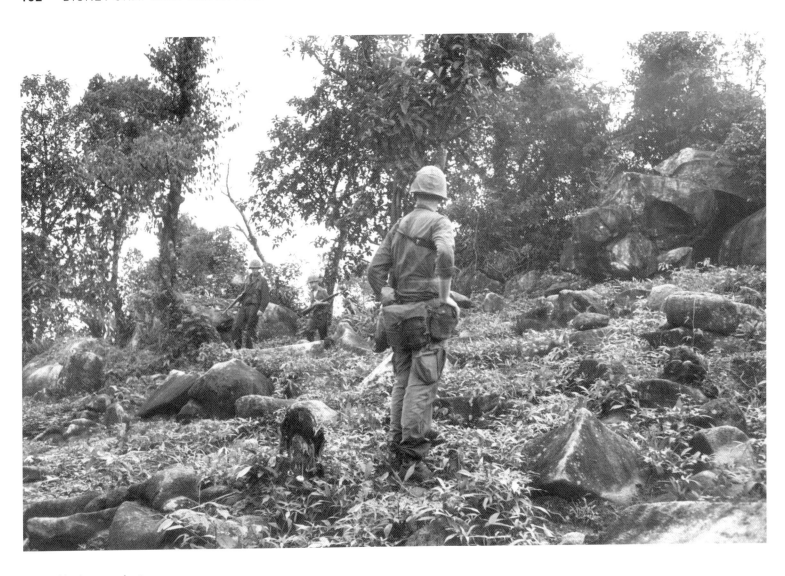

Three Marines navigate a
rocky hillside, 1965

WHi Image ID 115594

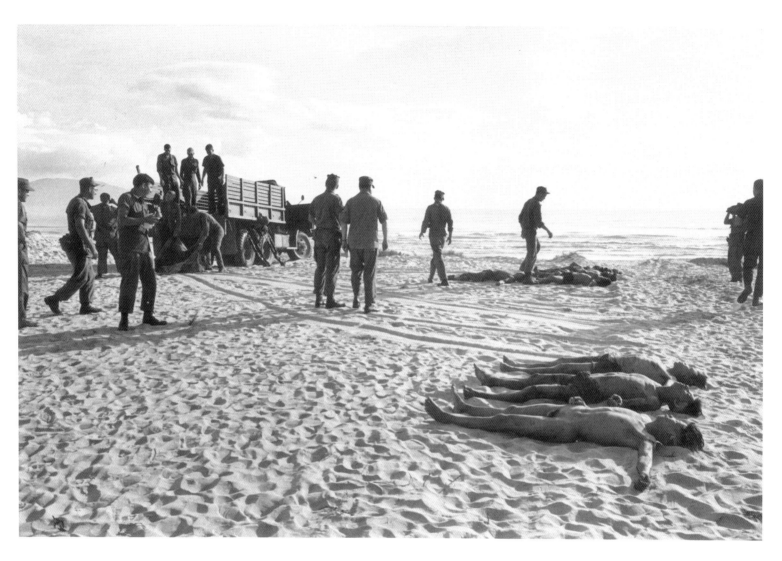

The bodies of dead Vietcong soldiers
are lined up for a body count, 1965

WHi Image ID 115615

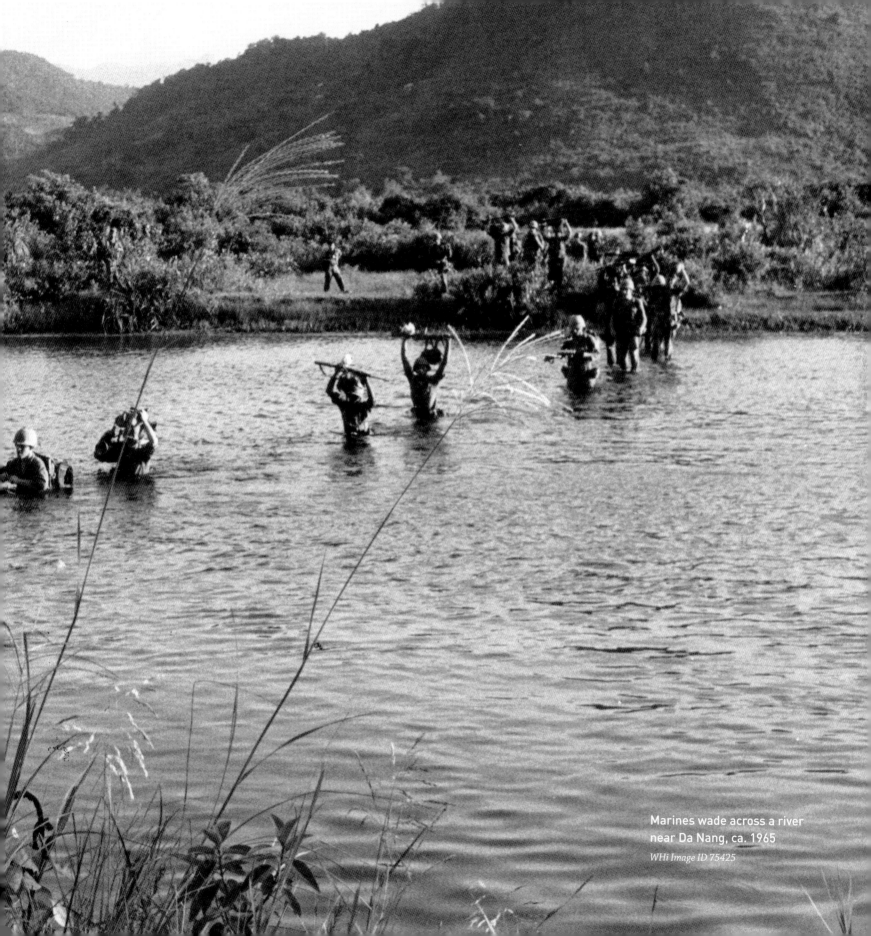

Marines wade across a river
near Da Nang, ca. 1965

WHi Image ID 75425

Epilogue

I hope there will be no mourning for me because you, my beloved family,

have seen that I have lived to enjoy deeply most of my entire life.

—Dickey Chapelle, from her handwritten will, dated November 14, 1956

Dickey's body was flown to Milwaukee with a Marine escort, a rare honor for a civilian, and she was buried at Forest Home Cemetery with full military honors. Her possessions, returned to her family by the Marine Corps, included an extra set of combat fatigues, the Australian bush hat she was wearing at the time of her death, at least one camera, and a few rolls of film. These items remained in a box in the attic of her brother's home in Madison, Wisconsin, for decades.

One year after her death, the Marines dedicated a field hospital near Chu Lai in Dickey's memory. The Marine Corps League created the Dickey Chapelle Award, which it gives out to this day, in recognition of women who contribute to the morale, welfare, and well-being of the Marine Corps. Among the attendees at the 1967 Marine Corps League dinner were noted Vietnam photographer Larry Burrows, actor Lee Marvin, and the award's first recipient, comedian Martha Raye.

Four years later Burrows and three other reporters were killed when their helicopter was shot down over Laos.

Accompanying Burrows was Henri Huet, whose final photograph of Dickey Chapelle had turned out to be eerily prophetic.

Real fame eluded Dickey during her career. But she left a tangible legacy. She fought against conformity when women were expected to adhere to rigid gender norms. She fought the military, demanding to be treated like every other reporter, regardless of her gender. She fought to earn a living despite making less money than men. She was willing to work harder, stay longer, and dig deeper to get her stories. And throughout her career, she fought her way into situations that could have gotten her killed.

■ ■ ■

Modern-day war correspondents have been reporting from battlefields around the world since the Crimean War in 1854, and they have been risking their lives ever since. Dickey Chapelle stands in the company of Ernie Pyle, Robert Capa, and many, many others who have died while trying to

document the truths of war. Pyle, the Pulitzer Prize–winning "roving correspondent," was killed by a sniper during World War II. In 1954 Capa, the Hungarian-born American photographer, became the first reporter from the United States to be killed in Vietnam. In all, as many as 135 war correspondents were killed while reporting the conflict in Southeast Asia.

Dickey Chapelle may have been the first American female war correspondent killed in action, but she wasn't the last to face harm. In 1967 reporter Phillipa Schuyler died in a non-combat helicopter crash in Vietnam. In 2012 American journalist Marie Colvin died while reporting on the civil war in Syria, killed by an improvised explosive device loaded with nails. In 2011 CBS News correspondent Lara Logan was sexually assaulted while reporting on the Arab Spring uprising in Egypt. In that same year, photographer Lynsey Addario was captured by the Libyan army and repeatedly assaulted. Many more reporters of many nations, covering many present-day wars, continue to be captured, tortured, and killed for their trouble.

According to Reporters Without Borders, eighty journalists were killed while reporting on wars and conflicts in 2013 alone. Dickey Chapelle was an unfortunate trailblazer, remaining the sole American female war correspondent killed in action for forty-seven years until Marie Colvin became the second.

And yet, for reporters like Dickey the work is both a calling and a compulsion.

"Good correspondents are created out of the simple compulsion to go see for themselves what is happening . . . ," Dickey wrote in her autobiography. "Other people have other missions—they can fight or halt or persuade or negotiate or barter or build or write symphonies. You may be free to do all those things or none, but what matters is that you keep your eyes open. If you call yourself a correspondent, your reason for being is first to see.

"And then, of course, to tell." ∎

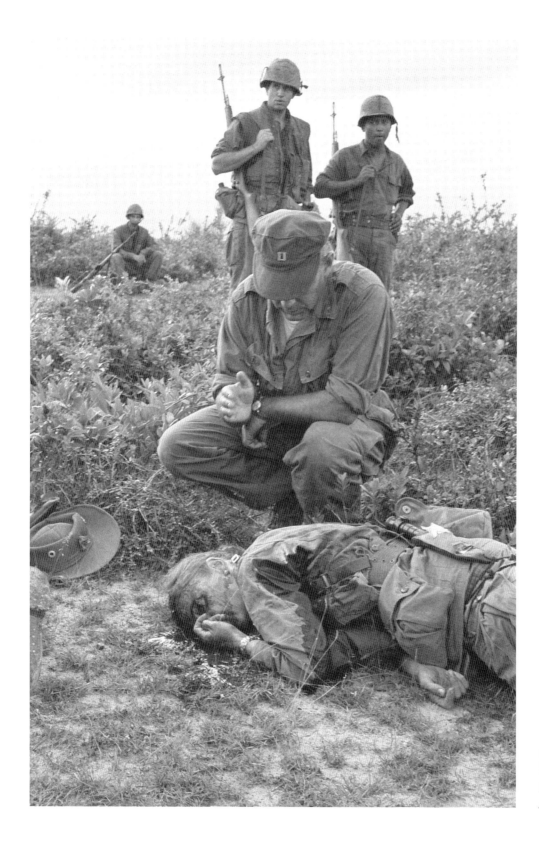

A Navy chaplain delivers last rites to
Dickey Chapelle November 4, 1965

Photo by Henri Huet
Associated Press

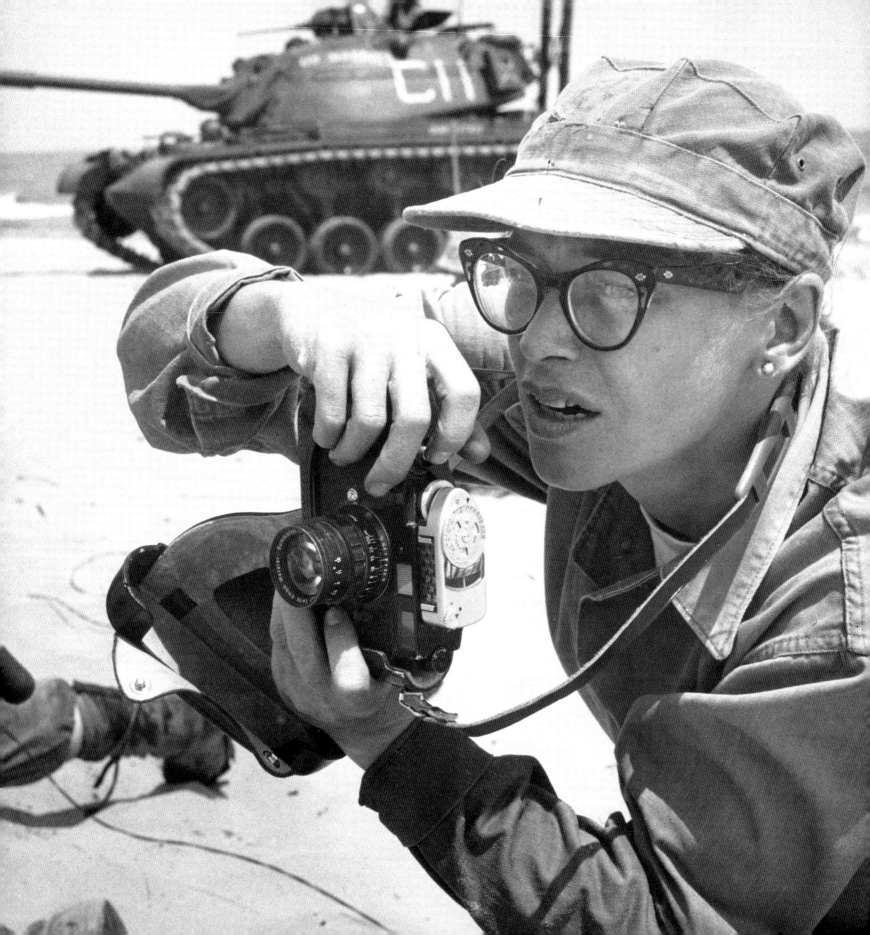

The Dickey Chapelle Papers: About the Collection

Andy Kraushaar, Visual Materials Curator, Wisconsin Historical Society Library-Archives

Just two decades after the ratification of the nineteenth amendment guaranteeing women the right to vote, three female photojournalists broke the gender barrier by covering World War II as combat photographers: Margaret Bourke-White, Marguerite Higgins, and Georgette "Dickey" Chapelle. In a field dominated by male photojournalists, the pioneering work of these women paved the way for today's female correspondents to report world news.

After Hans V. Kaltenborn, known as "the dean of American radio commentators," donated his papers to the Wisconsin Historical Society in 1955, Society archivists began soliciting additional papers from women and men who had worked in the field of mass communications. Three years later, the Mass Communications History Center at the Wisconsin Historical Society was formally organized with the purpose of documenting the mass media. A few of the important midcentury journalists whose papers and photographs are included in the collections are photojournalists Frank Scherschel and Wallace Kirkland and news correspondents Sigrid Schultz, Louis Lochner, Cecil Brown, and Alvin Steinkopf.

Opposite: This was Dickey Chapelle's favorite photograph of herself at work, taken in Milwaukee in 1958 by Marine Master Sergeant Lew Lowery, who also photographed the first American flag-raising on Mount Suribachi at Iwo Jima.

WHi Image ID 1942

One of the most important mass communication image collections at the Wisconsin Historical Society is that of Dickey Chapelle. Although her writing and photographic skills were exceptional, her tenacity and perseverance were her greatest strengths. The harlequin eyeglasses and pearl earrings she always wore were deceptive. She was an intrepid war correspondent who understood that as a photographer she needed to be on the front lines to serve as witness.

Shortly after Dickey's death, her brother, Robert Meyer, donated her archives to the Wisconsin Historical Society, including negatives, prints, published writings, and journals. In 1980 Dickey's agent, Nancy Palmer, donated major additions. From its inception, the Dickey Chapelle collection has been heavily used by a wide variety of researchers, and the Society often uses selections from her work to help prospective donors better understand the efforts of the Wisconsin Historical Society Archives' national collecting interests.

Despite Dickey Chapelle's numerous published articles and books, her award-winning autobiography, a biography written about her twenty-five years after her death, and even a song about her by the popular songwriter Nancy Griffith, the photojournalist's life and work remain relatively unknown to most Americans. The full sweep of her important work clearly deserves more attention.

The publication of this book is the first serious effort to focus on Dickey Chapelle's photography by showing a representative sampling of her images from across her career.

We are hopeful that this will lead to wider recognition and a greater appreciation of this remarkable journalist's career.

Forty years following the fall of Saigon, we are left with this powerful archive of photographs and manuscripts containing the work that Dickey Chapelle created while documenting conflicts around the world. This collection, emblematic of many collections available for research in the Wisconsin Historical Society Archives, can help us retain our collective memory and lead us to a better understanding of the past and present, which perhaps can give us insight into what the future may hold. ∎

Index

South Vietnamese marines move out at dawn, 1964. This photograph originally appeared in *National Geographic*, 1966.

National Geographic

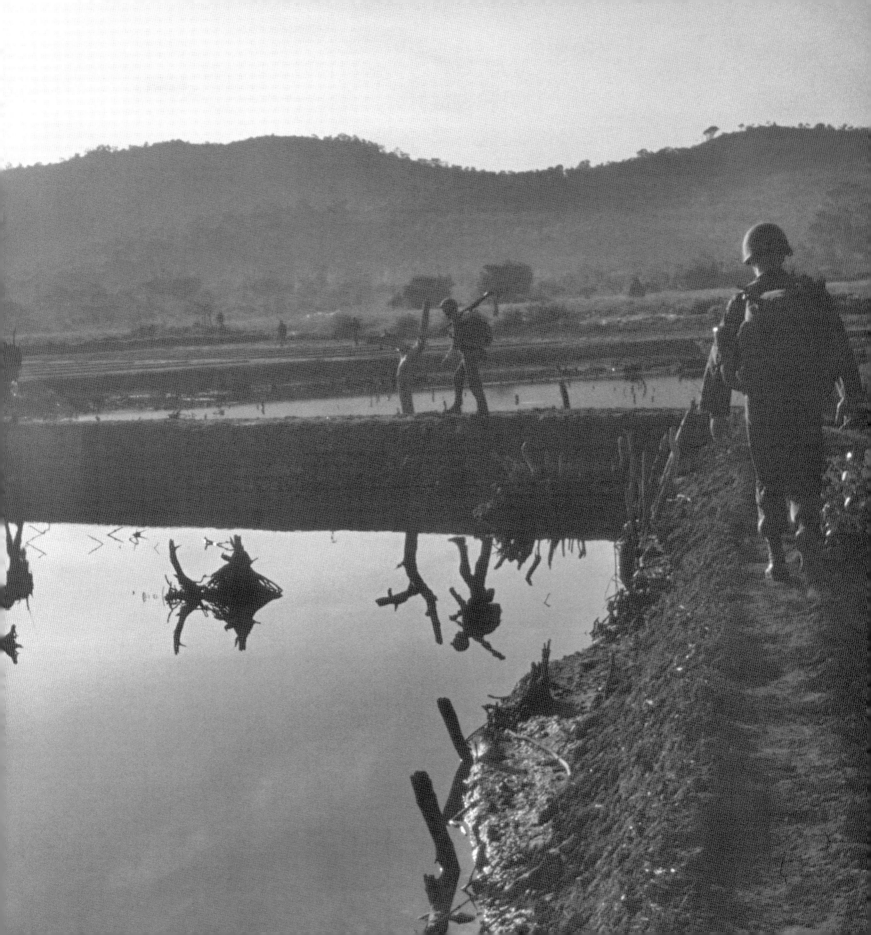